Food & Flowers

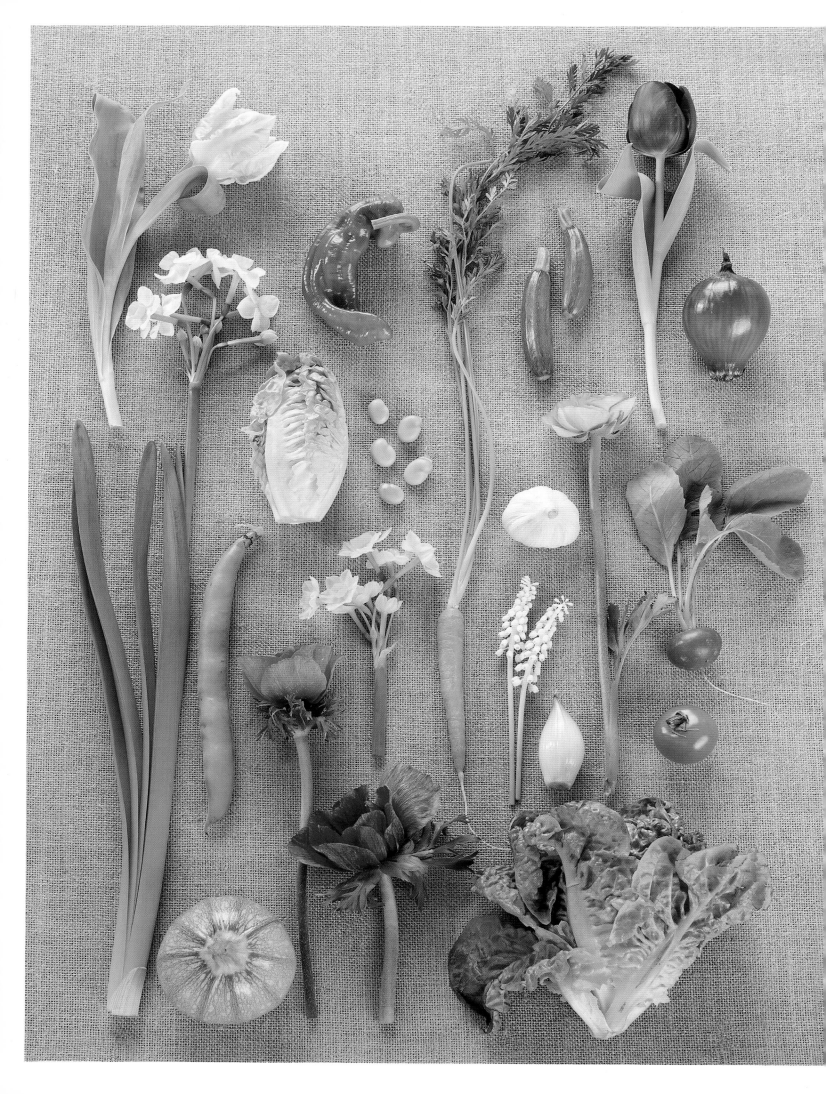

Donna Brown

Food & Flowers

Electa

I dedicate this book to the Earth and its fruits, with love and gratitude

Photographs
Federico Magi_TheYellowDog

Styling
Donna Brown

Translation
Studio Queens srl, Milan

Special thanks to

 International Flowerbulb Centre

for having kindly provided the flowers
photographed in the book

The publisher would also like to thank
Donna Brown for providing and authorizing
the publication of the texts and illustrations

www.electaweb.com

FSC
Mixed Sources
Product group from well-managed
forests and other controlled sources
Cert no. SQS-COC-100209
www.fsc.org
© 1996 Forest Stewardship Council

Contents

Preface

Every part of this book has been made for you with love and joy.

It is an honour and a pleasure to have been able to work on such an inspiring project; to share with you the changing of the seasons, delicious food, glorious flowers and enchanting photographs in the hopes of inspiring you to stop and look at what is around you, everyday ingredients and objects, and recognize them for what they truly are: gifts of infinite beauty and grace.

Let these pages take you on a trip of discovery of the creativity, the desire for fun and laughter.

Feel free to make your own changes; the recipes and decorations are to use as guidelines, to make you feel adventurous enough to do something as completely different and unique as you yourself are. Nothing you make with your heart could ever be anything but beautiful, so let yourself go and have fun.

I have used local products and things I have grown myself although I confess a weakness for cut flowers, especially during the winter months. The flowers and vegetables will obviously vary from country to country and climate to climate, but the principle remains the same: use the best and freshest local ingredients. Look around your house for little containers and unassuming objects, glasses, cups, pots, and in your pantry and garden for ingredients just waiting to be noticed: potatoes, onions, peppers, and match them up with all the lovely flowers that bulbs produce so easily.

It doesn't matter if you don't have the time or space to grow them yourselves. Look around you at the farmer's markets, flower stalls and even in the supermarket and you will be surprised at how much beauty you will find. In this book I have chosen to match up vegetables and bulbs; two of Nature's most interesting "objects of design." The architectural beauty of artichokes and cauliflowers, the delicate poetry of narcissus, the regal poise of the amaryllis make them a stimulating and natural choice.

Really look around you, enjoy what is probably the greatest luxury of all, that which you already have.

Spring

I love this season. Each bud bursts with promise. Initially uncertain, almost shy, they gradually bloom into a riot of colour that can only gladden the eye of the beholder. Stunningly beautiful, delicate, fruit tree blossoms froth in pink and white. Forsythia, *viburnum opulus*, and mimosa form a backdrop to crocuses, wild anemone, daffodils, hyacinths and early tulips.

My garden for cut flowers burgeons year by year. Bulbs grow cheerily with a minimum of effort. My collection of parrot tulips ripple in the breeze. They remind me of butterflies… I pick them in armfuls and arrange them in vases in the house.

The breeze is pregnant with the sweet scent of the hyacinths and the daffodils. I have to admit that I prefer them as they are growing in the open air, so I rarely pick them, preferring to enjoy them as I stroll around the garden. What I do pick are the wild anemones that dot the meadows. Our house is surrounded by swathes of wild daffodils.

Walks lengthen as the first days of spring unfurl their sunlit hours. We spend more and more time outdoors, spotting new nests and watching the swallows return. Newborn sparrows in the nests on our roof make an incredible noise and disturb the sleep of our guests, although we barely notice them any more.

With all the spring vegetables in the garden I am seized with a fresh desire to cook: broad beans, peas sweet enough to eat raw, asparagus, tiny courgettes, slim spring onions and fresh lettuce all bedeck the dining table in soups, fresh pasta, quiches or salads.

The tepid heat and sunlight of the first warm days bring happiness in their wake and an inevitable sense of sheer joy at the miracle of being alive!

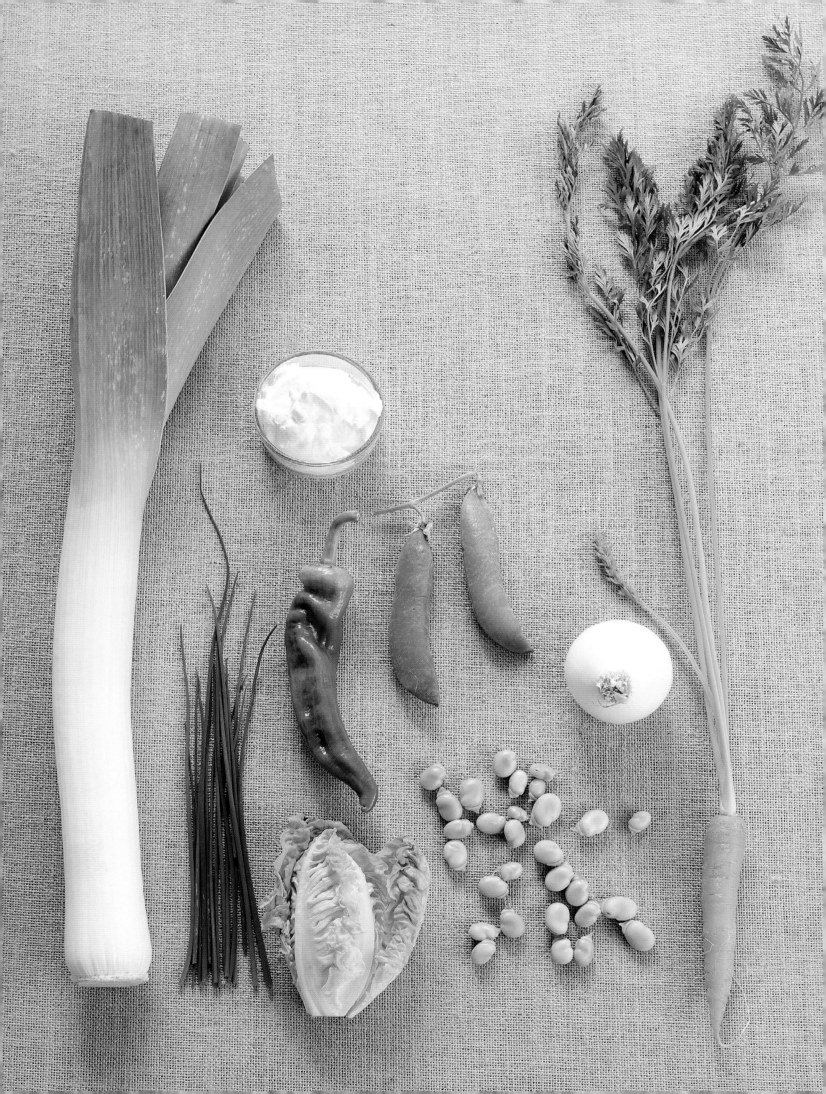

Lettuce, Fava Bean and Pea Soup with Chives

Serves 4

Preparation time: 15'
Cooking time: about 35'

450 g fresh, podded fava beans or peas (or both)
1 large white onion
1/2 leek
2 baby carrots
1 celery stalk
100 g sweet green chilli peppers
600 ml water
150 g baby lettuce
A small bunch of chives
100 ml cream
2 tablespoons of full-cream yoghurt or *crème fraîche*
3 tablespoons extra-virgin olive oil
Salt and pepper

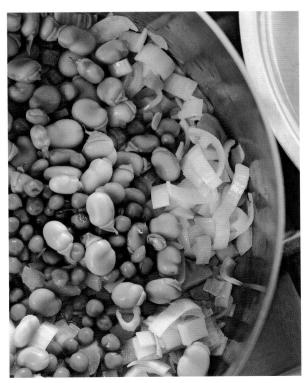

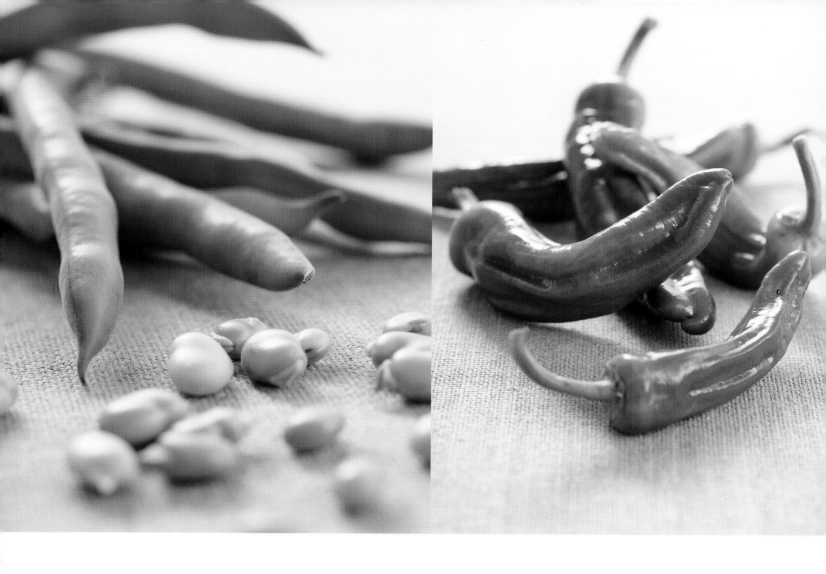

This tasty soup is a wonderful combination of all the flavours of spring; fresh peas, fava beans, young lettuce and chives with a hint of *crème fraîche*. It is sophisticated enough for a formal lunch or dinner, but easy enough for a mid-week family dinner.

You may use either peas or fava beans or a mixture of both; the choice is up to you.

Clean and slice the celery, carrots, onion and leek. Sauté briefly in oil and add the peas and/or the fava beans and the chillies cut lengthwise in two. Pour 600 ml of hot water into a pot, place the lid on and cook over a low heat for 20 minutes. Add the baby lettuce – break it with your hands first – and then add salt and pepper to taste before cooking for a further 7/8 minutes. Strain one third of the vegetables with a strainer; keep aside. Using a food processor, blend the remaining vegetables with the yoghurt and the cream. Put the whole vegetables and the whisked soup in a pot again and add the chopped chives. Heat quickly and serve.

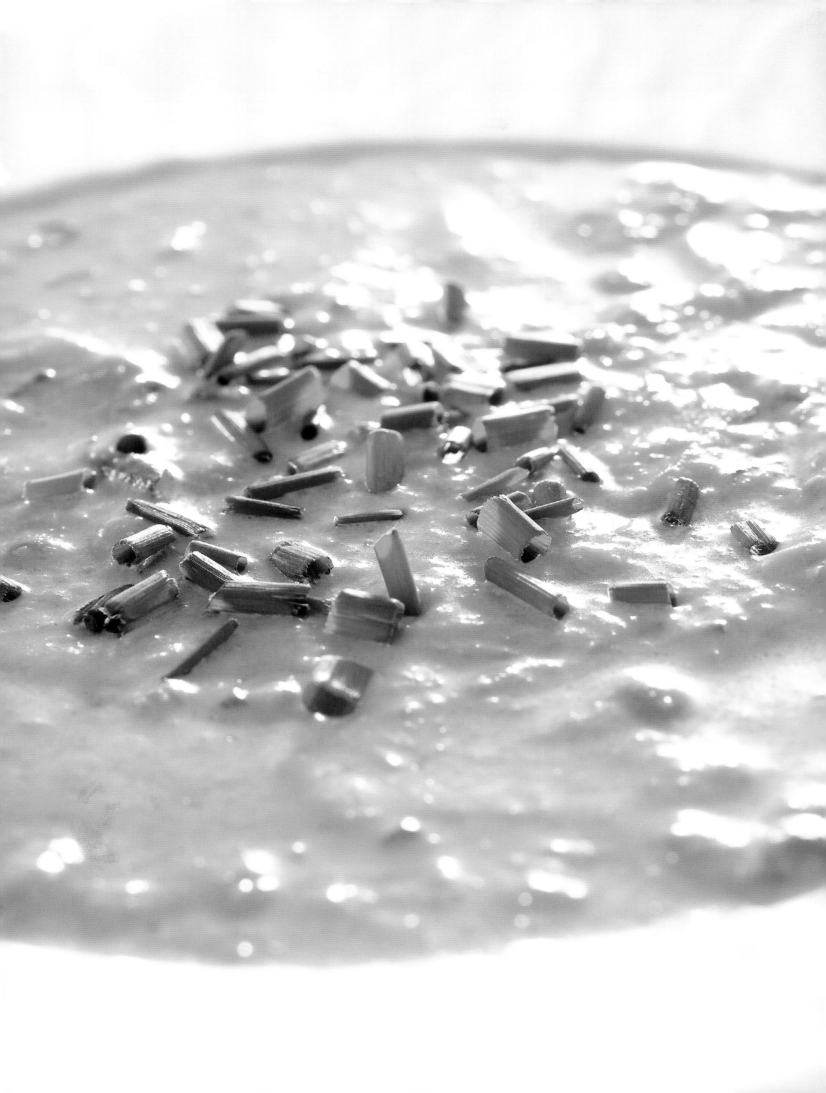

A Field of Young Lettuce and Spring Flowers

Preparation time: 20'

3 heads of young lettuce
7 white or light pink parrot tulips
9 purple anemones
25 grape hyacinths (muscari), white and light blue
7 small green chilli peppers
Cylindrical glass vase, approximately 28 cm diameter

Beautiful, fluffy, light green lettuce and bright, shiny sweet peppers serve as a base to hold up a "field" of tulips, grape hyacinths and anemones. Nothing could be simpler, but the effect is simply stunning.
Open the lettuce gently with your hands to coax the leaves open and place them in the vase. Add two or three peppers between the lettuces to form a fairly full "base" that will hold the flowers.
Add the tulips taking care to vary their height and direction. They should peep out over the top of the lettuce. Next, take the grape hyacinths in small bunches and fit upright throughout the vase.
The finishing touch are the anemones. Spread them through your composition for an even distribution of colour.

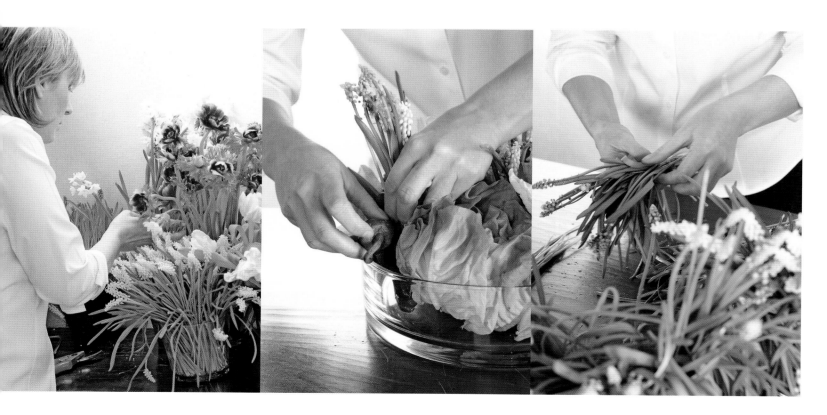

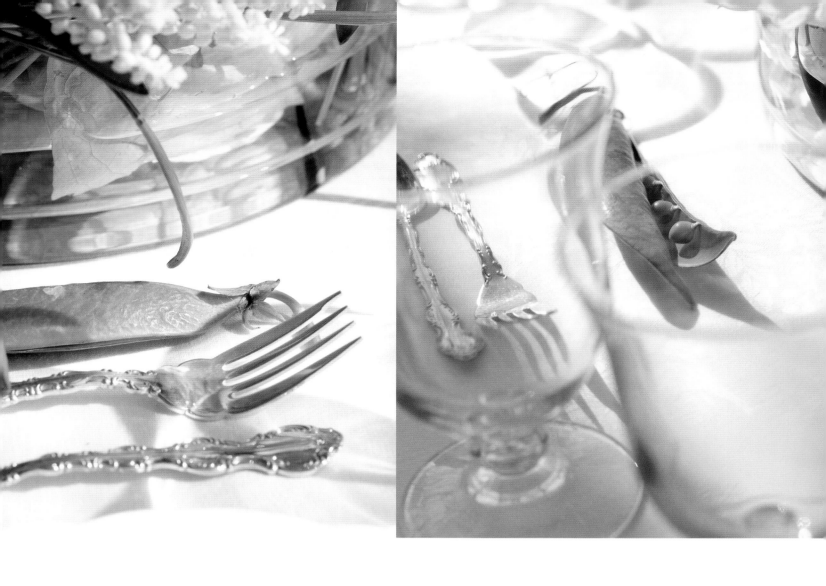

Freshly picked peas, opened in such
a way as to reveal their hidden treasure,
can be fresh, light-hearted...
and edible placemark!

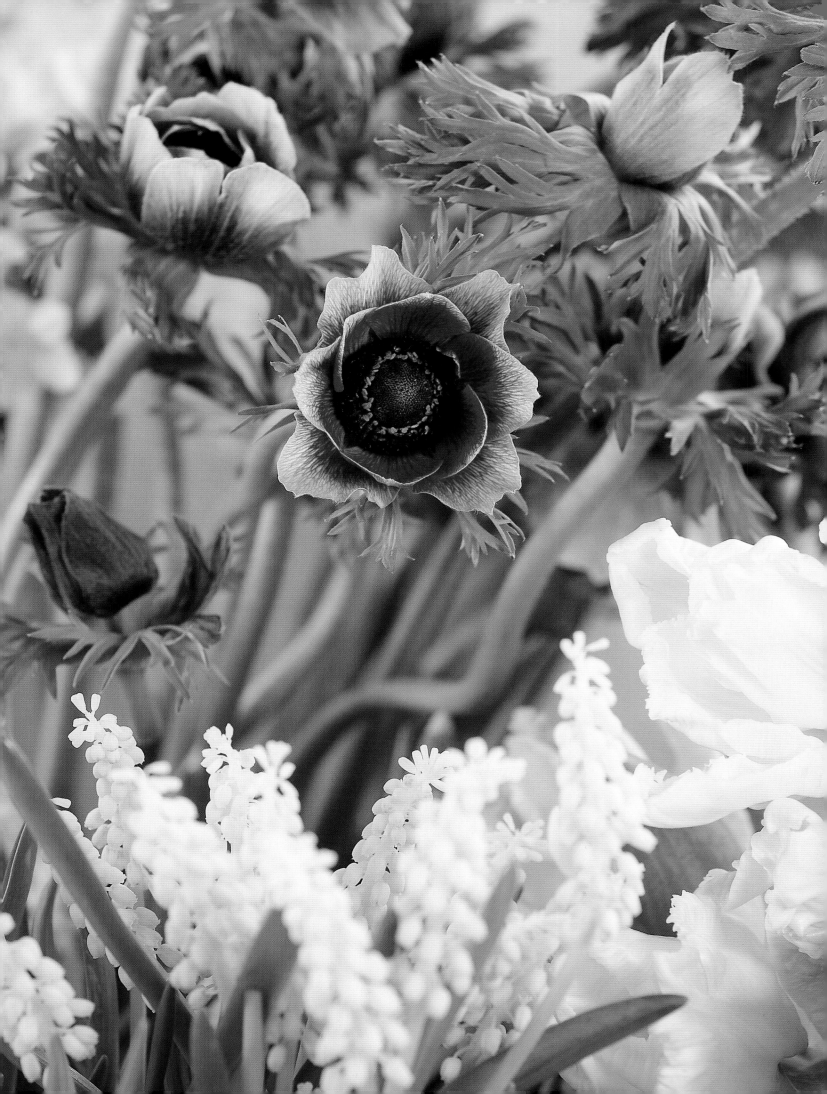

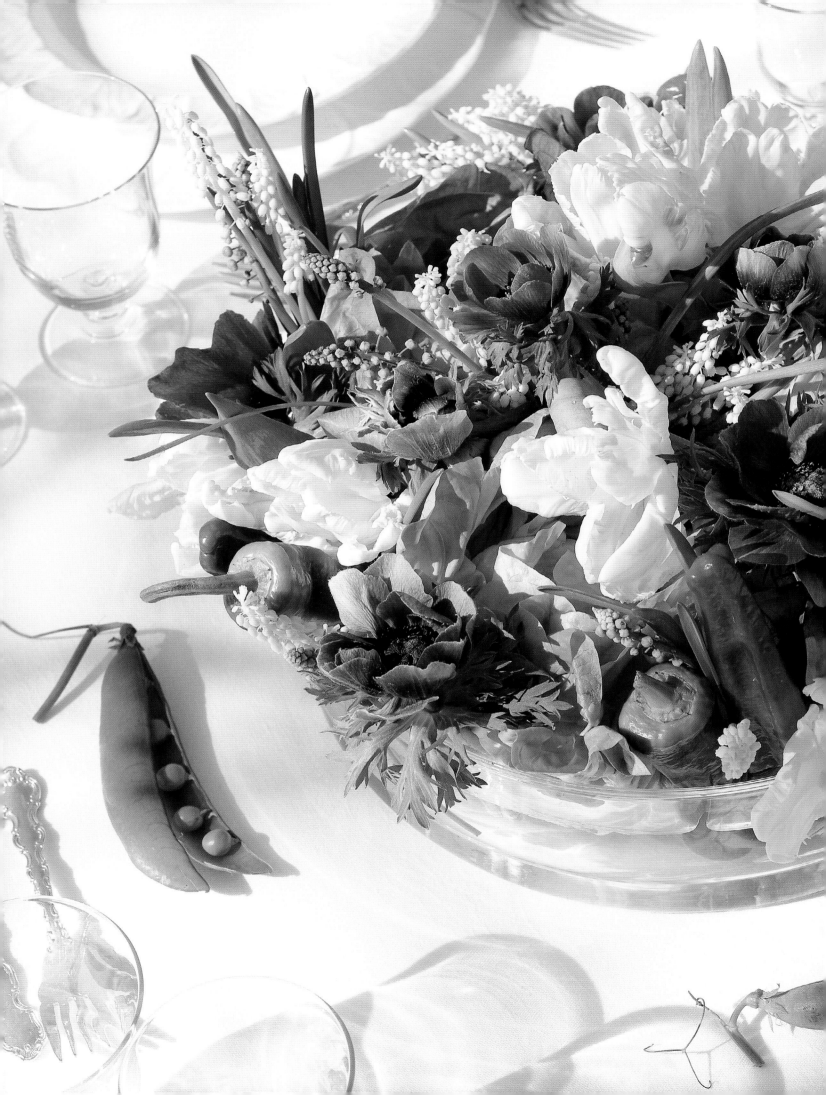

Linguine with Zucchini, their Flowers, Asparagus and Ginger

This surprising combination of ingredients makes a fantastic dish and has become a great favourite. The sauce is a sort of vegetarian "Carbonara" style sauce with the addition of leeks, ginger and zucchini flowers. The vegetables are sautéed quickly to maintain their colour and crunch and the whole thing together is scrumptious. The zucchini look like lovely green ribbons, while the asparagus tips poke their way through the linguine. It is a very festive looking dish but don't wait to have guests to try it yourself.

Finely slice the leek and then gently sauté in a pan with the extra-virgin olive oil along with the asparagus tips cut into halves lengthwise (or into four parts, if you can't find thin asparagus). Slice the zucchini lengthwise and sauté with the leek and asparagus. Cook over high heat for about 3-4 minutes making sure they stay crunchy. Blanch the zucchini flowers in salted water for 30 seconds. Using a food processor, blend them with the ginger, 2 tablespoons of fresh chopped parsley, the cheese, the eggs, the cream and some salt and pepper. Boil the pasta in plenty of salted water until it is *al dente*; strain. Sauté the pasta briefly with the cooked vegetables. Remove from heat and add the egg, zucchini flower and ginger mixture.
Mix everything thoroughly and serve immediately.

Serves 4

Preparation time: 20'
Cooking time: 5'

320 g linguine
250 g thin asparagus tips
250 g baby zucchini with flowers
70 g leek (white part only)
30 g ginger freshly grated
2 tablespoons chopped parsley
2 eggs
2 tablespoons cream
40 g grated Parmigiano
4 tablespoons extra-virgin olive oil
Salt and pepper

> This pasta, just like Carbonara, must be served immediately to get the best out of the dish

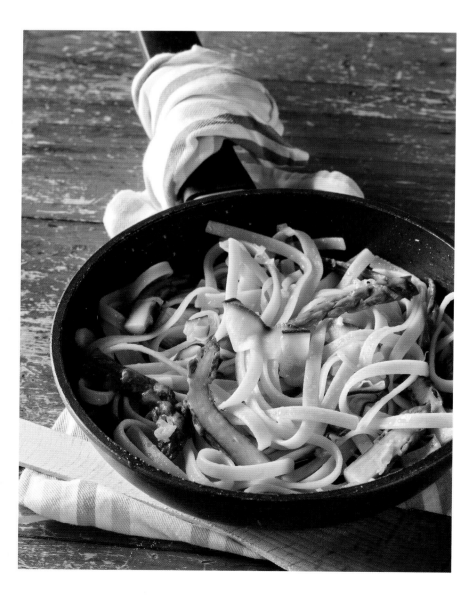

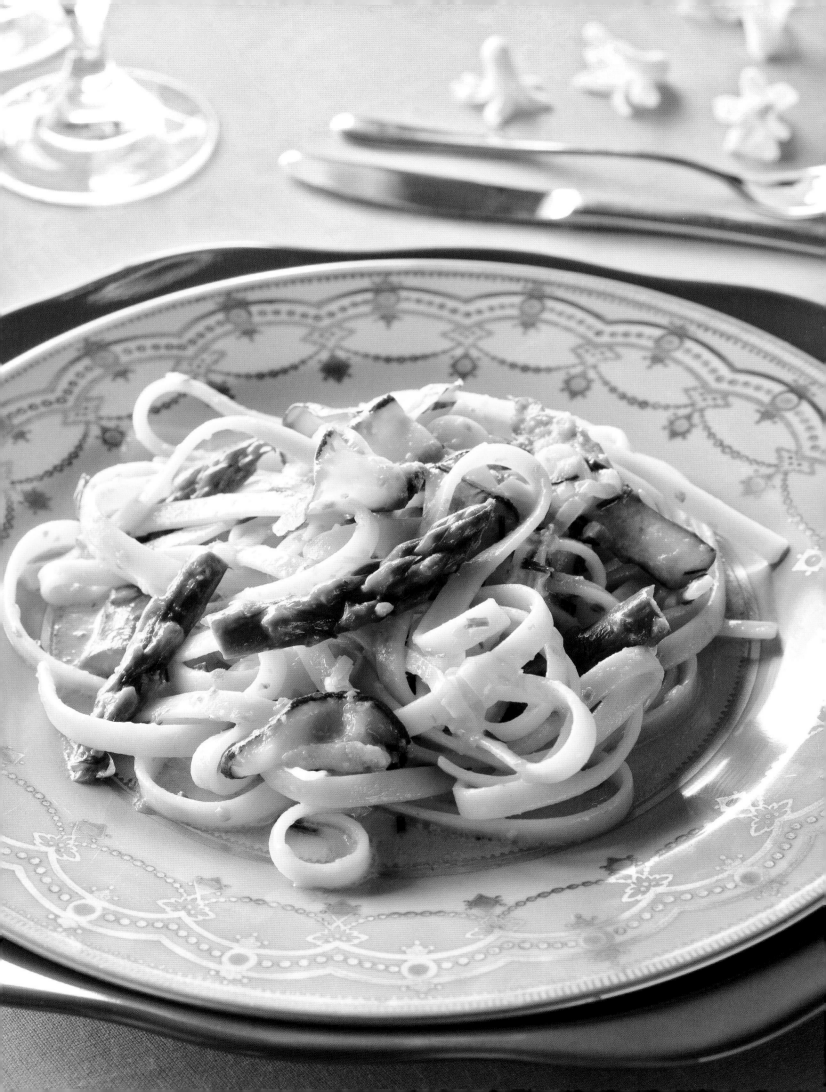

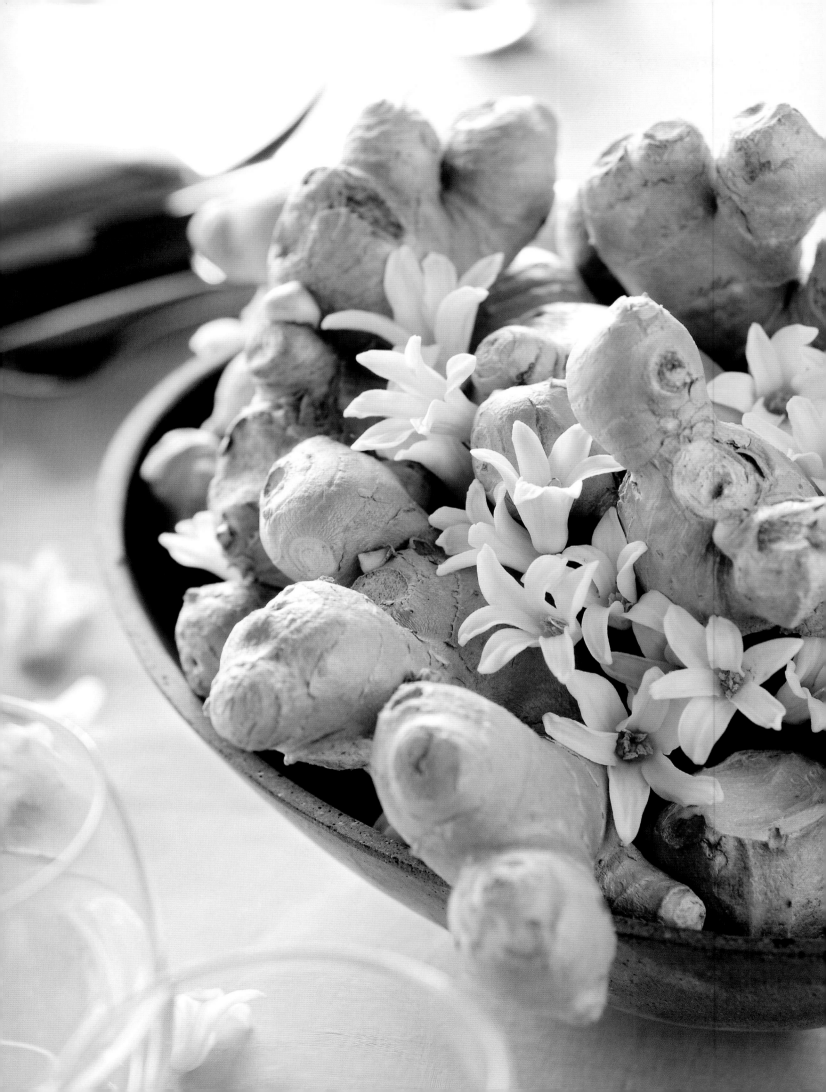

A Romance of Ginger, Ranunculuses and Hyacinths

Time for centrepieces: 30' each
Time for napkin rings: 5' each

8-10 pieces of ginger root
5 stems white hyacinth
25 pink ranunculuses
Florist's wire
1 block of moistened floral foam, divided in two pieces
Floral picks
2 oval bowls

This is a romantic decoration for a special occasion. Hyacinths are beautiful flowers with a seductive fragrance. Normally you shouldn't use flowers with a strong perfume for table decorations, but to be able to use the hyacinths, which I really love, I suggest you use the individual flowers, detaching them from the stem. Sprinkled through the ginger, they make a delicate contrast to the knobbly strength of the ginger root. Fluffy pink ranunculuses fill the other bowl and provide a sweet contrast.

Cut the moistened foam in two pieces and place them in the two bowls. For the first bowl, mount the ginger on the floral picks and insert them in the moistened foam. Cut the individual flowers from the hyacinth stem and cut the floral wire into many pieces (about 10-12 cm). Bend a small hook at the end of each piece of wire and then insert the other end into the centre of the flower. Delicately pull the wire through, until the hook attaches to the base of the flower. Prepare 15-20 and then start placing them like little stars throughout the ginger roots. In the other bowl, create a lovely, round, fluffy, pink cloud of ranunculuses.

For the napkin rings, take lengths of floral wire approximately 17-18 cm long and thread hyacinth blossoms until there are enough for the circumference of your napkins. Twist the ends together, cut short and twist back into one of the blossoms so the wire doesn't show.

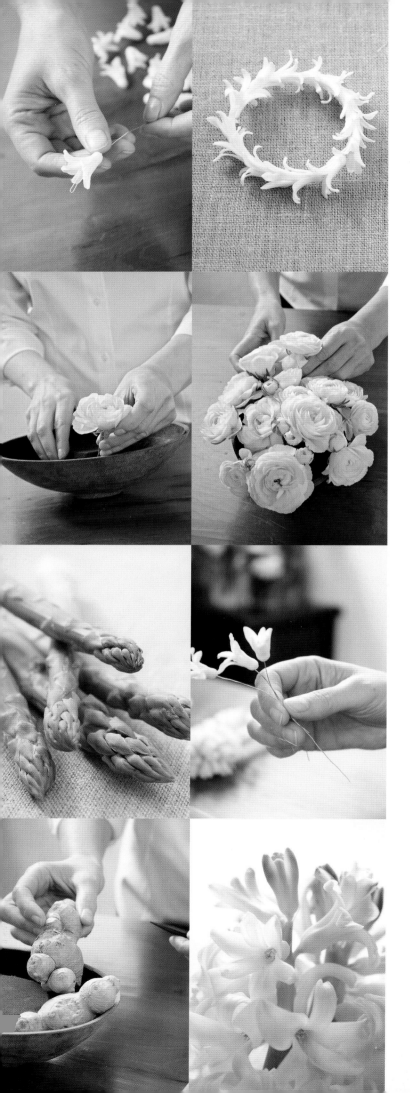

The napkin rings,
with their delicate beauty,
usually end up on
the wrists of the ladies
as souvenir bracelets

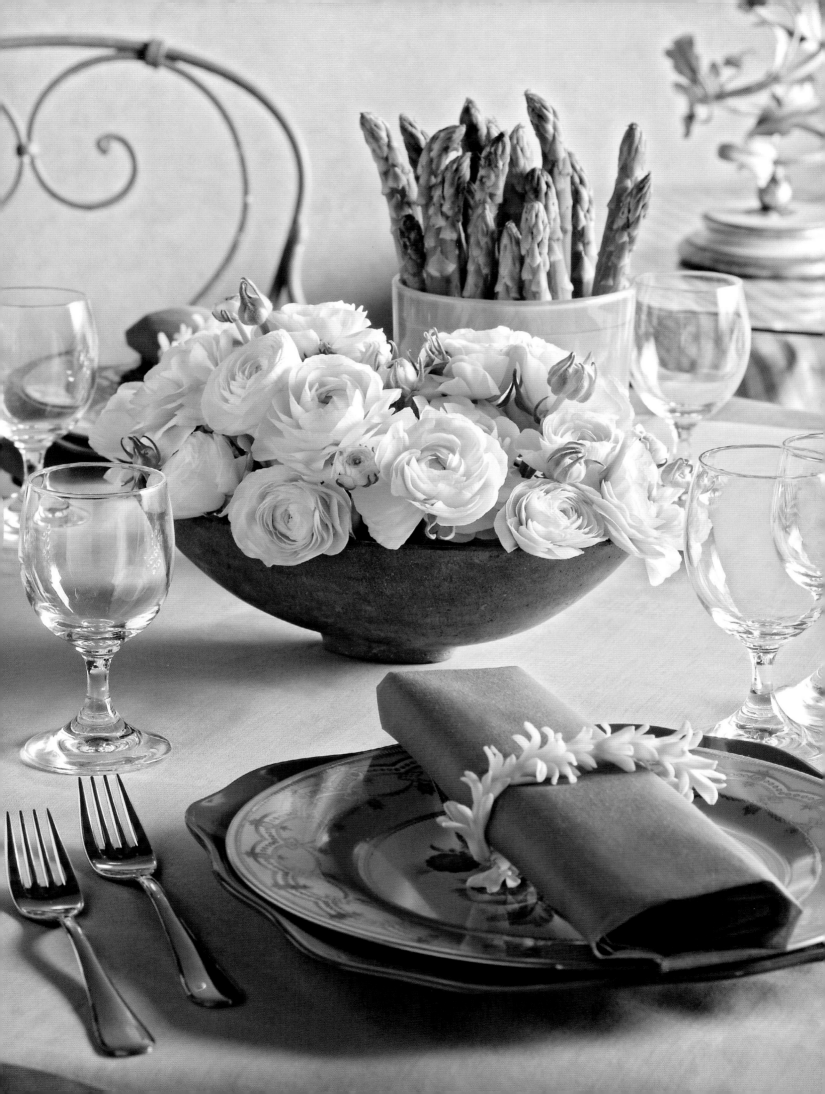

Cheesecake of Spring Carrots, Almonds and Verbena

Serves 6

Preparation time: 30'
Cooling time: 4 hours

150 g salted crackers
75 g butter
500 g cream cheese
30 g leek
1 dozen baby carrots with tops
75 g minced toasted almonds
2 tablespoons of verbena (vervain)
leaves
Organic lemon rind
Extra-virgin olive oil
Szechuan pepper

We all know how easy a refrigerator cheesecake is. This one has leeks and almonds to zing it up and the sweet, baby carrots are delightful to look at. This fun looking dish would liven up any table, but I think it would really stand out in a buffet.

Line the bottom of a deep spring form pan (24 cm diameter) with parchment paper.
Blend the crackers with the butter (cold) in a food processor and then press this mixture onto the bottom of the cake pan.
Blend the cheese with the white part of the leek (cleaned and chopped), the verbena, the lemon rind and 50 g of the chopped and toasted almonds. Flavour with plenty of Szechuan pepper, pour the cheese mixture into the pan and smooth the top carefully. Sprinkle with the remaining 25 g of almonds, cover and keep in the fridge for at least 4 hours.
Clean the carrots, leaving the top attached, and dress with a touch of extra-virgin olive oil, salt and Szechuan pepper. Take the cheesecake out of the pan and place on a serving plate. Garnish with the carrots and serve.

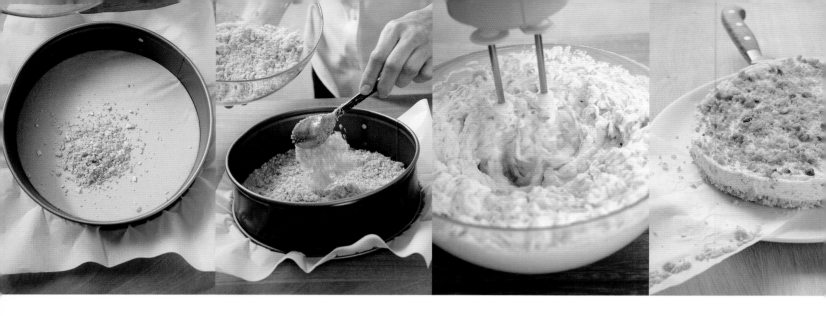

"
The wheel of brightly-coloured carrots
delights the eye, the creamy-crunchy
cheese filling, with its hint of leek,
delights the palate for a sunny,
spring luncheon
"

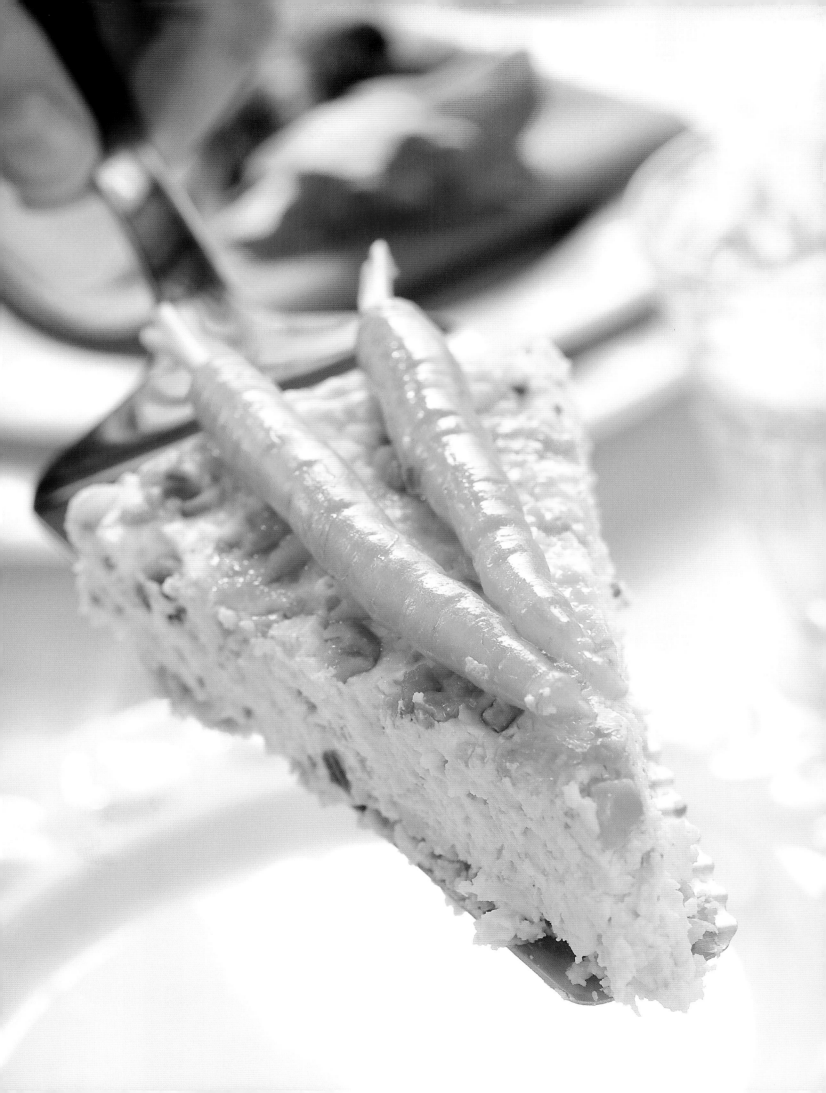

Anemones, Baby Carrots and Fennel in Preserving Jars

Preparation time: 30'

1 bunch of baby carrots
1 bunch of baby fennel
25 anemones
7 mason's jars and lids
7 tealights
3 butterfly potholders (optional)

This is a fun table. Colourful, naïf and slightly kitsch, it's perfect for a Sunday brunch in the country.
I bought these crocheted potholders at a charity sale and they make me smile every time I use them.

Divide the carrots and fennel into two bunches each. Put them in four jars and place on the table.
Fill the three remaining jars with water, divide the anemones amongst them and place them on the table.
For candle holders use the clean tops of the jars and place a large tealight in each one. Last, but not least,
place the butterfly potholders amongst the jars.

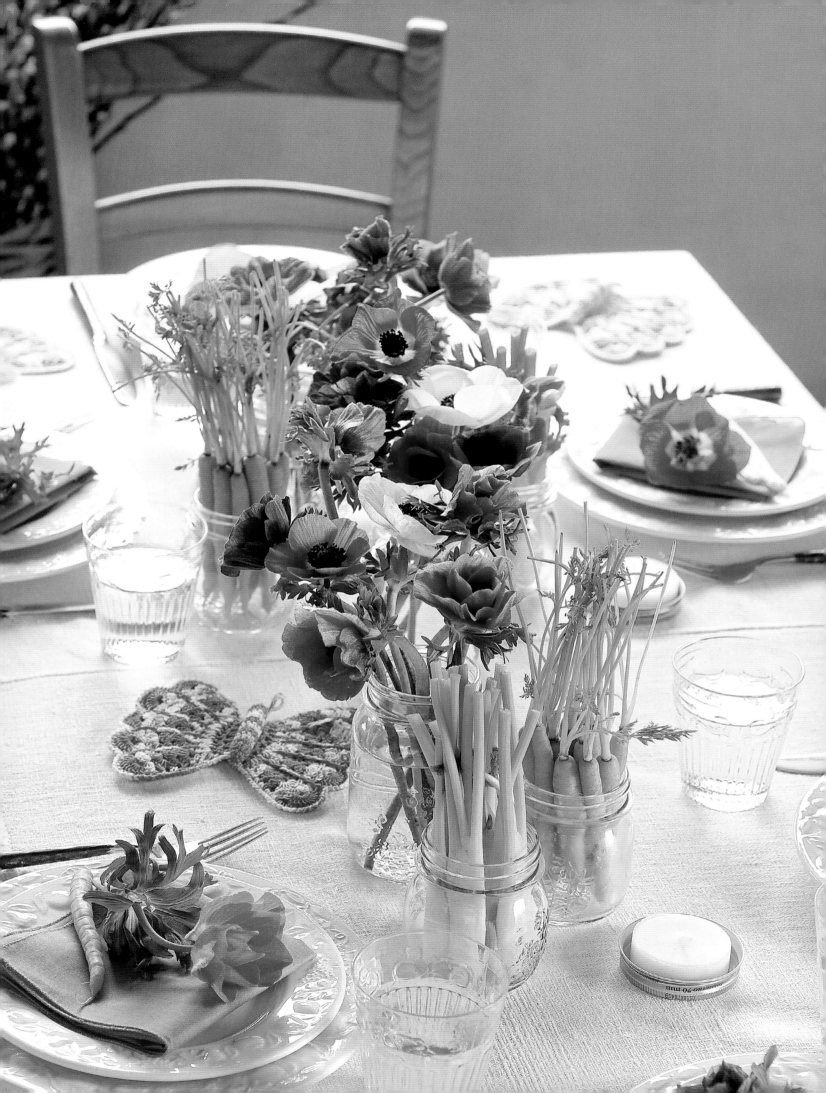

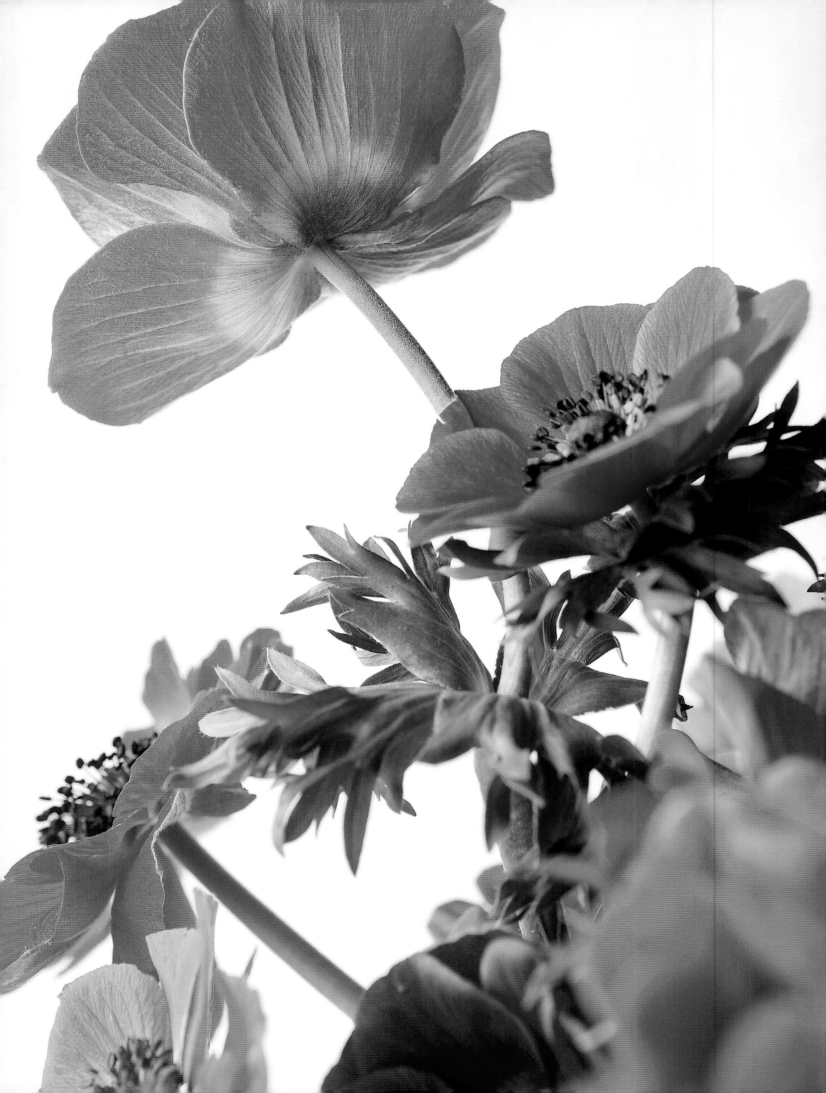

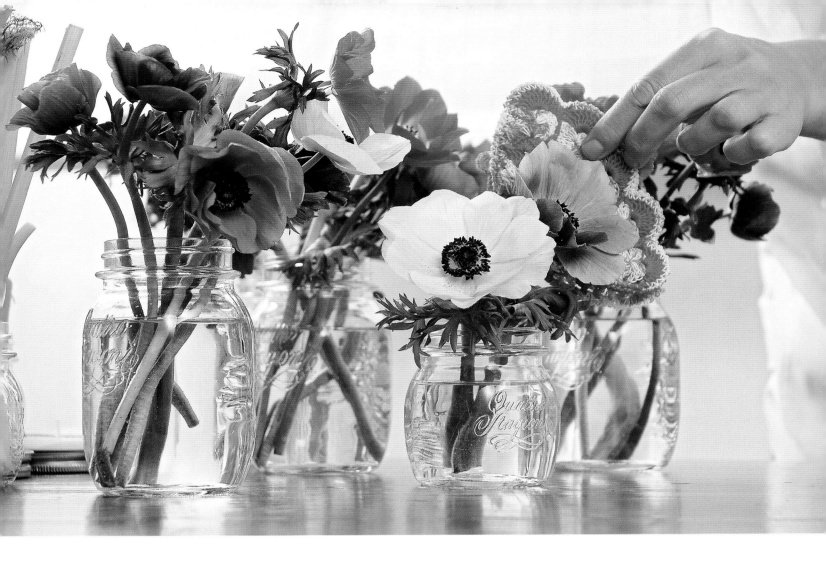

Remember to have fun and don't be
afraid of being a little kitsch!

Clafoutis of Zucchini, their Flowers and Brie

The first zucchini of the season are picked when they are very small and tender, with their flower still attached. They should be cooked the same day as the flowers do not last. Otherwise you could purchase the flowers and zucchini separately; they seem to last longer that way.

Cook this only until just set, just like not over-cooking your eggs. The result should be a fluffy egg mixture with golden flowers and emerald green zucchini. Perfect for a spring brunch.

In a bowl, mix together the eggs with a plentiful tablespoon of herbs (ideally fresh), a generous amount of grated nutmeg, the cornstarch, the *crème fraîche*, the milk, salt and pepper.

Finely slice the onion and then sauté in a non-stick pan with 2 tablespoons of extra-virgin olive oil. Add a ladle of warm water so that the onions slowly become transparent. Chop off the tips and tops of the zucchini and then cut into halves (lengthwise) before chopping into fairly large pieces. Add these to the onion and then cook over a medium heat for a further 7 or 8 minutes. Add in the flowers (remove the pistils) and some salt and pepper. Remove from the heat. Grease an oven-proof dish and sprinkle thoroughly with the breadcrumbs. Place the zucchini with flowers and the very thin slices of Brie in alternate rows in the dish. Pour the entire egg mixture over the top.

Bake in a pre-heated oven at 375°F for about 25 minutes and then serve.

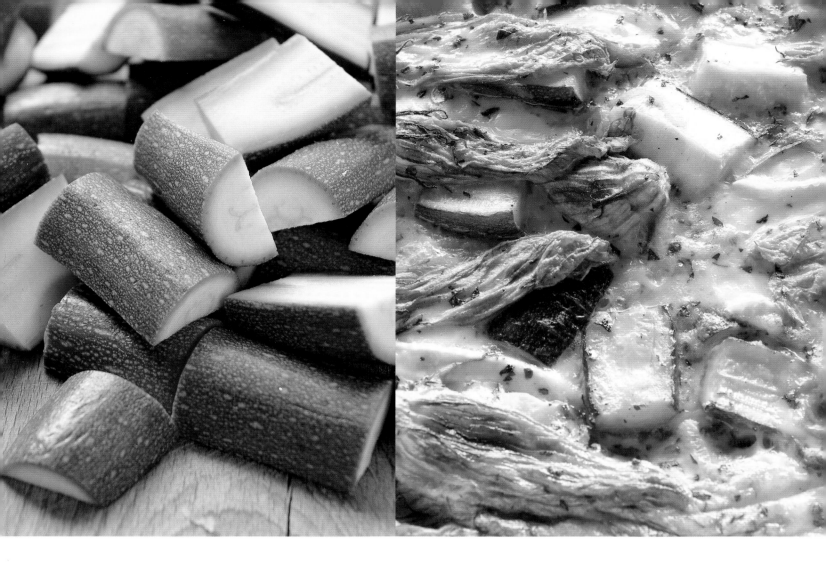

Serves 4

Preparation time: 15'
Cooking time: 45'

600 g baby zucchini with flowers
1 large white onion
250 ml *crème fraîche*
250 ml milk
10 g cornstarch
150 g sliced Brie
2 whole eggs plus 2 yolks
50 g breadcrumbs
Extra-virgin olive oil
Butter
Oregano and marjoram
Nutmeg
Salt and pepper

The first warm, sunny days
of spring bring everyone
out into the open
and the sunshine-yellow
zucchini flowers and
the emerald green zucchini
perfectly reflect
the new season

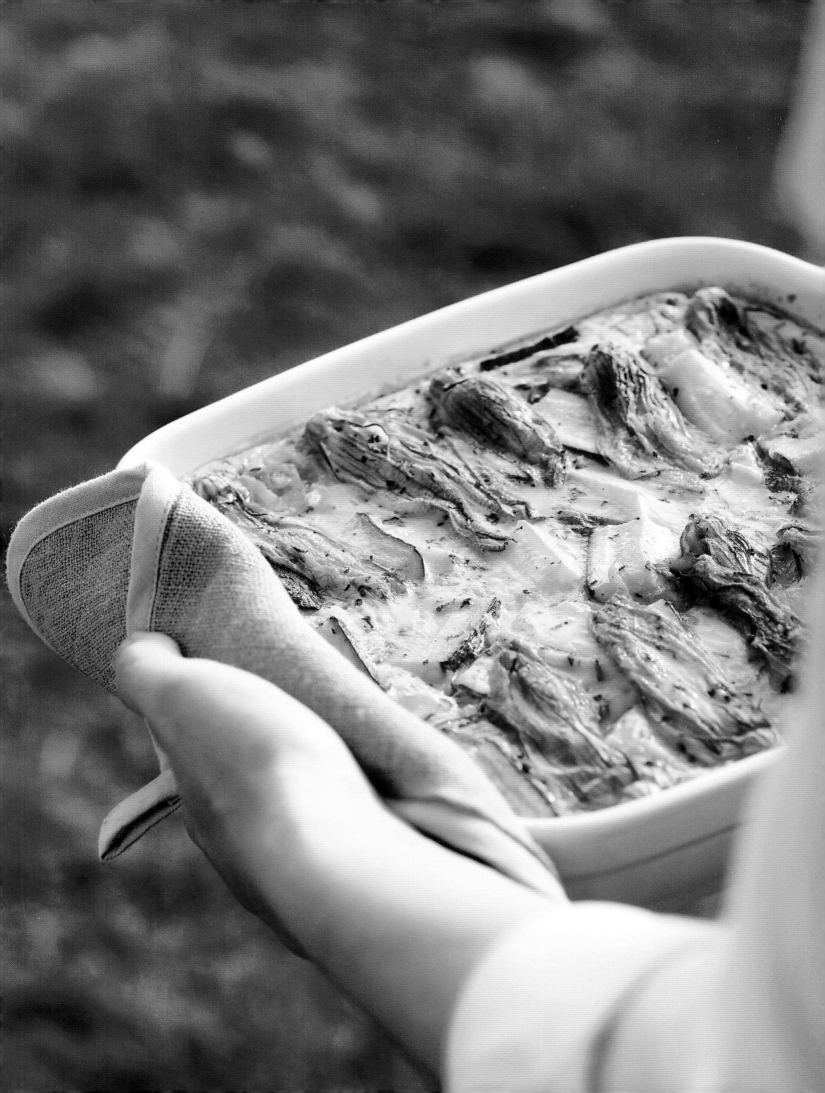

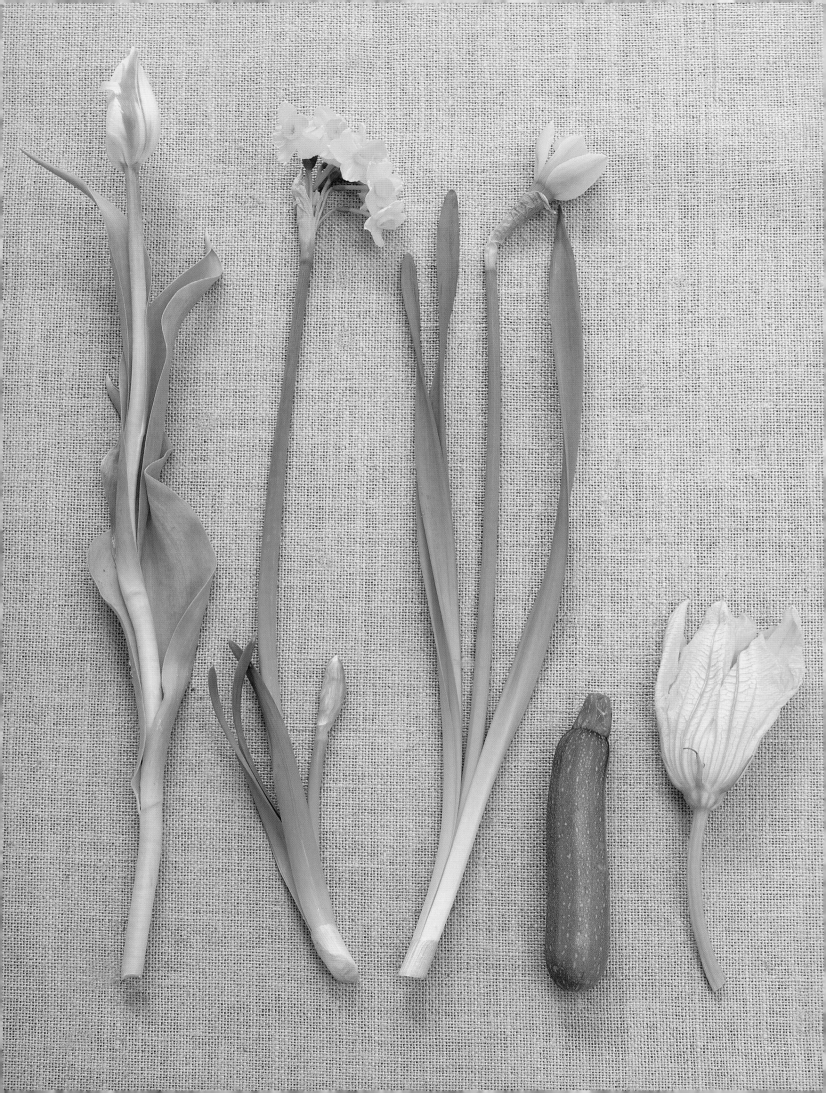

Mosaic of Narcissus and Zucchini

Preparation time: 45'

12 daffodils
5 narcissus
12 yellow tulips
9 small zucchini
6 larger zucchini
1 round zucchini for each guest
7 square vases of various sizes

Daffodils have the happiest yellow that shouts "spring!" Mixed with shiny, emerald green zucchini, they make an irresistible combination. The square vases offset the ruffles of the daffodils and give them a graphic presentation.

To prepare this decoration is quite simple; tie little bouquets of flowers and bundles of leaves, and fill each vase with either the flowers, the leaves or the zucchini.
A round zucchini becomes a tubby little bud vase by cutting away a little core of pulp with a vegetable knife. If you wish them to last longer, cut them a little deeper so that they hold a little water or moistened cotton wool. For tulips, line a vase with their leaves and put tulips cut short inside.
This joyous composition may be used as a centrepiece or for a buffet. Should you need or wish a larger composition, add more or even taller vases.

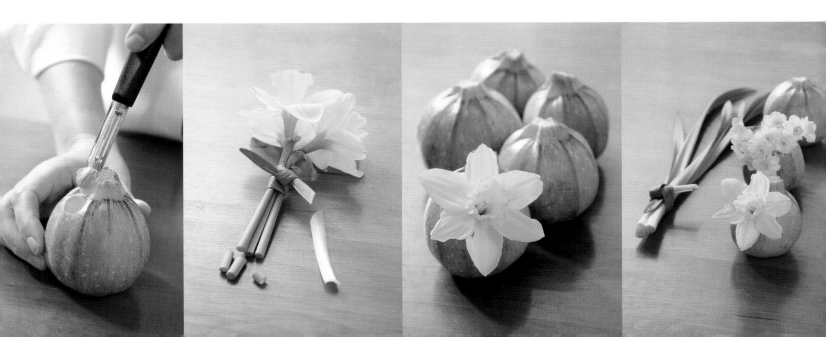

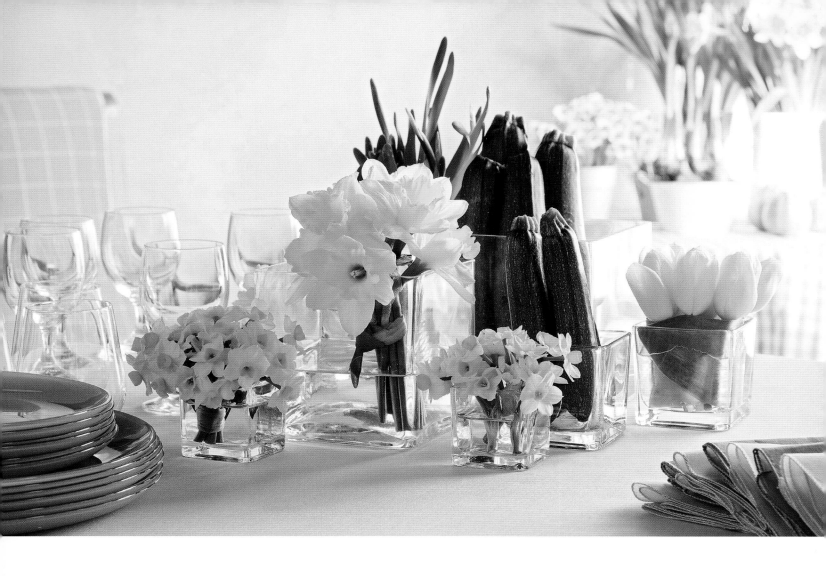

Spread your flowers and vegetables
around the room to bring more depth
and interest to your compositions

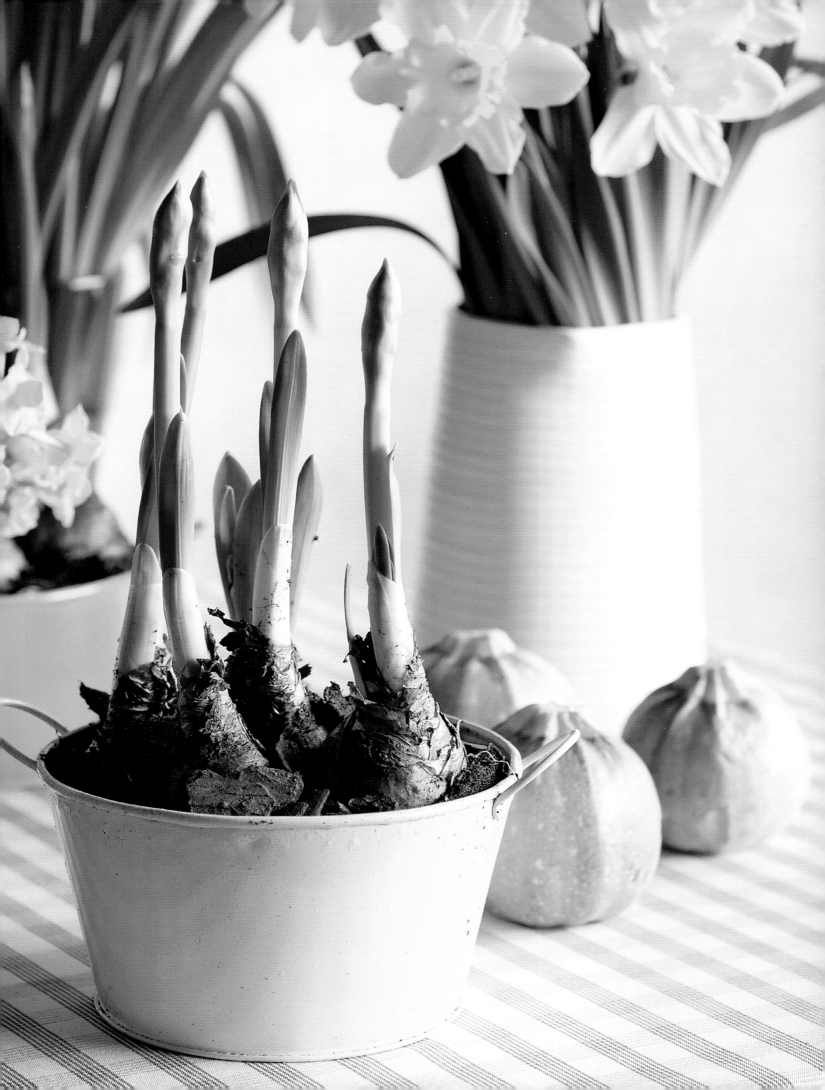

Sprout, Celeriac and Tulip Salad
with Estragon Vinaigrette

Serves 4

Preparation time: 15'

100 g mixed sprouts of radish,
onion and leek
200 g alfalfa sprouts or other
sprouts as you prefer
1 green apple
40 g toasted pine nuts
100 g wild rocket
100 g raw celeriac
2 pink and yellow tulips
1 shallot
1 small bunch estragon
Extra-virgin olive oil
White wine vinegar
Salt and pepper

The spring, with all the new seeds planted out in the vegetable garden, is a wonderful moment. It's such a promising sight to watch the seedlings grow. This salad was inspired by them and the lovely tulips in the garden.
The seedlings, on the other hand, are miniature concentrates of what they will become; onions, leeks, cabbage, so choose the mixture of sprouts which suit your tastes, as strong or as mild as you prefer.

Wash the sprouts thoroughly, dry and then place on a clean cloth to disentangle them carefully.
Slice the green apple finely and julienne the celeriac. Rinse the tulip petals and then blend the shallots with a tablespoon of estragon, 2 tablespoons of vinegar, 4 of extra-virgin olive oil, salt and pepper. Place the rocket on the plates, add in the apple slices, celeriac, petals and sprouts.
Sprinkle with the pine nuts, pour over the dressing and serve.

Not everyone knows that tulip petals
are edible! Make sure you use only
organically-grown flowers

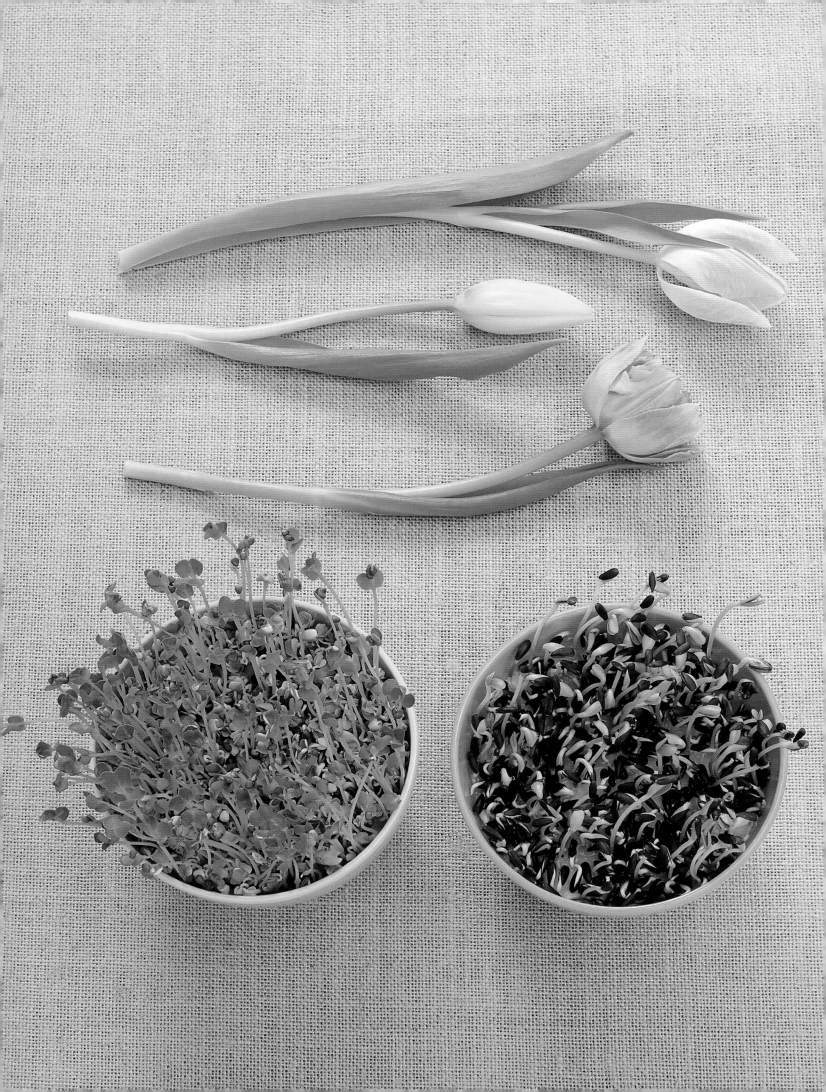

Sprouts and Tulips

Time for sprouts: 3-4 days depending on variety
Time for decoration: 30'

15 pink tulips
15 lilac peony tulips
15 yellow tulips
A variety of seeds
Small, coloured bowls
Cotton wool

Children love to watch seeds sprout. At school we have all sprinkled wheat grass seeds on cotton wool, watered and watched them grow. This made me think that it's not a joy meant only for small children. Many people grow sprouts to eat, so I decided to combine the two things and plant them in brightly coloured plastic bowls.

One thing lead to another and before eating them I decided to use them on the table as a centrepiece. Tulips with their beautiful colours and clean shapes are a great match for these spindly sprouts.

Plant any and as many seeds as you like on cotton wool in your favourite containers. The ones used here are all from the same children's service, but the choice is yours. Depending on the seeds you have planted they may take anywhere from three days to three weeks to sprout, so if you have a date that you wish them to be ready by, read the seed packet carefully. When setting the table, place the bowls of sprouts in an irregular pattern down the centre of the table. Add the bowls for the tulips, alternating them with the sprouts. Cut the tulips quite short, just over the rim of the bowl.

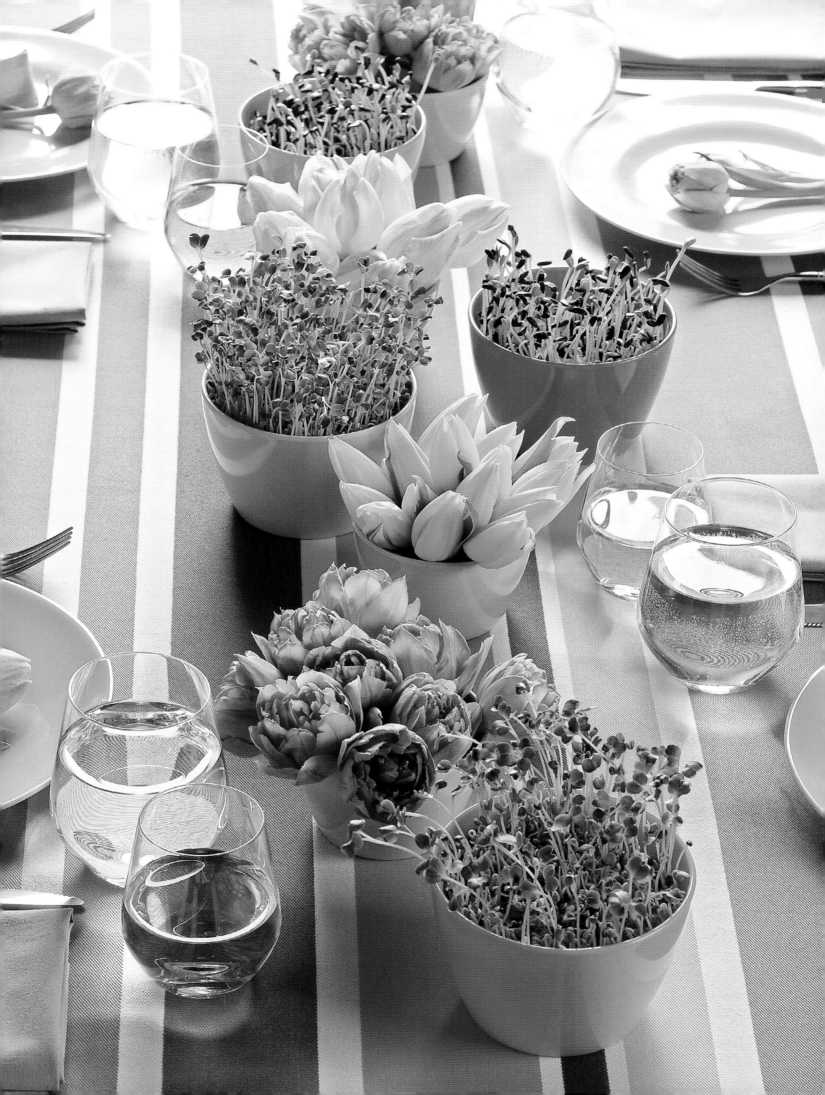

Summer

The holidays are here at last and we are finally free from the frenetic pace of urban life. Here in the country, time slowly seems to expand as the days lengthen and everyone relaxes. We are accompanied by a background of crickets chirping and the scent of the grass burnt by the sun in the meadows, while the heat drives us to seek refuge indoors. Long siestas and lazy walks in the cool of the early morning or the evening and plenty of time to catch up on the books we have been meaning to read all year.

The sheer luxury of not having to keep to a schedule gives rise to a pleasant break from routine: we eat when we are hungry and sleep when we are tired. The earth begins to yield in abundance all the things that were planted and tended through the spring: tomatoes, beans, fennel, lettuce, onions, aubergines and peppers. This abundance spurs me into action and I alternate days of idleness with bursts of feverish activity, producing enough bottled tomato sauce, preserved aubergines, relishes and chutneys to feed an army. I contemplate the resulting stock of provisions with a glow of satisfaction, as I look forward to relishing delicious sun-kissed delicacies lovingly prepared during the cold winter months.

I pick vegetables at two different times of day, and each of them has a completely different atmosphere. Early morning is invigorating; the vegetables are still cool after the night, pearled with dew and moist with the promise of the day's activities. In the evening the vegetable garden is a different place; its fruits are charged with the heat of the day, saturated and scented with sun, warm to the touch. I only pick what I need for the evening meal because it is still too hot to do any more, although I might polish the dust from a tomato on my trousers and munch it as "I work," nipping off a couple of sprigs of fresh marjoram, thyme and oregano as I make my way back into the house.

I pick flowers in the morning, when they are in the full flush of vigour after the refreshing night hours. There are fewer flowers during the summer, so the ones I do find are doubly precious. I hunt for them in the vegetable patch and in the rest of the garden. Dahlias are the queens of the vegetable garden, as our

grandmothers were so fond of saying. The taller ones straggle sometimes, but they make up for it with their marvellous colours and forms. I mix them with gladioli in a riot of shades and shapes to make rather old-fashioned bouquets. Sometimes, when I cannot fit the gladioli in their full glorious length, I divide the stems into smaller bunches of coloured blooms. I come across liliums in the flowerbeds, while the arum lilies hide away under the loggia to escape the sun's harsh rays. They have different characters and according to how I am feeling I find myself attracted to one or the other. Liliums are romantic and scented; the arum lily is an elegant flower with its starkly designed shape.

I fill the house with flowers, in the bedrooms, the kitchen, on the dining room table. I never make elaborate arrangements in the summer… it is too hot and anything complicated would look inappropriately formal. I just pop a couple of flowers into a vase or glass and put the vegetables straight down on the table in a simple still life.

Gazpacho of Cucumbers, Mint and Basil

Serves 4

Preparation time: 20'
Cooking time: 5'
Refrigeration: 2 hours

4 cucumbers
2 spring onions
1/2 red pepper
1/2 yellow pepper
2 ripe pear tomatoes
400 ml Greek yoghurt
250 ml vegetable broth
Sweet paprika
15 basil leaves
5 mint leaves
2 slices country bread, crusts removed
1 clove garlic
Extra-virgin olive oil
Red wine vinegar
Salt

Accompaniment
4 slices country bread
1 large clove garlic
Extra-virgin olive oil

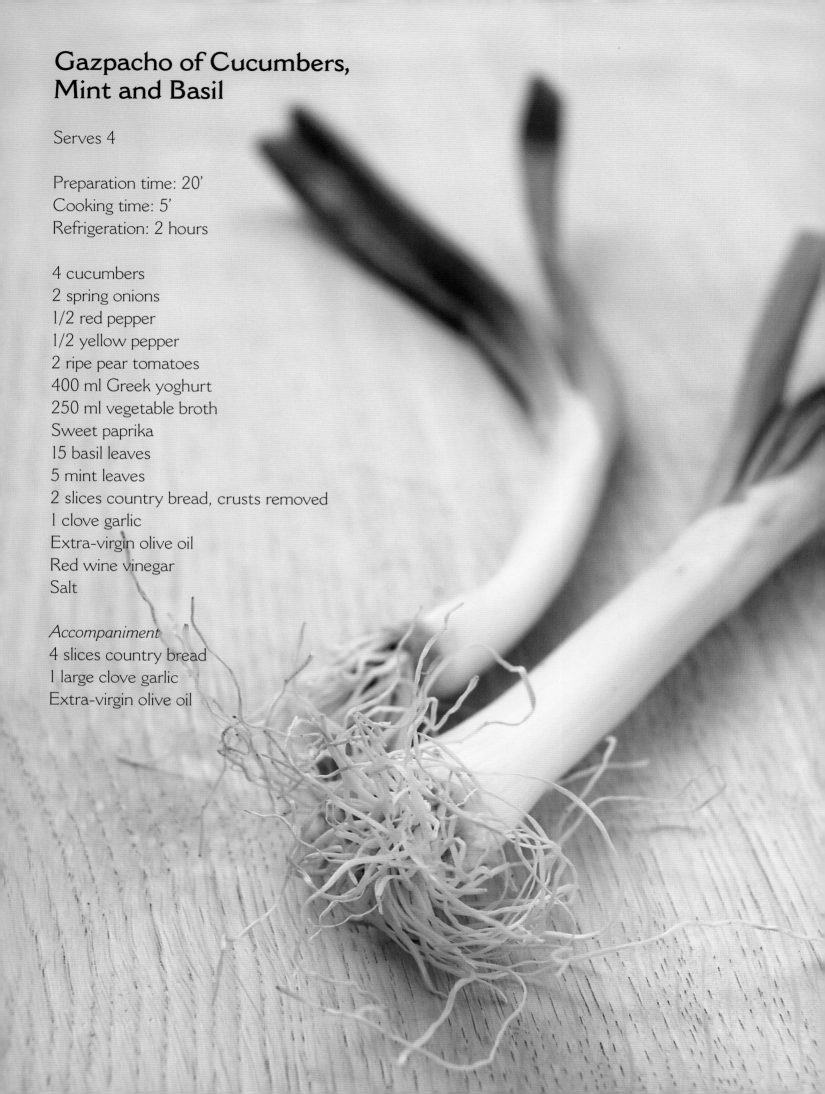

This soup is light, refreshing and is a beautiful pale green. It has a touch of sophistication without being pretentious. You can serve it at a formal meal or even for a simple family dinner. It whips up in a matter of minutes and then chills while you are off taking a dip, reading a book, or having a nap. What could be easier? The pastel colour gives it a romantic air and so the tomato and pepper garnish creates a lovely colour contrast.

Finely slice the spring onions and chop the garlic. Sauté in a pan with 3 tablespoons of extra-virgin olive oil. Add the peeled and diced cucumber and cook for about 2-3 minutes. Add salt to taste and allow to cool. Blend everything in the food processor with the bread previously moistened and add a teaspoon of vinegar, the mint and basil leaves, the broth and the yoghurt. The quantities for the herbs are merely a guideline and can be changed according to taste. However, make sure not to smother the delicate taste of the cucumber. Cover and place in the fridge for a few hours. Salt and sprinkle with some sweet paprika. Dice the peppers and tomatoes and serve the Gazpacho well-chilled, sprinkling it with the diced vegetables. If you want, you can serve it with toasted bread rubbed with garlic and lightly seasoned with extra-virgin olive oil.

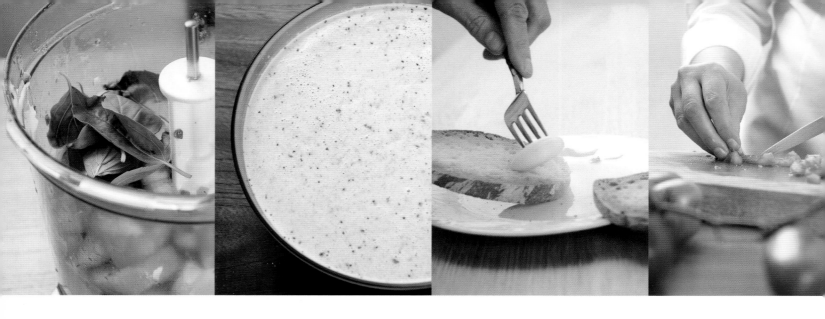

Make the *crostini*
at the last minute to ensure
they are warm, creating a contrast
with the cool soup.
The Gazpacho, a lovely rich salad
and berries round off
a truly perfect lunch

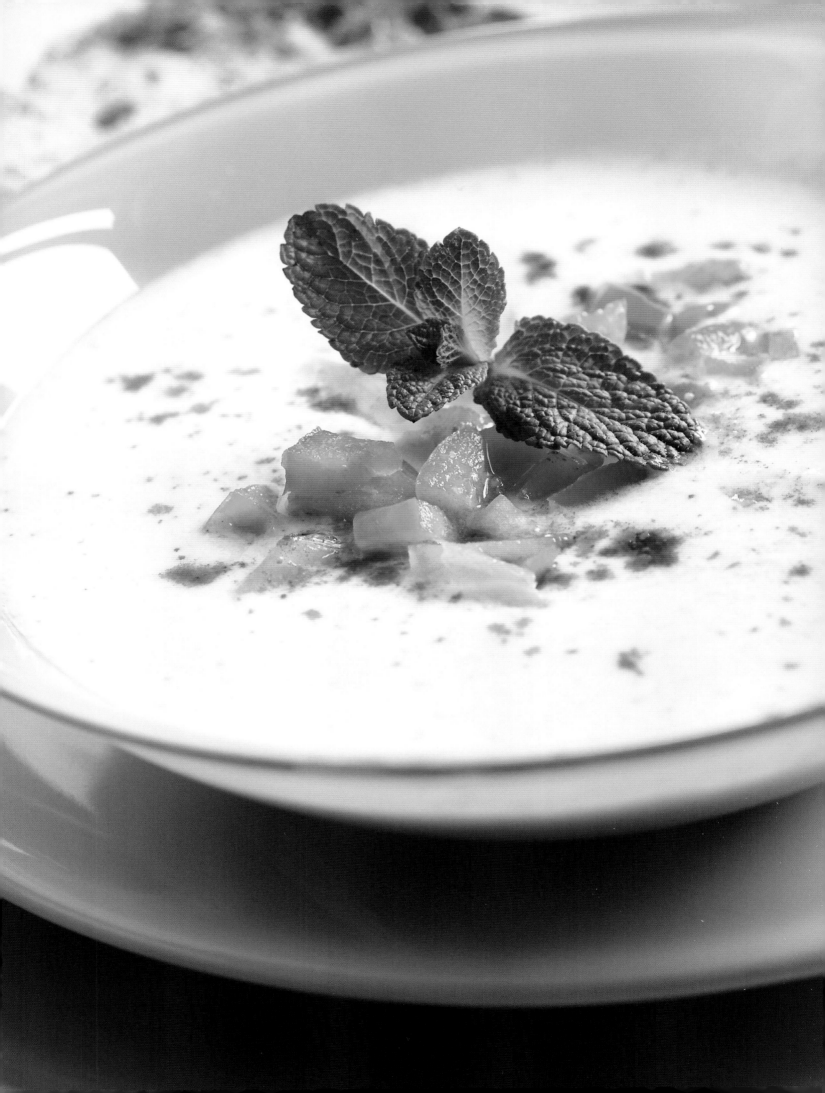

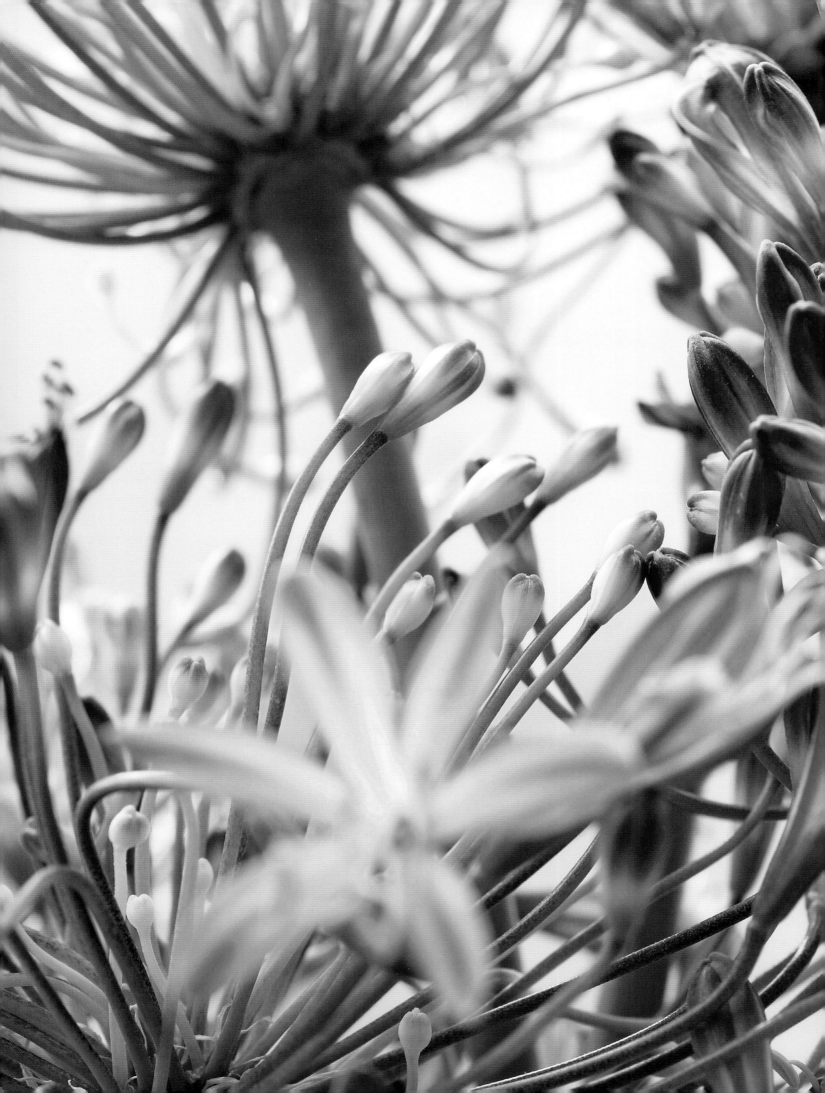

Furoshiki of late Summer Flowers

Preparation time: 45'

3 stems of agapanthus
1 stem of lilies
2 large arum lilies
2 cucumbers
1 miniature arum lily for each place setting
Two glasses
1 napkin or handkerchief in a light fabric

For some reason, no matter how many vases and containers one has, there is always a colour or a shape that is missing. Here is an easy way to make your own exactly the colour you had in mind.
The technique is from the Japanese *furoshiki*, squares of beautiful fabric that are knotted into diverse forms; to wrap a gift, become a handbag, carry book or a melon, or as in this case, turn two very plain glasses into a pretty vase for some lovely, late-summer flowers.
A miniature arum lily, moulded with your hands to follow the curve of your guests' plates is the perfect final touch.

Centrepiece
Place the napkin on the table, turned so that a point is facing you and put the two glasses, side by side, in the centre.

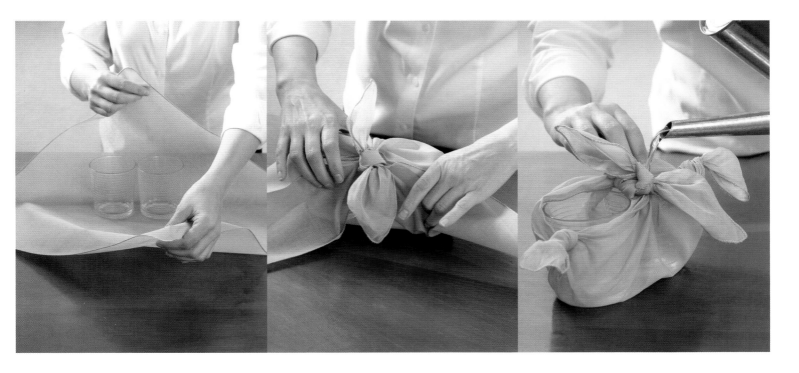

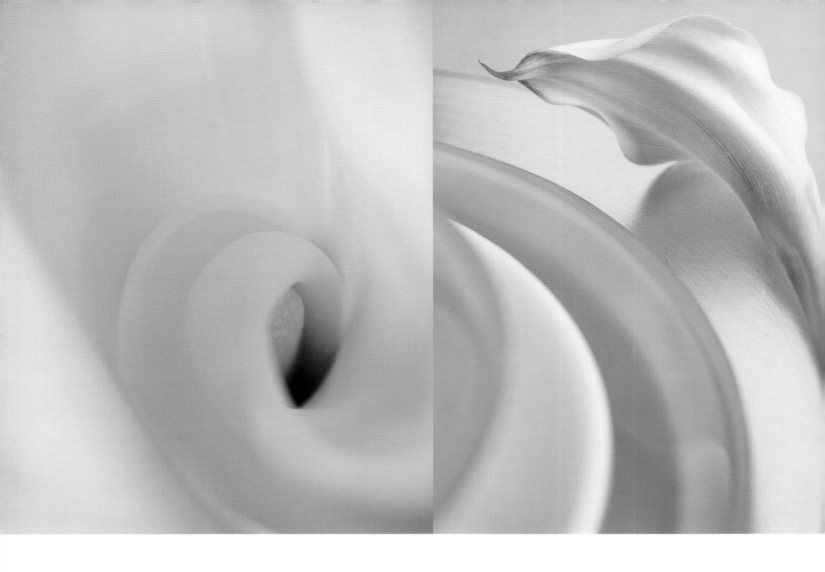

Taking the corner in front of you and the one on the opposite side, tie a knot in between the two glasses. The knot should be close to the edge of the glasses.

Tie each of the remaining corners in a knot on either side of the glasses.

Add water carefully to the glasses, fill with the flowers cut quite short and the cucumbers cut in quarters lengthwise.

Place Setting

Arum lilies have very flexible stems and may be coaxed into very interesting shapes. The important thing is not to be in a rush. It doesn't take long, but needs to be done carefully.

Look at each flower; as you will see, the stems already have the beginning of a curve in the way the flower grows out from the stem. All you need to do is hold the arum lily horizontally with both of your hands and gently curve the stem. The warmth of your hands will help the stem bend. Do this several times until the flower has the shape you desire.

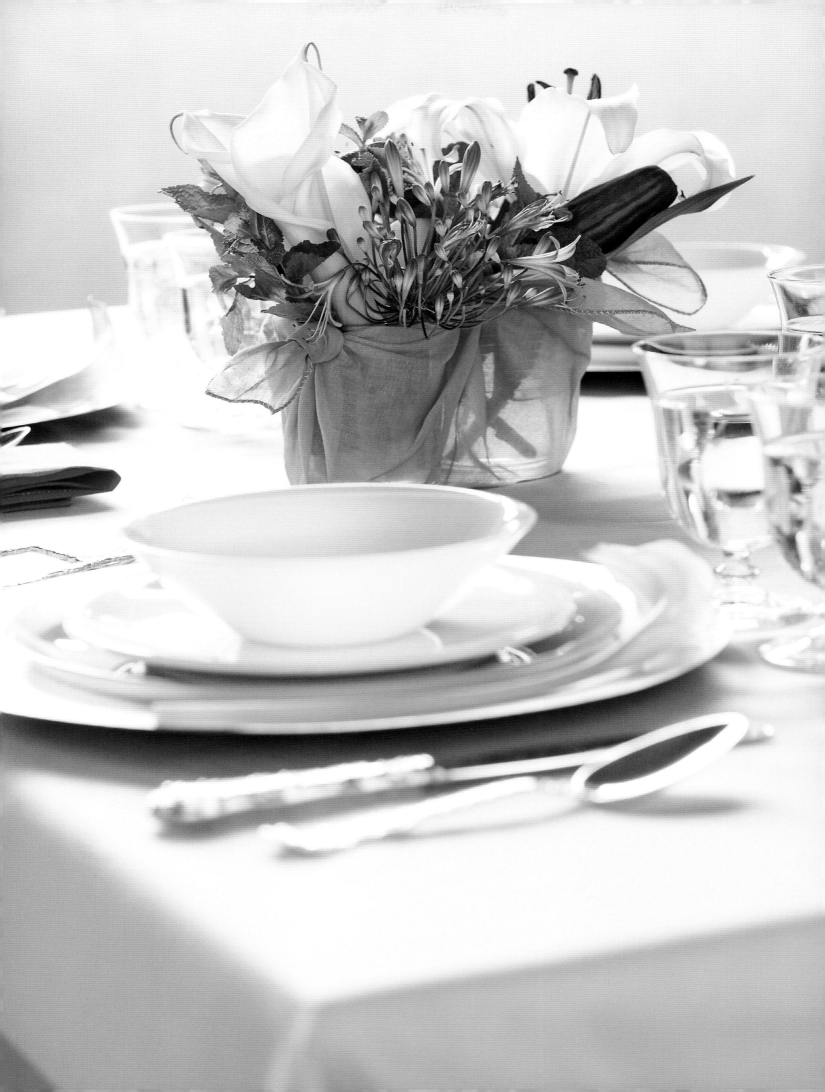

Straccetti with Herbs and Grilled Vegetables

Serves 4-6

Preparation time: 1h 10'
Marinade: 2 hours
Cooking time: about 15'

Pasta
400 g extra-fine flour
4 large eggs
Water, as needed
15 basil leaves
A small bunch of chives

Marinade
1 small red pepper
1 small yellow pepper
2 small zucchini
3 spring onions
200 g diced smoked tofu
or seitan (optional)
2 cloves garlic
10 basil leaves
4 sprigs thyme, possibly lemon-scented
8 tablespoons extra-virgin olive oil
Salt and pepper

I am definitely not the queen of homemade pasta, but that does not stop me from trying! There is something very satisfying about doing it all by hand start to finish. As you drop the pasta into your pot and watch it swell up, you just have to be a little bit proud. It doesn't matter if they are not perfectly shaped, that's what "Straccetti" are, little "rags" of pasta.

Wash, dry and finely chop the herbs. Make sure you pat them dry with paper towel.
Place the flour on the pastry board and make a well in the centre (or, if you prefer, use the food processor). Add the herbs, break the eggs into the centre and then sprinkle in a pinch of salt. Fold in the flour and bind the mixture together, kneading energetically and thoroughly until the dough is soft and smooth to the touch (it might be necessary to add in a few tablespoons of cold water). Shape into a ball and then wrap in a lightly floured cloth. Allow to stand for around 30 minutes.
Clean and cut the vegetables in large slices; cut the spring onions into halves. Cook everything on a very hot grill for about 4 minutes, making sure they remain crunchy. Cut the vegetables into diamond shapes and then place in a bowl with the diced tofu, crushed garlic, thyme leaves, basil (broken apart by hand), extra-virgin olive oil, salt and pepper. Cover and allow the vegetables to marinate at room temperature for at least 2 hours. Once in a while, stir the mixture.
Roll out the pasta on a flour-covered pastry board until you have a thin sheet. Using a flour-covered pasta cutter, cut the sheet into long strips and then into irregular diamond-shapes that are about 8 cm long.
Boil these pieces in plenty of salted water and then dress immediately with the marinated vegetables, adding in a few tablespoons of the cooking water.
Fresh pasta soaks up sauces wonderfully and this one is full of summer goodness; sun-yellow peppers, intensely flavoured basil, chives, thyme that bravely faces the summer heat, and obviously, the best extra-virgin olive oil you can find.

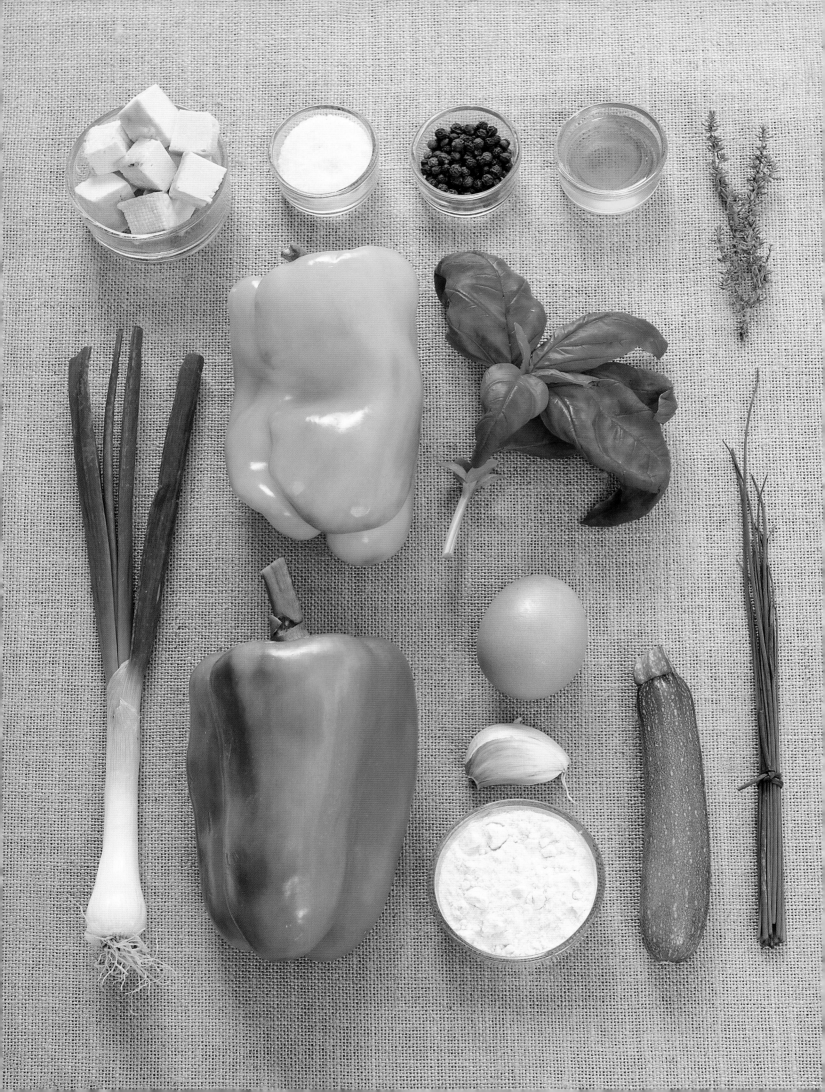

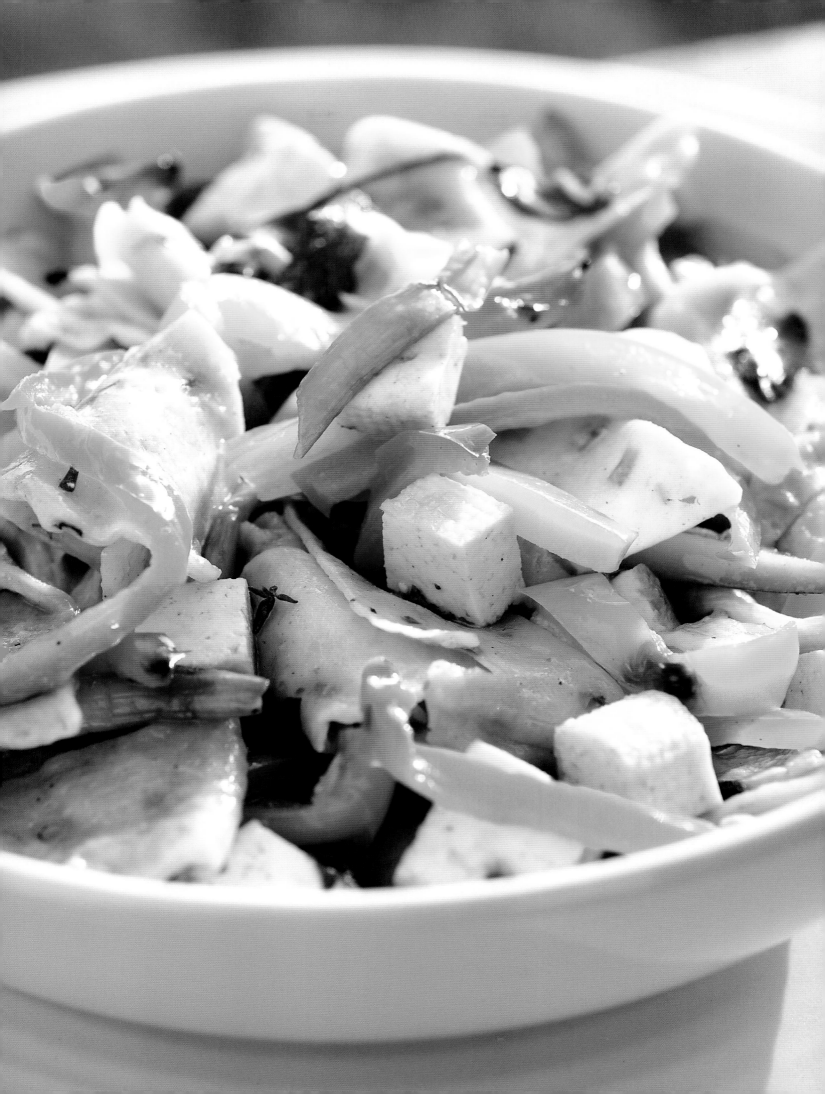

Centrepiece of Peppers and Lilies

Preparation time: 20'-30'

1 stalk each of white and orange lilies
2 large red peppers
A small piece of moistened floral foam
Plastic floral picks or bamboo skewers
1 floral adhesive pick
1 dinner plate

Decorations like this are fun to make; just a few ingredients and only a very tiny bit of patience and you'll have a great, colourful centrepiece. Do not worry about not being a florist; the trick is to choose your materials carefully. The crooked, oddly-shaped peppers that you normally wouldn't buy to stuff or to cook are just the ones you want for this decoration. The more interesting the shape, the better. If you mention to your grocer that you wish to use them for a decoration, he is usually very happy to let you pick and choose your own.
Lilies are beautiful flowers but they do have one small fault, their pollen can leave quite a stain, so make sure to take off the anthers before they ripen.
Apply the four-pronged floral pick to the plate; cut a small piece of moistened floral foam, approximately 1/4 of a block slightly angled and insert it on the pick.

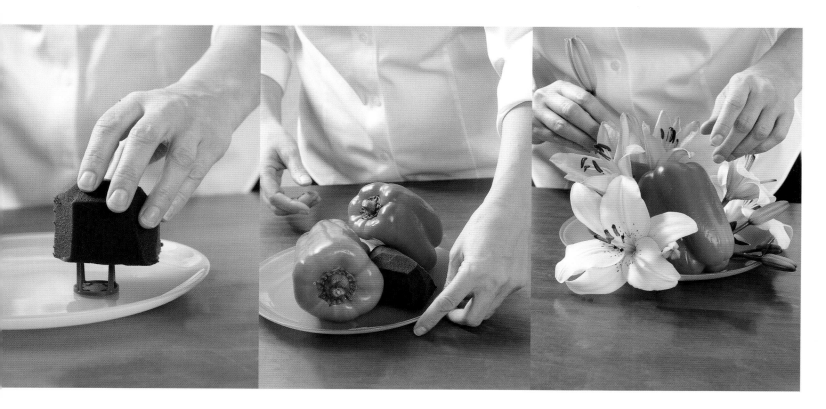

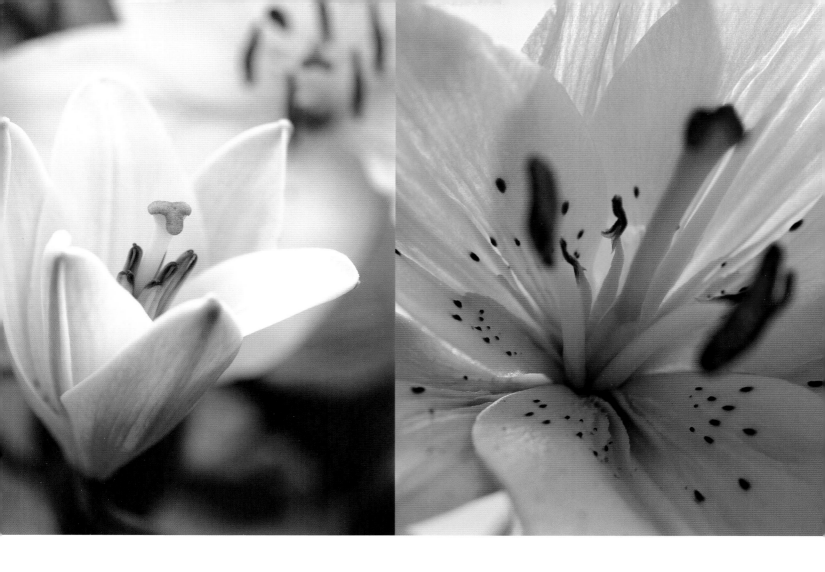

Study the shapes of the peppers. Take a minute or two to hold them in your hands, look at them from all sides and decide which way they look most interesting. Only then take your skewers and put them in the peppers at the angle you have chosen and insert them in the foam. They should be slightly converging and form a rough triangle pointing upwards.

Choose a very open lily, either orange or white. Place it at the base of the peppers, without letting it touch the table. Add another smaller flower beside or above it.

Turn the plate and do the same on the other side with the other colour lilies.

Remember to keep turning the decoration, to make sure that it is evenly balanced all the way round.

Add a few more smaller buds to fill in any spaces left without crowding, leaving the smallest ones at the top. Take care not to go much higher than the peppers.

Keep in a cool place until you set the table.

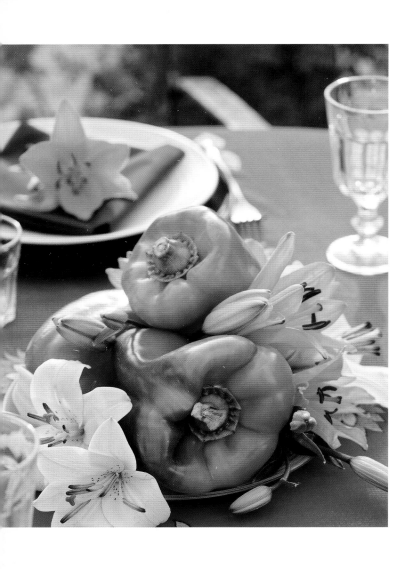

66

A single lily, placed
on the napkin, adds a touch
of colour to each place setting.
If you are cunning enough
to leave them soaking in water until
the last moment, they'll stay fresh
throughout the dinner

99

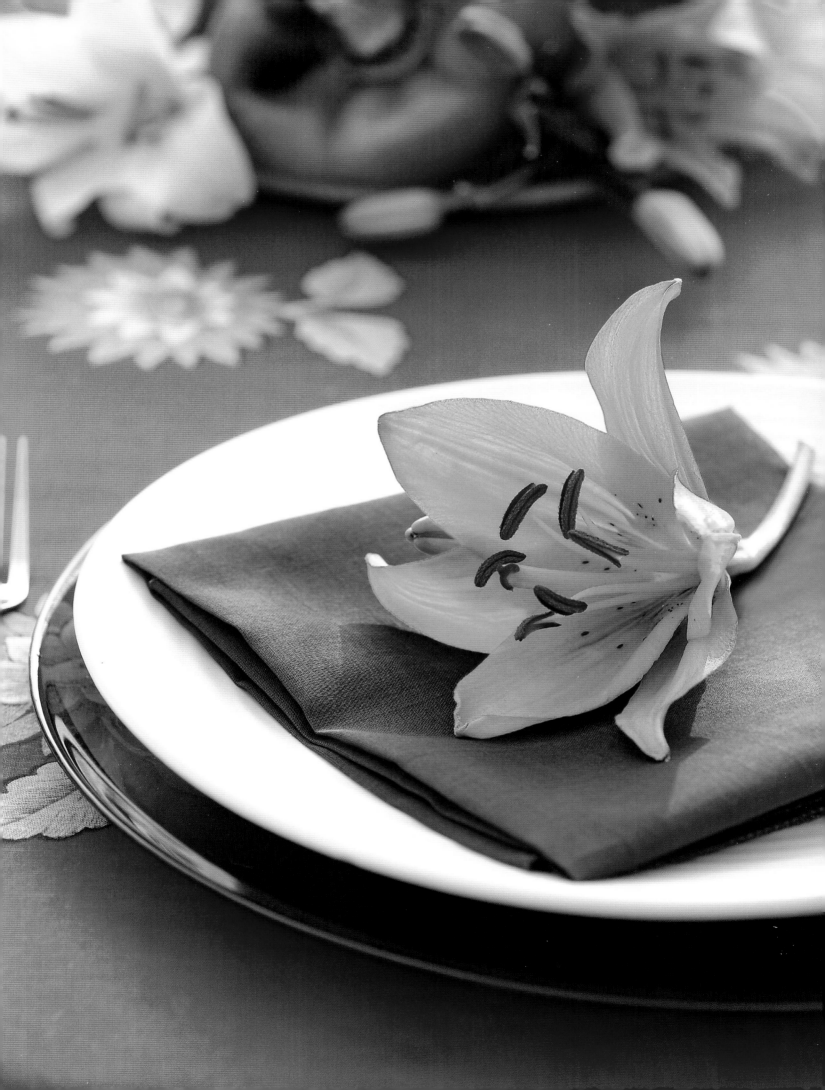

Tortilla of Potatoes and Thyme

Peel and wash the potatoes before slicing thinly. Lightly grease a pan with olive oil and then place the potatoes in, overlapping them slightly.

Sprinkle with salt, cover and allow the potatoes to cook over a low heat, making sure that they do not become golden. Turn over the slices, paying attention not to break them once cooked, making sure they do not stick to the pan.

Turn up the heat and add a touch of extra-virgin olive oil. In a bowl, beat the eggs and add salt. Pour the eggs over the potatoes and cover once more. Once the one side is cooked, turn the tortilla over. (To do this, I have come up with the following system, that might not be the most common one, but it ensures I don't get burnt! Using an oven glove – so you can hold the pan at the base of the handle – take a serving dish and then, over the sink, turn the tortilla over. A few drops always fall into the sink, but that's not a major problem. Slide the tortilla back into the pan and place over the heat again). Cook until ready without covering.

Turn the tortilla out, once again, onto the serving dish (that you have cleaned in the meantime). It should be beautifully rounded. Sprinkle with salt while it is still hot and then serve at room temperature.

Even though a true tortilla does not have other aromas, placing a sprig of thyme or rosemary on the potatoes while they cook certainly adds an interesting note. Obviously, feel free to try any herbs you want, but a friend from Madrid has warned me never to use pepper.

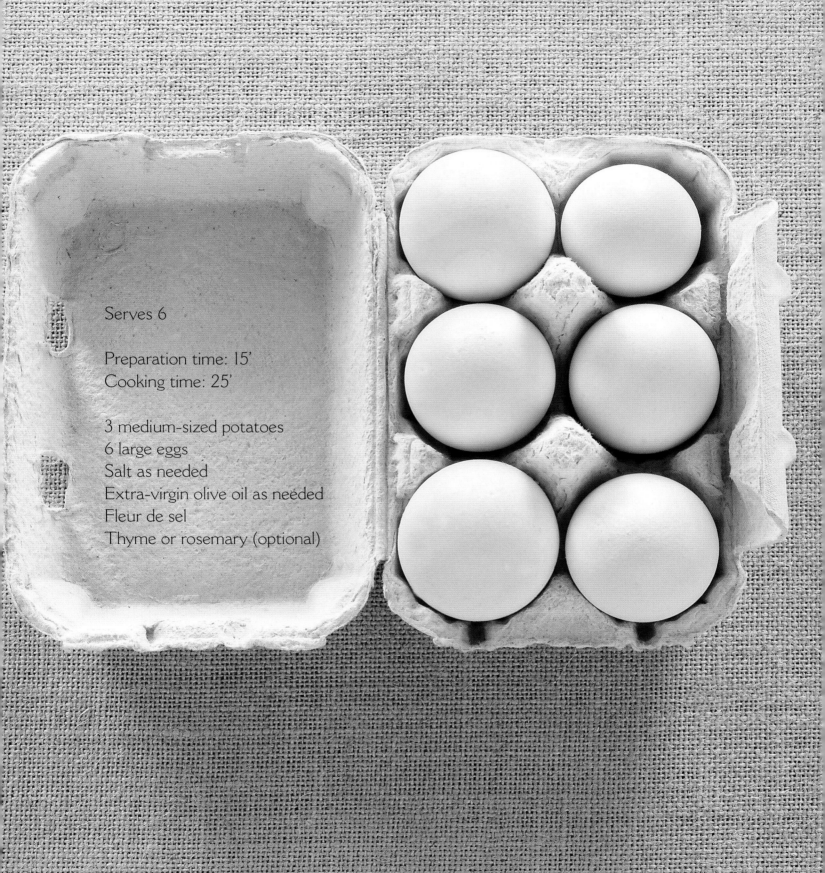

Serves 6

Preparation time: 15'
Cooking time: 25'

3 medium-sized potatoes
6 large eggs
Salt as needed
Extra-virgin olive oil as needed
Fleur de sel
Thyme or rosemary (optional)

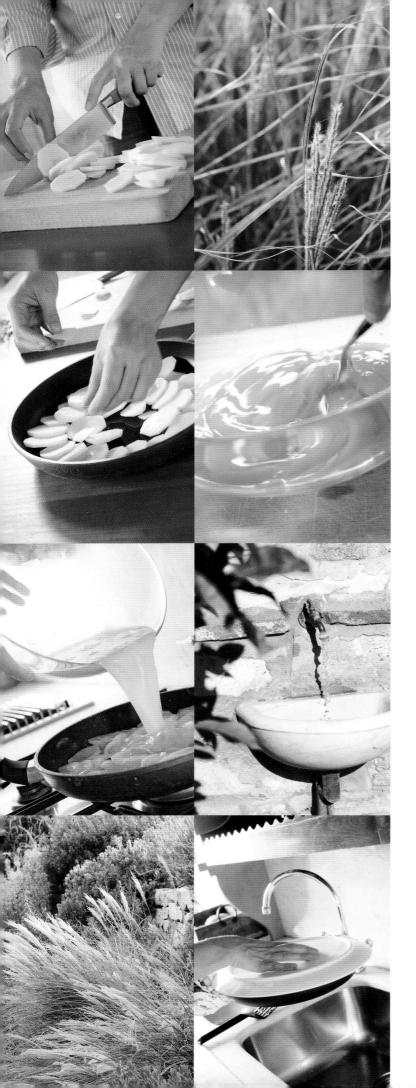

This recipe is plainly
perfect and perfectly plain.
It is wonderful for picnics,
lunches and lazy
summertime dinners.
I often cut it into
very small diamonds
and serve it as
a rustic appetizer

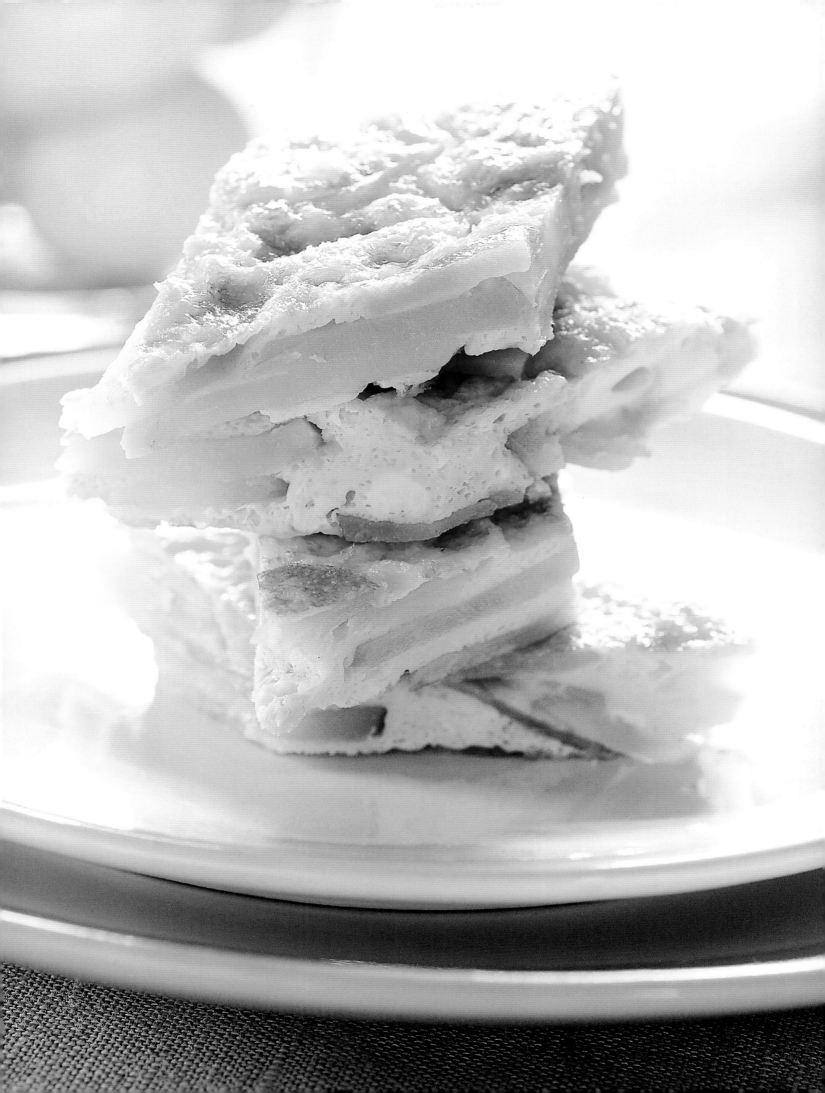

Easy Decoration of Dahlias, Eggs and Potatoes

Preparation time: 20'

A dozen or so eggs
8-12 potatoes
12 cream-coloured dahlias
Small vases and pots, the number will depend on how big your table is, how many people will be there
Black or any other colour marker that suits you

What could be easier than this? Everyone is always surprised to see the humble potato as a decoration on the table, but I love them and would put them everywhere if I could. They come in so many fantastic shapes and colours that they could quite easily hold the stage on their own. At Casellino we have the good fortune to have our own fresh eggs, and they too are beautiful. To put them all together with a few wonderfully fluffy dahlias makes a perfect table in no time at all. I used two types of containers to add a little more interest, small glass vases and some dark earthy pots for contrast. The potatoes look so lovely and smooth I thought I would try writing on them, and the result was fun and a great surprise for my guests.

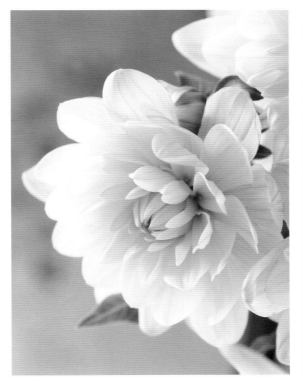
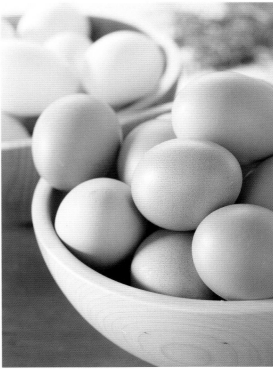

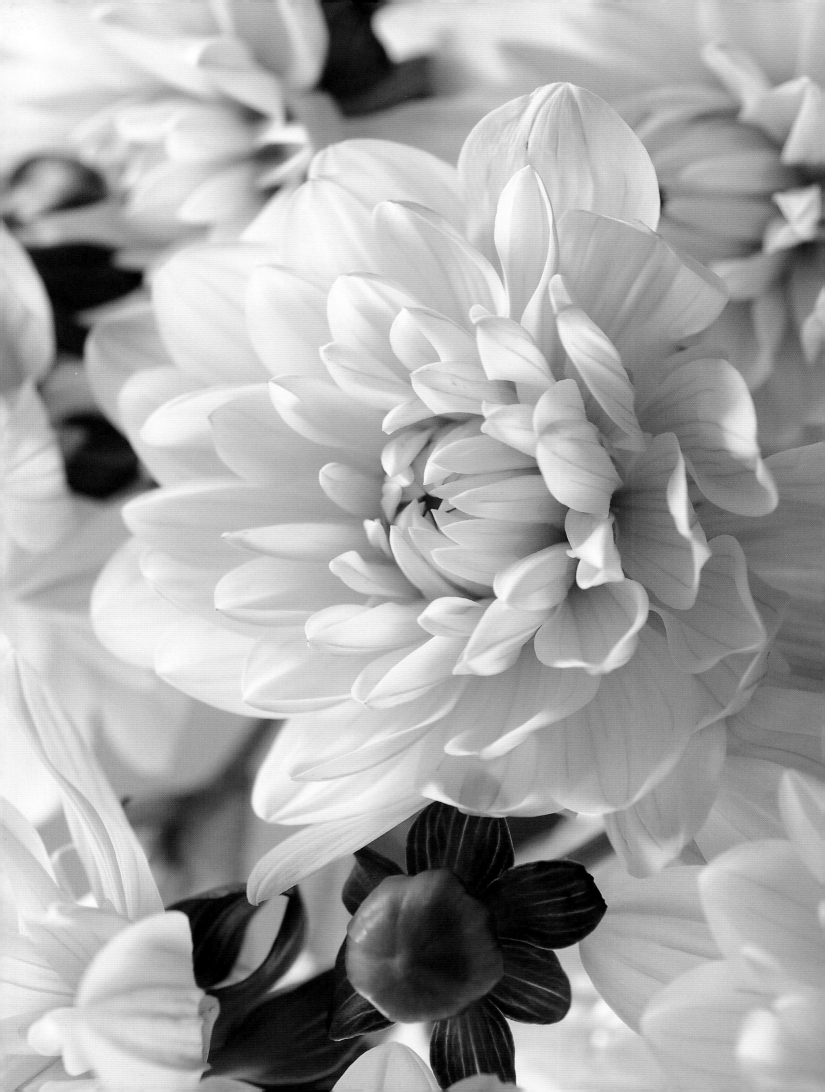

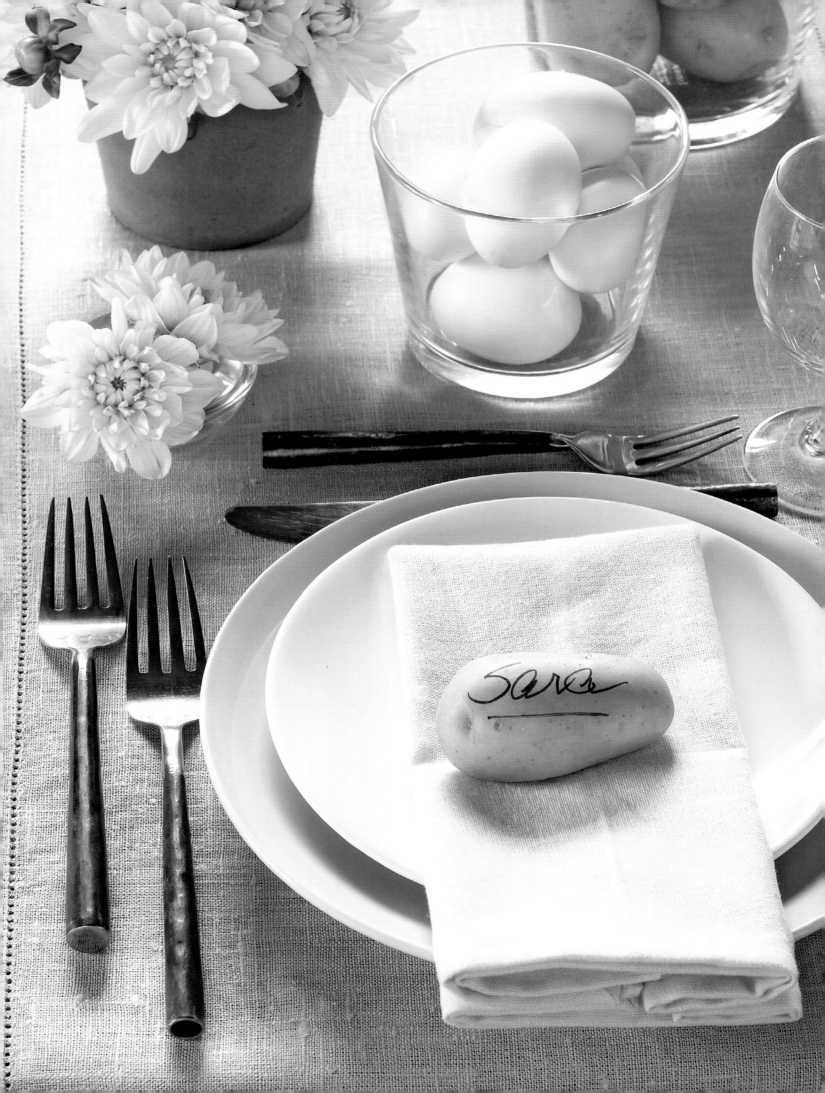

A perfect Sunday brunch
with friends.
You can be sure that
they will want to take
their potato placemarks
home with them

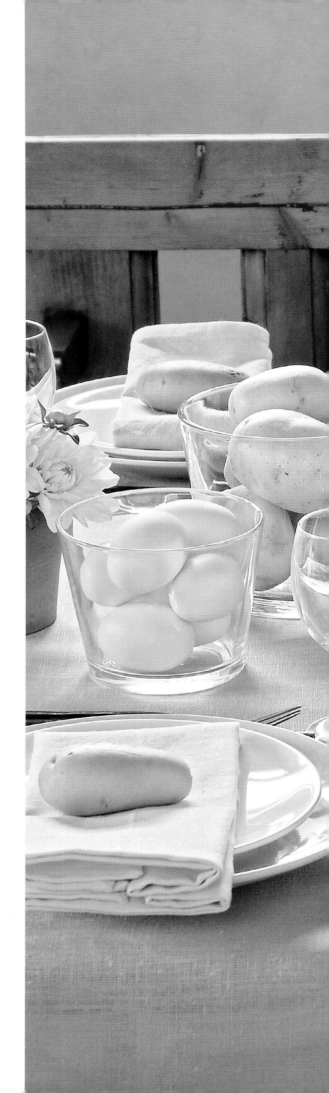

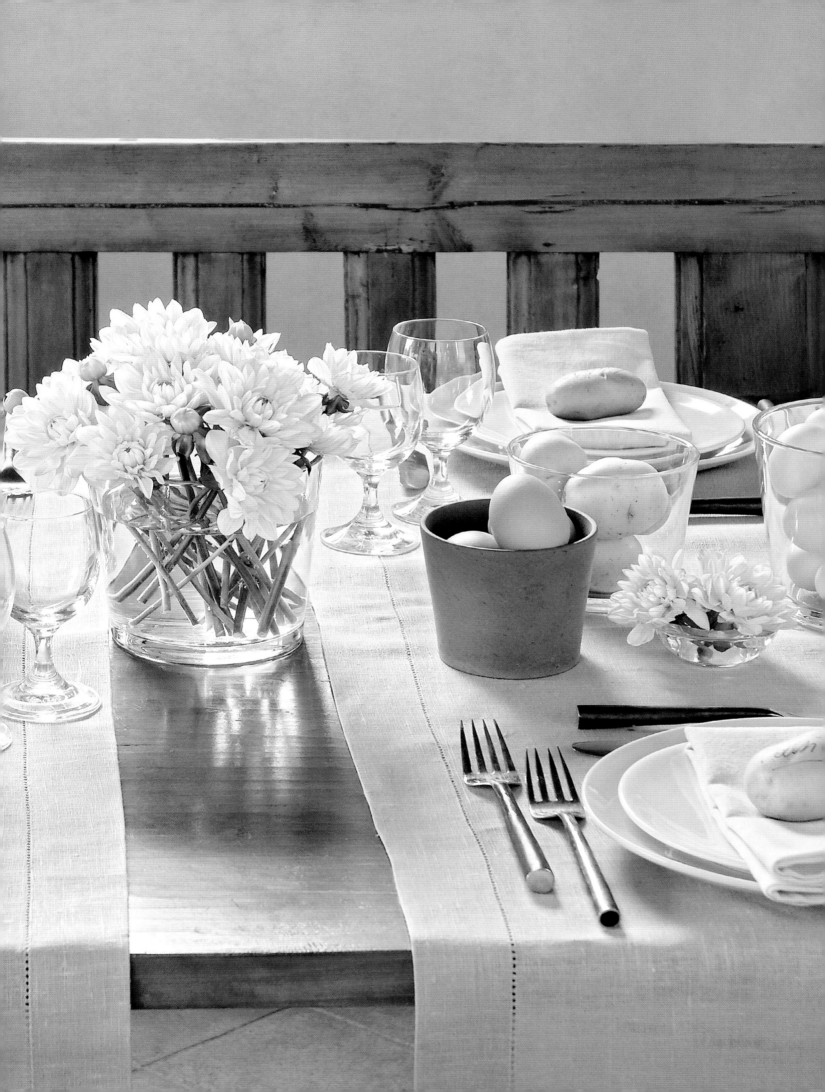

Stuffed and Grilled Aubergines

Serves 4

Preparation time: 10'
Cooking time: 40'

2 long aubergines, cut in half
200 g cherry mozzarella or diced mozzarella
150 g cherry tomatoes
250 ml tomato purée
6 tablespoons grated Parmigiano
A few basil leaves
1 tablespoon extra-virgin olive oil
1 clove garlic
1 slice red onion
1-1/2 tablespoons freshly chopped coriander (optional)
Salt and pepper

The original Neapolitan recipe calls for frying the aubergines first and then finishing them in the oven. Cooking them outdoors on a wood fire gives them great taste and not quite so many calories. The coriander gives a twist on classic "pomodoro," but you are free to leave it out.

The smell and taste of all things grilled
is irresistible and there is also all the fun
of playing with fire,
which to me is no small thing!

Tomato sauce
Sauté the garlic and the onion slice in some extra-virgin olive oil in a small frying pan. Once golden, remove and add in the tomato purée. Cook over a low heat until the sauce becomes thick. Pour the sauce into a bowl.

Aubergines
Cut the aubergines lengthwise and remove some of the central pulp to create little "boats." Salt both the boats and the removed pulp and then grill them lightly for about 5-10 minutes.
Chop the grilled aubergine pulp into cubes and the cherry tomatoes into halves. Add the tomato sauce, along with the mozzarella, a few basil leaves (chopped into large pieces), two tablespoons of grated Parmigiano and the chopped coriander. Mix everything well.
Fill the grilled boats with plenty of the mixture and then sprinkle with a tablespoon of grated Parmigiano. Wrap them individually in aluminium foil and place on the grill for a further 10-15 minutes to allow the mozzarella to melt.

"Pomodoro and Mozzarella" Dahlias in Aubergine Boats

Preparation time: 45'

7 red pompon dahlias
7 white pompon dahlias
Several stalks of cherry tomatoes
A few sprigs of basil, rosemary, *viburnum tinus*, *buxus sempervirens* or other herbs and greenery of your choice
1/3 block of moistened floral foam
Jar of tomato preserves (optional)

Cut the aubergine in half lengthwise and core them as you would for the recipe. Cut a small piece of moistened floral foam to fit the cavity, having it come up just slightly over the edge of the aubergine.

Alternate the red and white dahlias to look as if they were the tomato and mozzarella filling, remembering to let a few "spill out." Keep the flowers cut quite short; there will be less foam to cover up that way and the aubergine will look "stuffed."

Fill in the remaining space with the various herbs and greenery to your taste. Choose two or three longer sprigs for the ends of the aubergine and let them almost touch the table.

Place the two "stuffed" aubergines on the table on a slight diagonal and slightly overlapping. Add a few sprigs of rosemary and the stalks of cherry tomatoes laying them directly on the table to complete the decoration.

As a finishing touch, if you like, you may add a jar of homemade tomato sauce.

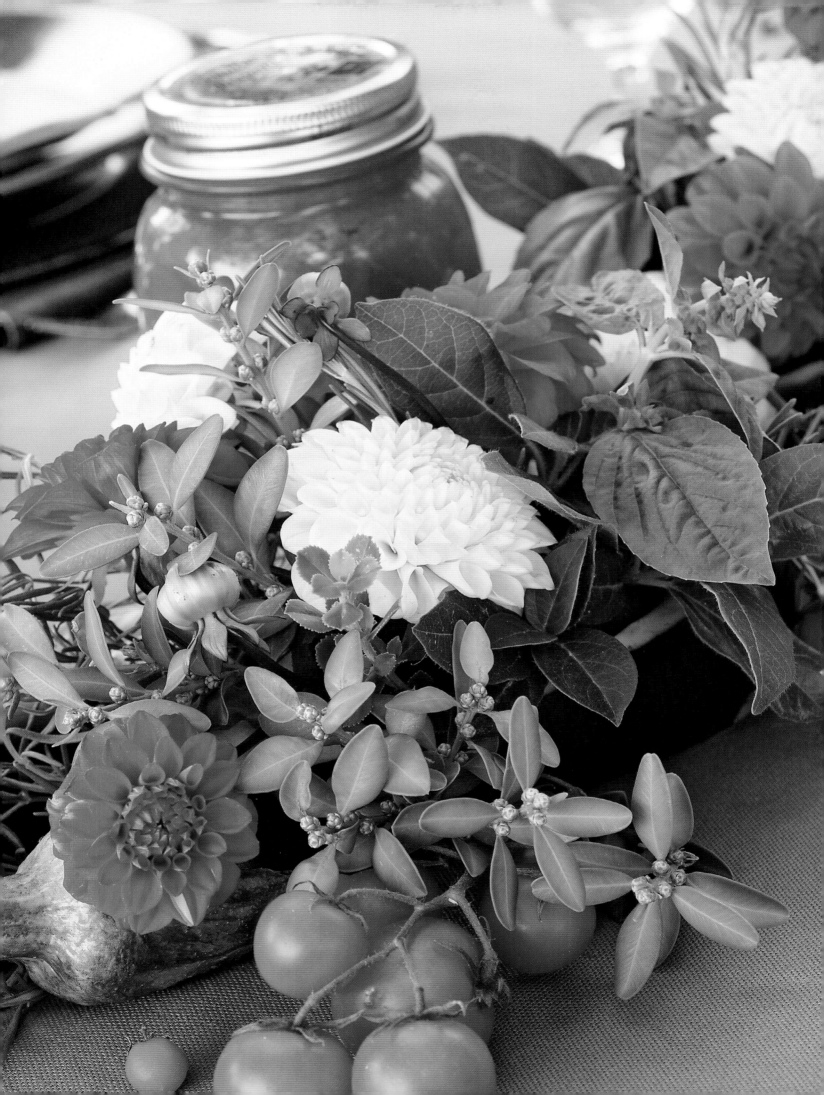

Summer Salad of Spelt and Borlotti Beans

Serves 6

Preparation time: 30'
Cooking time: 45'

300 g podded Borlotti beans
3 carrots, julienned
3 zucchini, diced
1 coarsely chopped red onion
1 large bunch fresh, coarsely chopped coriander
2 fresh chilli peppers, finely chopped
500 g spelt
Extra-virgin olive oil
Salt, black pepper, as needed

Cook the Borlotti beans, only adding salt at the end. Drain and dress with a touch of extra-virgin olive oil. Boil the spelt in plenty of salted water. While the spelt is cooking, chop the carrots, zucchini, onion, coriander and chilli.
In salted water, lightly blanch the carrots and zucchini separately, making sure they remain al dente (rinse under cold water when done to stop them cooking further).
Strain the spelt and then dress immediately with a touch of extra-virgin olive oil. Add the carrots and zucchini, the raw red onion, the chilli and the coriander. Mix everything well, add extra-virgin olive oil, salt and pepper to taste. Cover and place in the fridge.
This dish should be served cool on a bed of curly lettuce leaves.

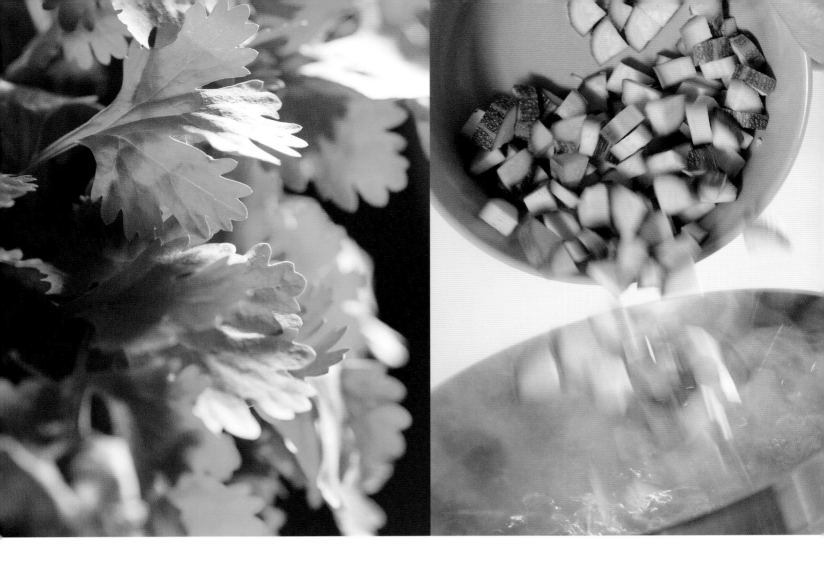

"
Remember to rinse the blanched
vegetables with cold water to stop
them cooking any further and to keep
them nice and crunchy
"

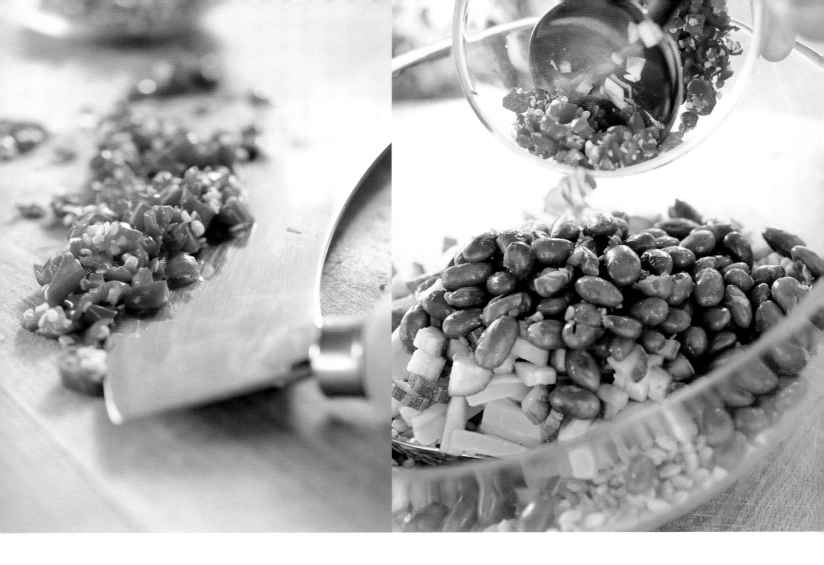

In our house spelt is used often in both winter and summer. It is an extremely tasty, versatile and nutritious cereal to use in soups, salads and side dishes. The fantastic thing about this kind of salad is that you can put in it whatever your heart desires, or whatever you happen to have in the fridge.

Cheese, prosciutto, salame make for a more substantial one-meal dish. Fresh tomatoes and basil turn it into a great side dish for fresh mozzarella or burrata. Grilled marinated peppers and aubergines, garnished with fresh mint, will give it a Middle Eastern flavour.

Feel free to experiment; put in it just what your family like best, just make sure to dress the spelt while it is still warm so that the flavours have time to really meld.

66

For a refreshing change,
use only raw vegetables:
tomatoes, cucumbers, carrots
and use fresh marjoram and basil

99

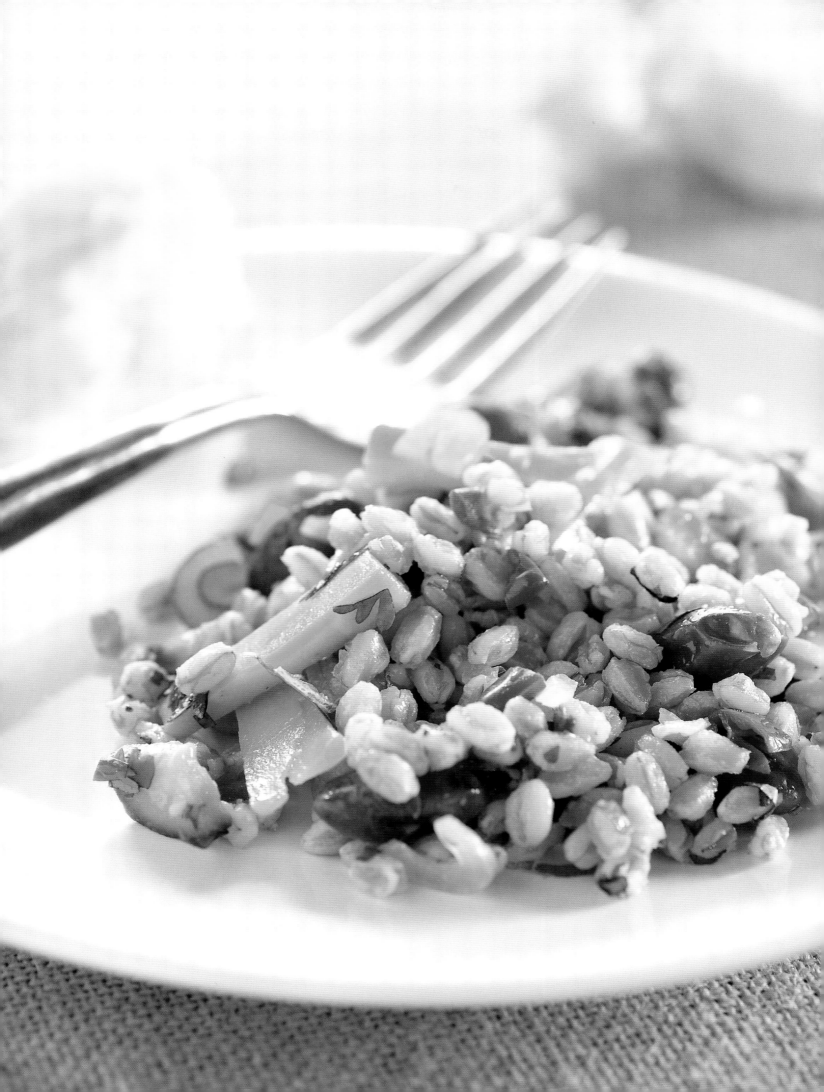

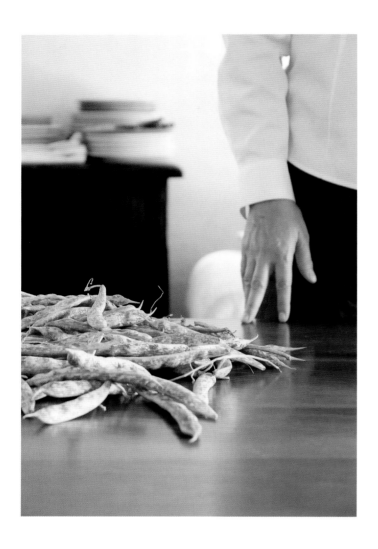

Buffet of Borlotti and Dahlias

Preparation time: 30'

25 pink dahlias
1 kg or more of borlotti bean pods
1 glass vase (about 30 cm high)
1 small footed vase

The colours and patterns of borlotti pods are so delightful that I'm always a bit sorry to pod them. As such, I decided to use them on the table complete with their shell, in all their splendour.

I love decorating buffets because they are so informal, allowing me to do what I want. Here, I took all the coloured plates I had at home that recalled the colours of dahlias and borlotti beans.
I used a couple of baskets of greenery to give volume and then I made the actual decoration with the beans and dahlias.

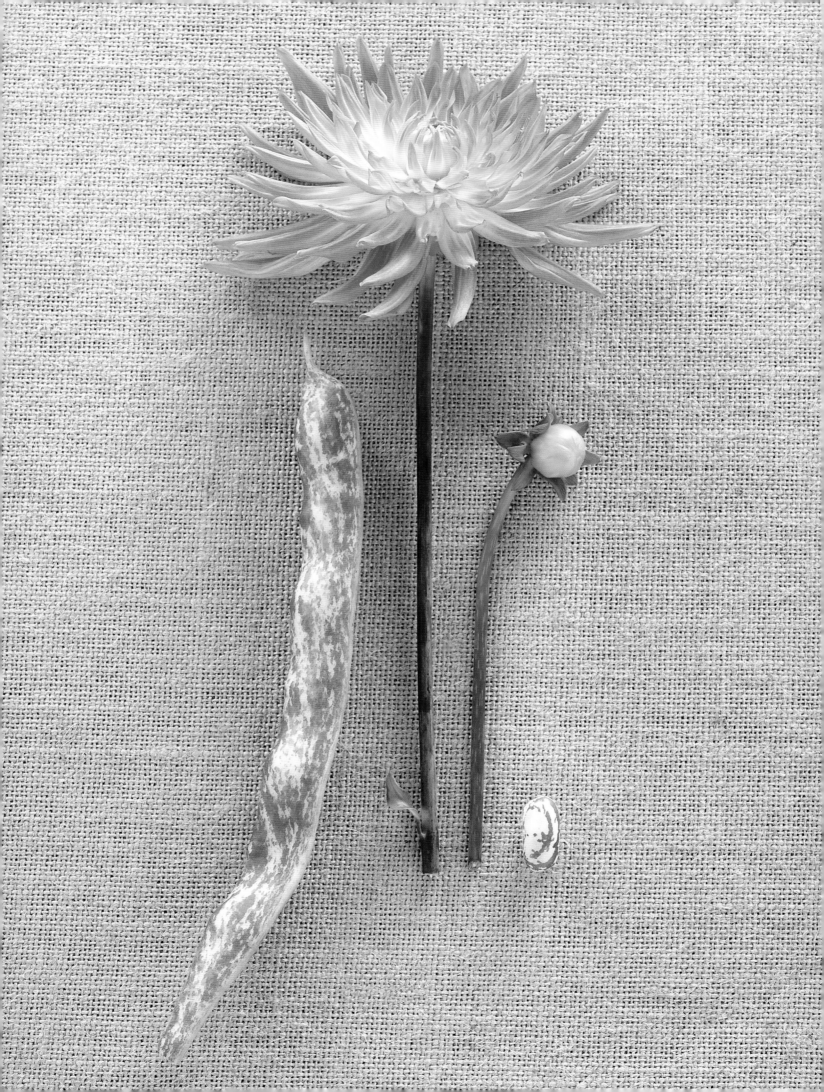

I suggest you prepare everything not more than a couple of hours before the guests arrive so that the water will still be fresh and you will still be ready to welcome your guests with a smile.

Fill the large vase with plenty of borlotti beans. They are needed to keep the dahlias in place. Add the water and then start putting in the flowers. To make sure the stems are the right length, measure them against the side of the vase, before cutting them. Use enough flowers to create a full "canopy" but don't overfill the vase. Flowers are much more beautiful when there is a bit a space between them.

Small footed vase: place some borlotti beans on the bottom, add some water and cut the dahlias very short, so they form a cushion of blooms.

Final touch: right before the guests arrive, you can place a few flowers, with the stems cut short, directly on the table cloth.

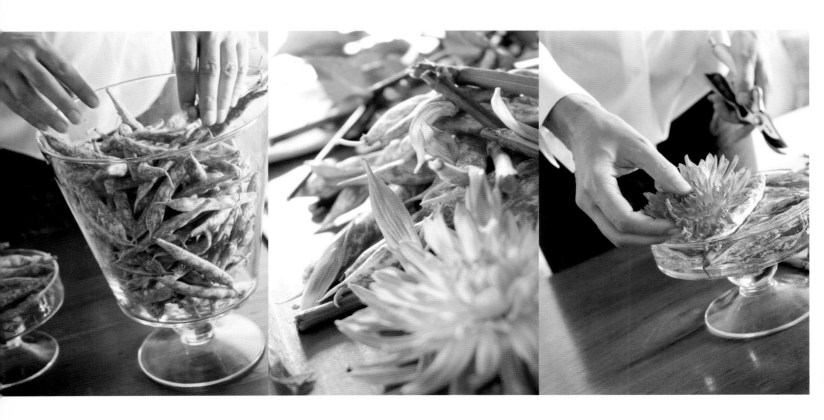

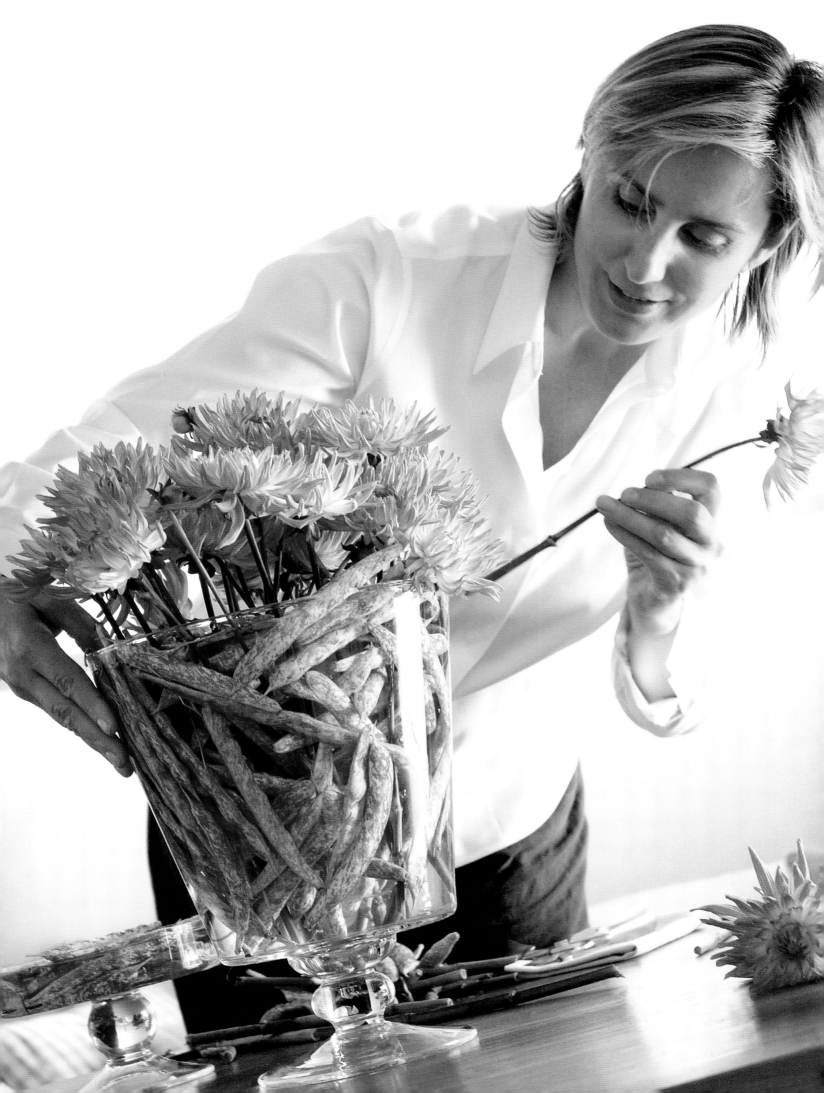

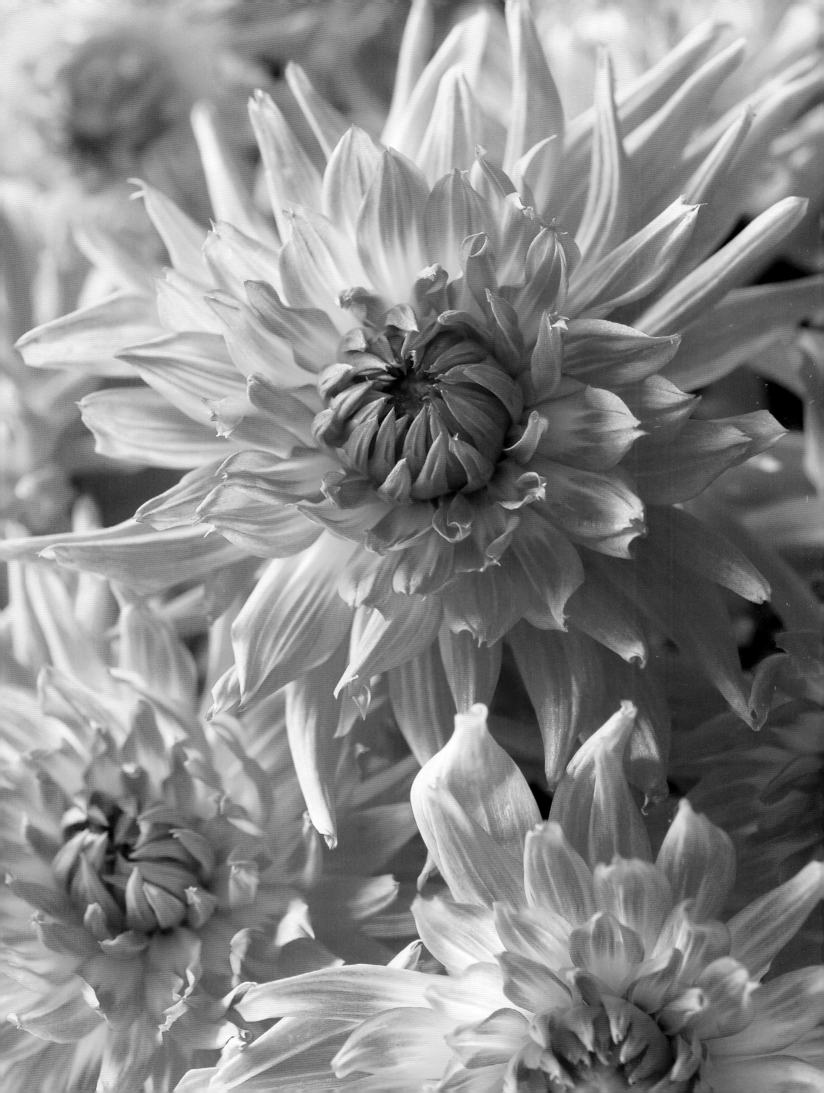

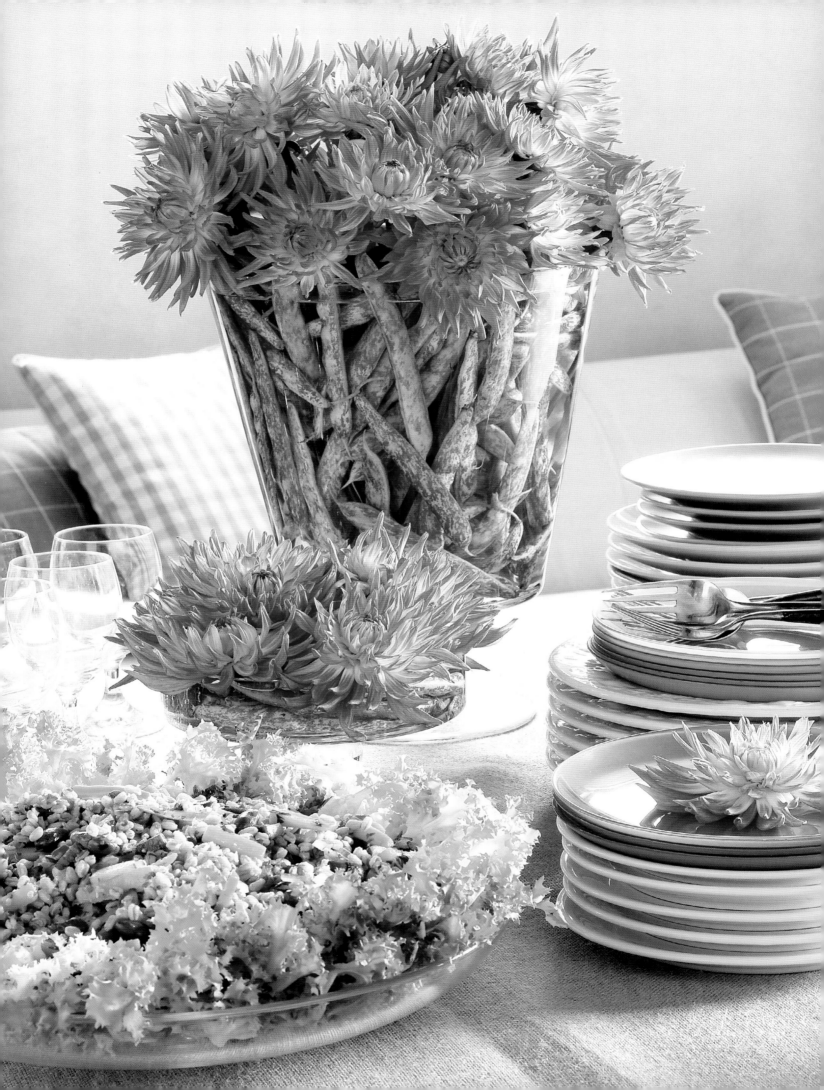

Autumn

As I write I glance out of the window at the valley filled with morning mist like a lake. The almost summer-like warmth of the sun gradually evaporates the mist in wispy veils with a poetic effect that transforms the scene into an enchanted place. Autumn colours begin to overlay their summer counterparts; late blooms and turning leaves are eloquent messengers of both a belated burst of energy and resignation at the passing season. Powerful autumn scents fill our senses with nostalgia: wet earth, dry leaves, a whiff of smoke from a bonfire in the fields.

The household gathers increasingly in front of the warmth of the fire, where we roast what we can; chestnuts, potatoes, artichokes and sausages. The chill in the air whets our appetites for hearty dishes cooked slowly to extract their full flavour. I prepare soups, quiches and oven-roast vegetables, adding pinches of spice for warmth, together with a few fresh herbs that have survived summer's passing.

I walk through the woods looking for colourful branches, mosses, lichens and mushrooms. The vegetable garden yields the last dahlias and the odd obstinate gladiola. I arrange the flowers with artichokes, aubergines, cauliflowers, pumpkins and leeks. Together they make wonderful compositions with strongly contrasting colours that I often have fun rearranging as fancy takes me; after all, I need them for the soup too! The house is strewn with an array of pumpkins, flowers, twigs and berries, the family look on affectionately, resigned to my extravagances.

The days are a whirlwind of activity as we harvest the olives and the long evenings are enlivened by the tales of the pickers in serene counterpoint to the fatigue of the hours in the groves. We all wait for the first oil from the presses with bated breath, ready to try it and comment. Freshly-pressed Tuscan olive oil has a unique taste and its sampling is a ritual. It is redolent of slightly bitter herbs and grasses, but ripe with the promise of its mature vigour, its vital energy. We put it on everything, literally, for the pure joy of savouring the fruits of our labours, something we have produced with our own hands.

Pumpkin Velouté with Curry and Marjoram

Serves 4-6

Preparation time: 30'
Cooking time: 40'

900 g diced pumpkin
4 shallots
1 large potato
3 sprigs marjoram
1,2 l vegetable broth
300 ml cream
Extra-virgin olive oil
1-1/2 tablespoons mild curry powder
Salt and pepper

I love squash and pumpkins. To me they represent autumn. There are so many different shapes, colours and flavours and each country has its own varieties; used for everything from preserves to soups and desserts.

This is a gorgeous, creamy, vibrantly coloured "Velouté" that is a snap to make.

Wash and dry the pumpkin. Using a long and sharp knife, remove the top and then clean the inside by removing the seeds and some of the pulp, then dice the pulp and put aside.

Wrap the cleaned pumpkin and its top in aluminium foil and then bake in a pre-heated oven (355°F) for about 40 minutes. Peel and slice the shallot very finely. Sauté in a non-stick saucepan, in 4 tablespoons of extra-virgin olive oil. Add the pumpkin, and the peeled and diced potato. Brown for a few minutes before adding the marjoram, warm broth and salt and pepper to taste. Cover and cook for about 20 minutes. Flavour with a tablespoon of curry powder, add the cream and then blend. Re-heat and serve the pumpkin velouté in the hollowed-out baked pumpkin or in a warm soup tureen. Don't let having to bake the whole pumpkin stand between you and the soup.

It's too delicious to pass up!

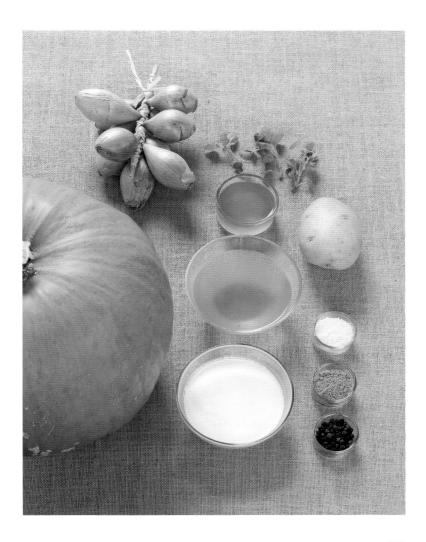

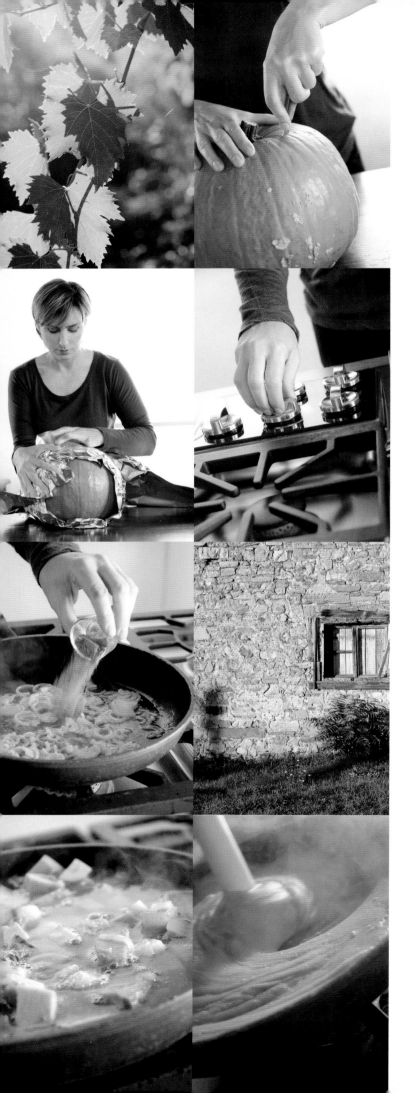

Serving it in the
hollowed-out baked
pumpkin is definitely
spectacular, but
not fundamental

Runner of Tulips, Pumpkins and Autumn Leaves

This decoration reminds me of Halloween and Thanksgiving. Living in Italy, we don't celebrate these holidays and I miss them quite a bit. These colours bring back all the memories. The tulips might be a bit of an unusual choice in this season, but they look wonderful together with the pumpkins.

The quantities above are a guideline for a table of eight; size up or down as you need to. I have used a runner made of a very old fabric but you could use a tablecloth. If you do so, it is a good idea to partially set the table first, so that you know how much space to leave for plates, glasses and cutlery.

Start with a sprinkling of leaves down the centre of the table, thinning them out at both ends, to give you an outline to work from.

Place your large pumpkin in the centre of the table.

Place the two small bowls with the moistenedfoam on either side of the pumpkin, slightly off-centre so as not to be symmetrical.

Work on both sides of the pumpkin at once (remember to divide your material in two groups). The tulips in the two bowls should form a sort of triangle that is about two-thirds of the height of the pumpkin and that reaches down to the tablecloth. Choose the tulips carefully, and follow the lines of the pumpkin with the stems of the flowers. It is a good idea to start with three flowers that form the outline of the triangle and then fill in the space with the remaining tulips.

Work on both sides at once so that you can be sure to keep them balanced but varied.

As a finishing touch, add the tealights and a few tulip petals sprinkled amongst the leaves.

Preparation time: 30'

1 large pumpkin, or two
slightly smaller ones
5-7 baby pumpkins or squash
20 orange parrot tulips
Autumn leaves of several sizes
and colours
2 small glass or pottery bowls
1/3 block moistened floral foam
Tealights and holders

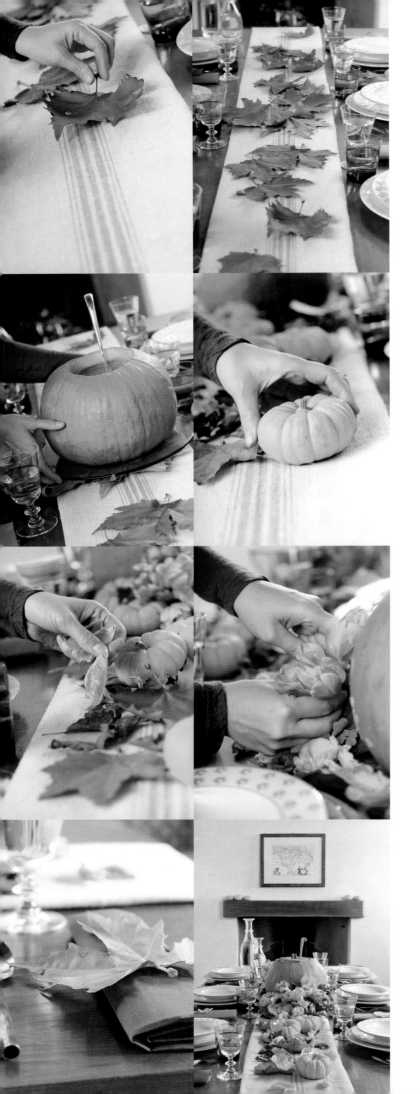

A few petals scattered
across the table
light up the colours
of the autumn leaves

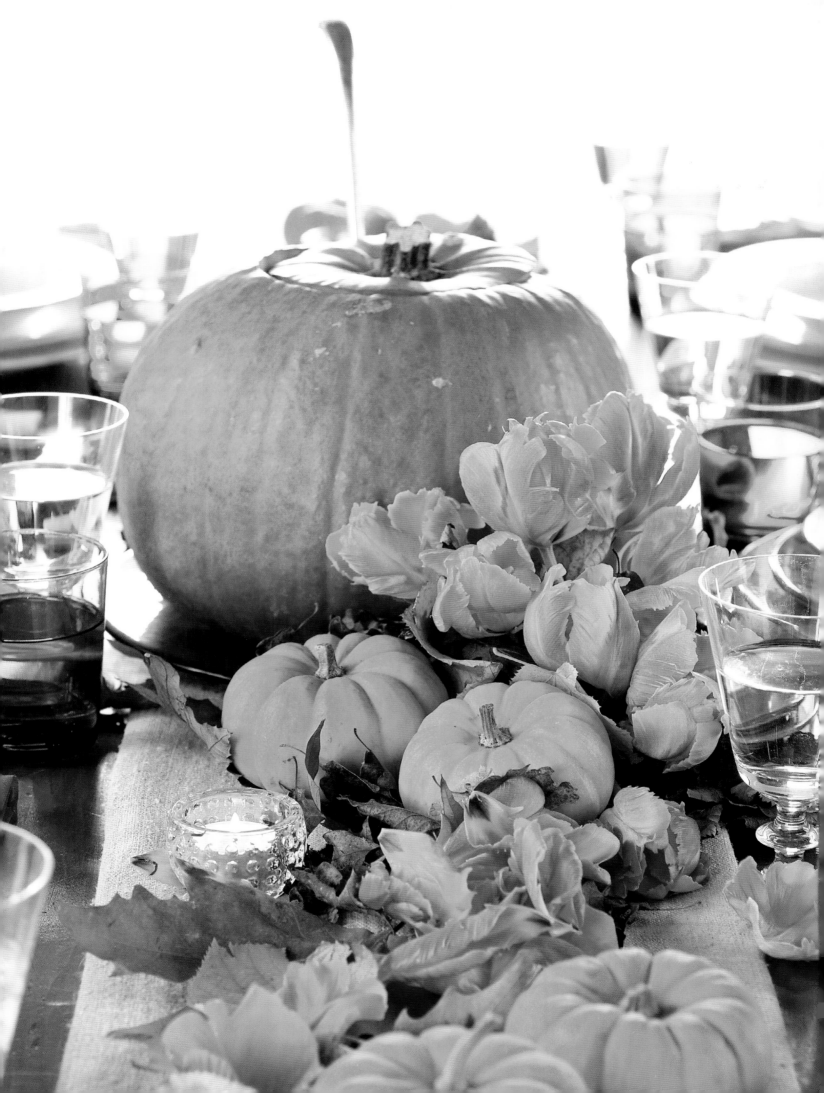

Radicchio and Barolo Risotto with Onions Caramelized in Balsamic Vinegar

Serves 4

Preparation time: 10'
Cooking time: about 35'

Caramelized onions
7 medium red onions (1 kg)
3 tablespoons sugar
6 tablespoons balsamic vinegar
Extra-virgin olive oil
Salt
Water

Risotto
360 g Arborio or Carnaroli rice
1,2 l vegetable broth
1 small golden onion (80 g)
2 heads Treviso radicchio
250 ml Barolo wine
50 g grated Parmigiano
2 tablespoons butter
2 tablespoons extra-virgin olive oil
Nutmeg
Salt and pepper

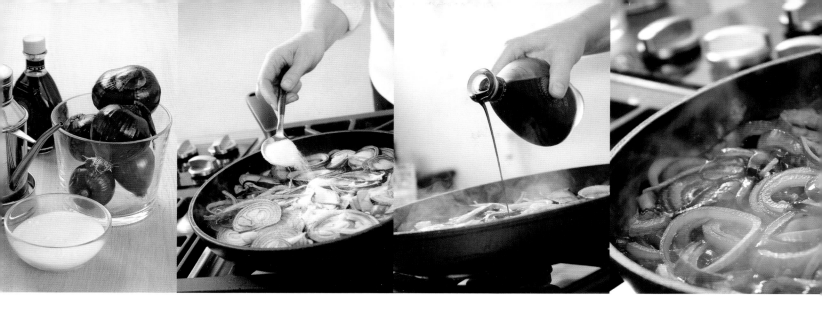

Risotto is a wonderful dish and not at all difficult to prepare; you need just a little time, patience and to re-member to keep stirring.

The bitterness of the radicchio is rounded out and enriched with Barolo, a very full-bodied wine from Pied-mont. The perfect touch are the dark, caramelized onions cooked with balsamic vinegar. If you don't feel like looking after two things at once, the onions may be done well ahead, even up to a week, and re-heated. I suggest you add a couple of tablespoons of water to them if you do so.

Caramelized Onions

Thinly slice the onions. Cook over a low heat in some extra-virgin olive oil until they become transparent. Add the sugar, vinegar and salt. Cover and continue to cook over a low heat until the onions become golden and the sauce becomes thick. While cooking, if you wish or as needed, add vinegar and sugar in equal propor-tions, or even a little water.

Risotto

Peel the onion and slice it finely. Sauté in oil and butter for about 10 minutes over a low heat, adding a la-dle of broth.

Clean the radicchio, wash and chop into large pieces. Add to the onion and cook over high heat briefly be-fore adding the rice. Cook this mixture over high heat for a few minutes, then add the wine and allow to evaporate over medium heat.

Cook the risotto, slowing stirring in the warm broth slowly (about 20 minutes). Flavour with some grated nutmeg, salt and pepper to taste, add the Parmigiano, cover and allow to stand for a few minutes before serving with the caramelized onions.

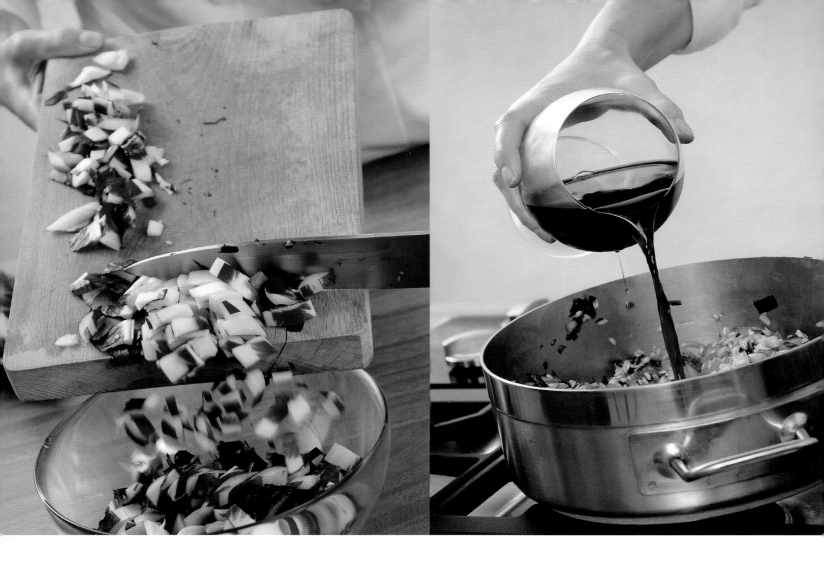

Since they are such a wild
success with my onion lovers
at home, I tend to make
a double batch and keep it
in a jar in the fridge

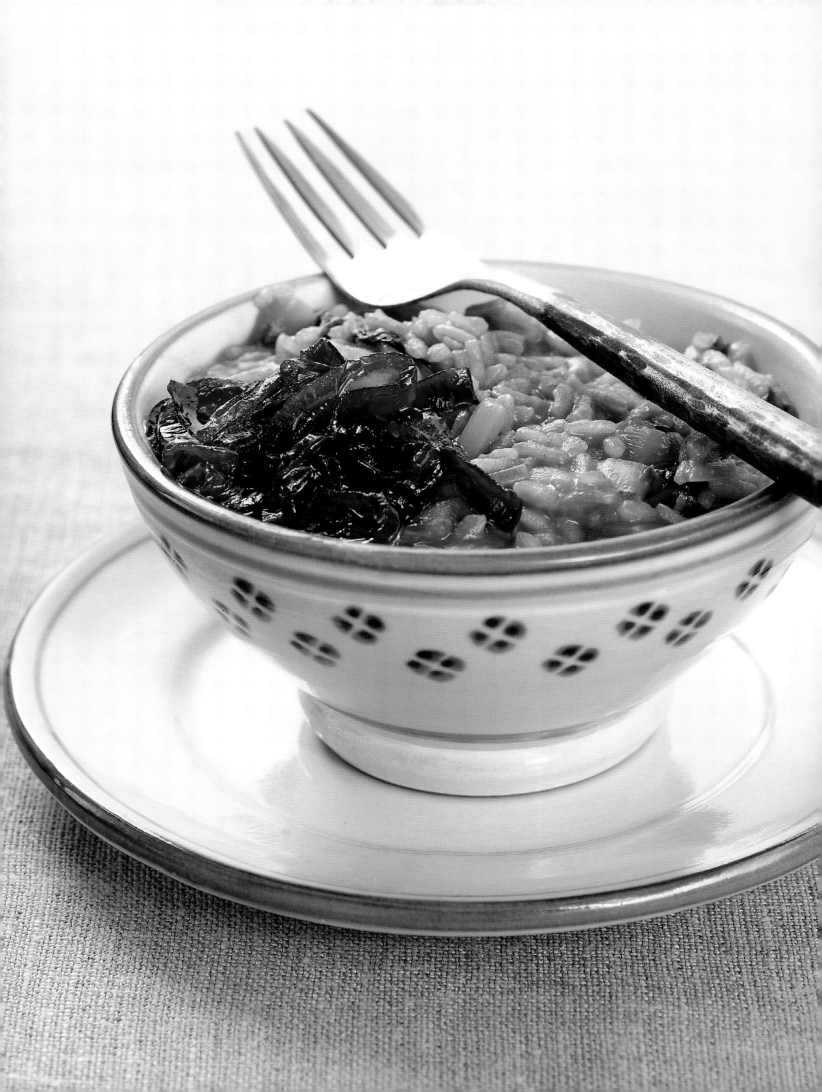

Shades of Bordeaux: Buffet of Amaryllis and Radicchio

Preparation time: 40'

12 dark red or bordeaux Amaryllis, or a mixture of both
A selection of early and late Radicchio Trevisano, approximately 5-7 heads of each
3 kg Carnaroli or Arborio rice
Coarse salt
Baskets, mason jars, ceramic containers or a mixture of both

This is a very informal buffet decoration inspired by all the wonderful "Alimentari" that you find in Italy.
Usually family run, these grocery stores are a treasure trove of goodies.
To make this, I simply placed some of the ingredients I used to make the Risotto: rice, salt and radicchio
in very large, simple containers and added some gorgeous wine-coloured amaryllis stalks in a large jar.
The great, old weigh scale makes a lovely focal point but may be easily replaced by a selection of baskets
or ceramic serving dishes.
This kind of decoration can be adapted to any recipe you choose and will show it off to perfection.

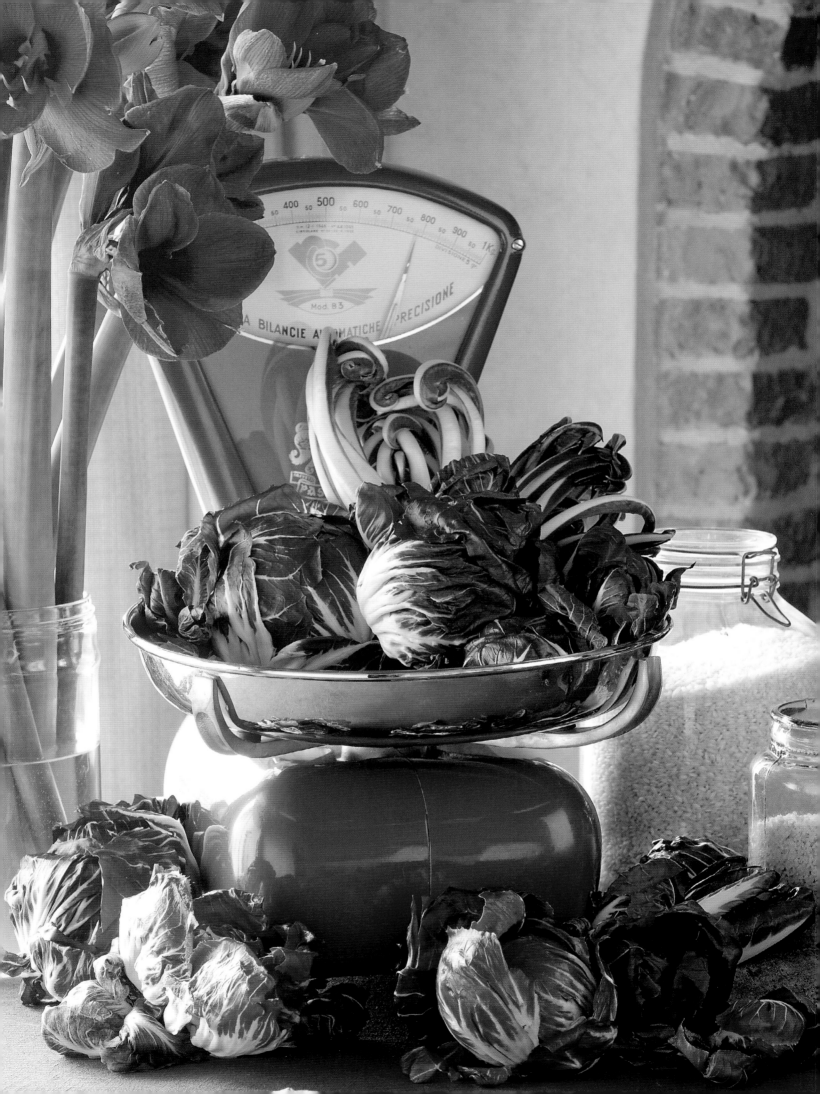

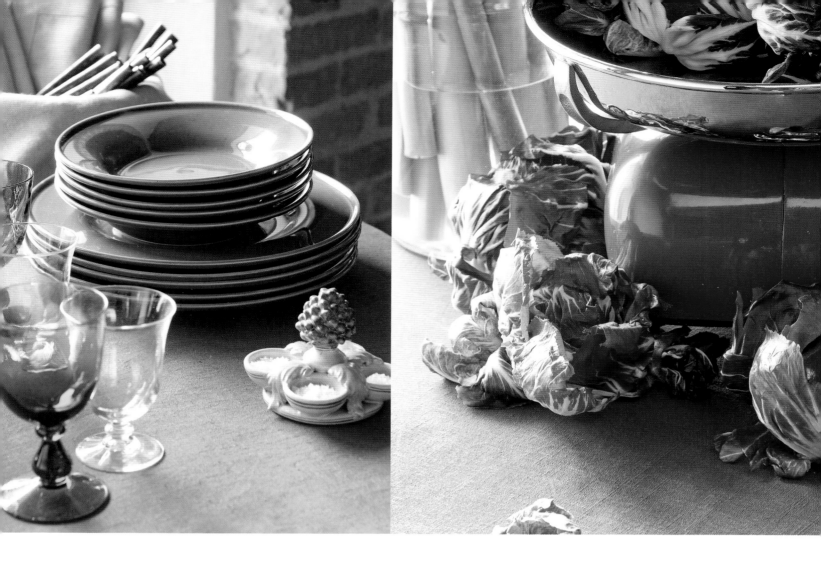

Place some radicchio on the table
as well, next to the baskets and the jars
to complete the effect

Quiche of Swiss Chard, Hazelnuts and Caprino

This is a colourful, tasty quiche suitable for a luncheon, a dinner by the fireplace, or as in this case, for a buffet. The Swiss chard partially maintains its beautiful colours that are set off by the golden crunchy hazelnuts.

Prepare the pastry by hand or in the food processor. Sift the flour onto the pastry board and make a well in the centre. Add a touch of salt and the softened butter (in pieces). Work quickly, gradually mixing the butter into the flour using the tips of your fingers (this stops the butter melting too much from the heat of your hands). Add the water and mix together to form the dough. Shape into a ball, cover in plastic wrap and allow to stand in the fridge for 30 minutes.

Peel and finely chop the onions. Sauté in a pan with 4 tablespoons of extra-virgin olive oil. Add the chard (washed and roughly chopped). Add a ladle of water, salt and cover. Cook over medium heat for approximately 15 minutes. Remove the lid and allow the liquid that has formed to evaporate by placing it over high heat for a few minutes. Remove from heat and allow to cool.

Chop the hazelnuts and place them in a bowl.

Grease and flour a 2 pieces tart pan (24 cm diameter). Roll the pastry to a medium thickness, line the tart pan and trim off any excess pastry. Prick the surface with a fork.

Beat the eggs with the goat cheese, Sbrinz, some grated nutmeg, salt, pepper and a tablespoon of chopped herbs. Mix everything with the chard. Pour the filling into the lined pan.

Decorate with the chopped hazelnuts.

Bake in a pre-heated oven (375°F) for approximately 30 minutes and serve it either hot or room temperature.

Serves 4-6

Preparation time: 35'
Cooking time: 1 hour

Pastry
210 g flour
100 g butter
5 g salt
75 ml water

Filling
2 large Tropea red onions
2 small bunches Swiss chard
(800 g roughly)
50 g peeled hazelnuts
300 g fresh Caprino (goat cheese)
70 g grated Sbrinz (hard cheese)
5 eggs
Nutmeg
Oregano, savory to taste
Extra-virgin olive oil
Salt and pepper

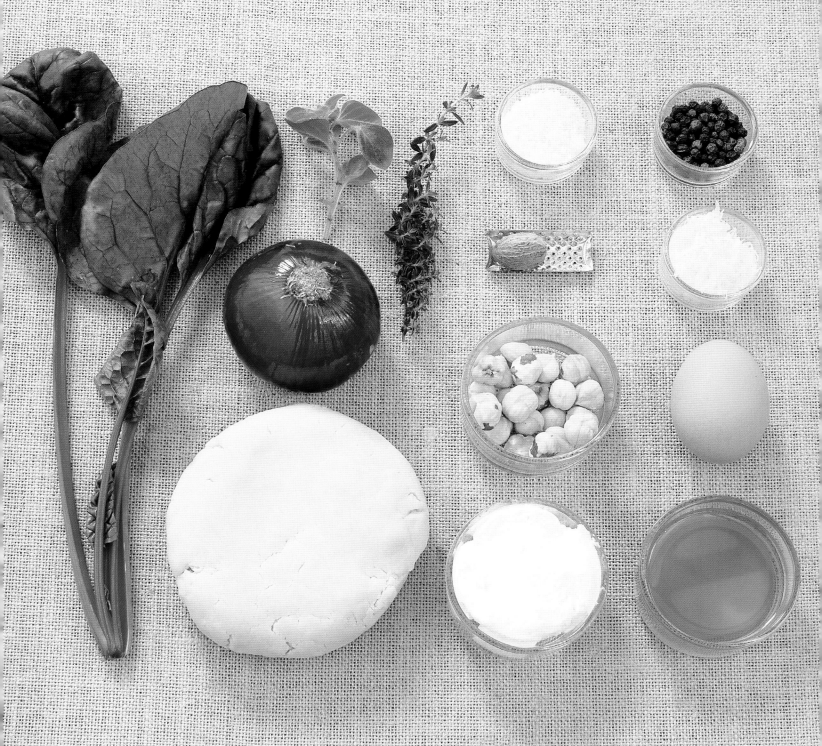

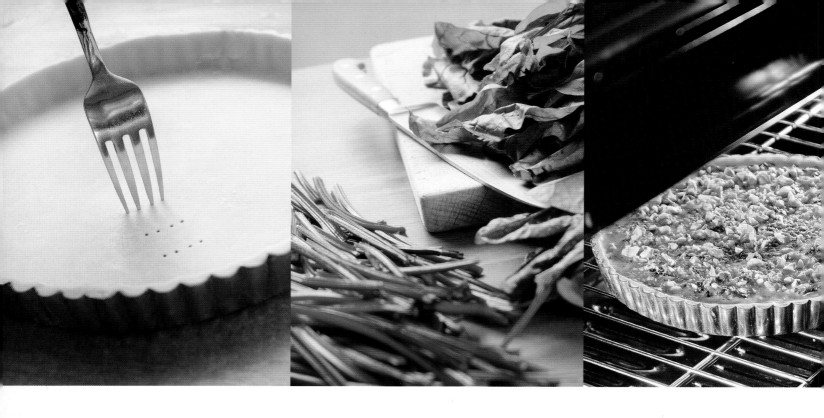

This quiche, with its wonderful
autumn colours is a feast
for the eyes!
Serve it hot or warm
to enhance the flavour

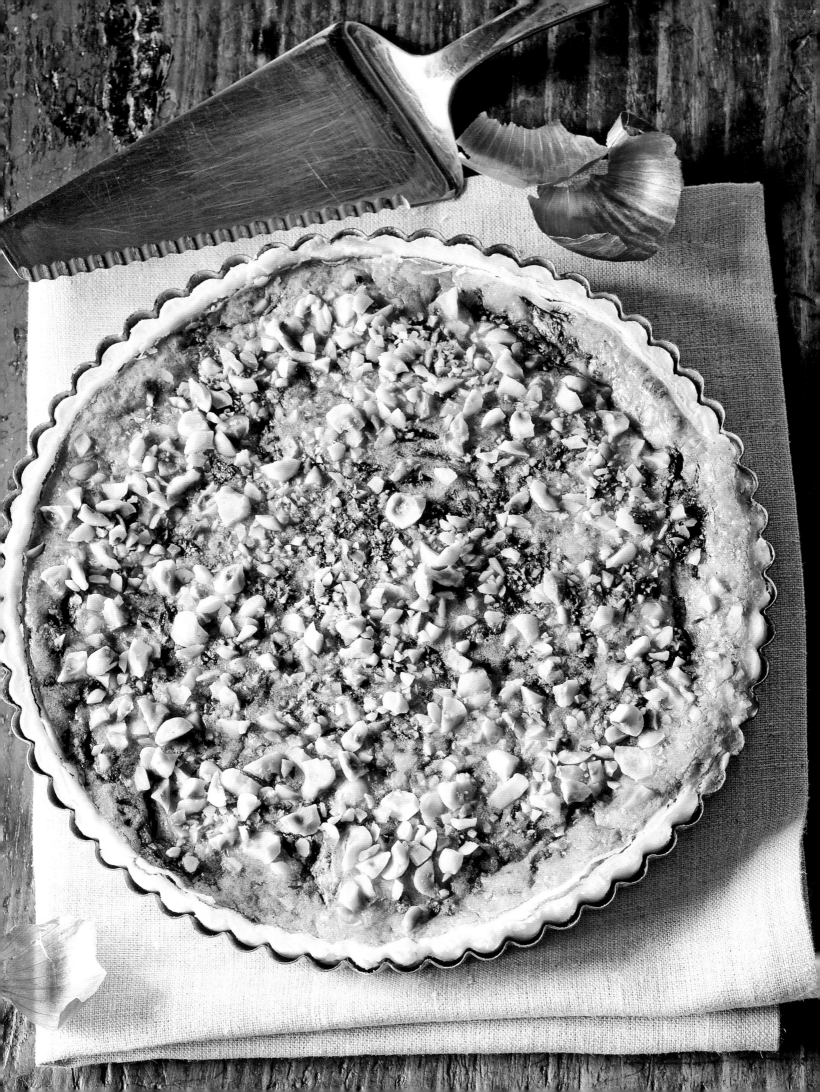

Vases of Vegetables with Tulips and Ranunculuses

Preparation time: 45'

50 dark purple tulips
50 burgundy ranunculuses
3 bunches of Swiss chard
1 kg hazelnuts in their shell
2 kg peeled red onions
Onion peels
Glass vases, size and number of your choice

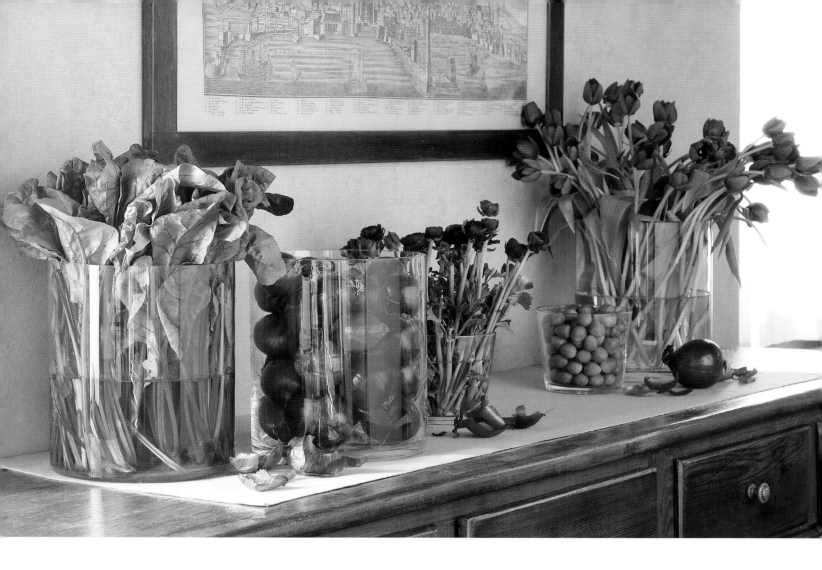

All those who know me will agree that it is quite easy for me to be running late. Therefore I have become extremely inventive in last-minute decorations.

Over the years, I have come to the conclusion that it is very useful to buy flowers that "match" the ingredients of your recipes; that way you can always mix them up according to the time and energy you have at your disposal.

Changing the sizes and heights of your vases will give your composition more interest, especially if it is on a sideboard or a buffet. If your decoration is going to be the centrepiece, remember to keep it low so your guests may see each other.

If you have enough ingredients and flowers, try to put each material into two or three different-sized jars. This will give your creation an overall sense of harmony. Some onions, with their peels, placed directly on the buffet table will give the decoration a more spontaneous look.

Try to make your composition asymmetrical as it tends to be more eye-catching.

In this composition I peeled the onions because they are so incredibly beautiful and shiny, with their magnificent magenta colour glowing through the vase. However, when I looked at the pile of onion skins with the light shining through them, their own special beauty caught my attention. So they were temporarily saved from the compost, and put on the table as well.

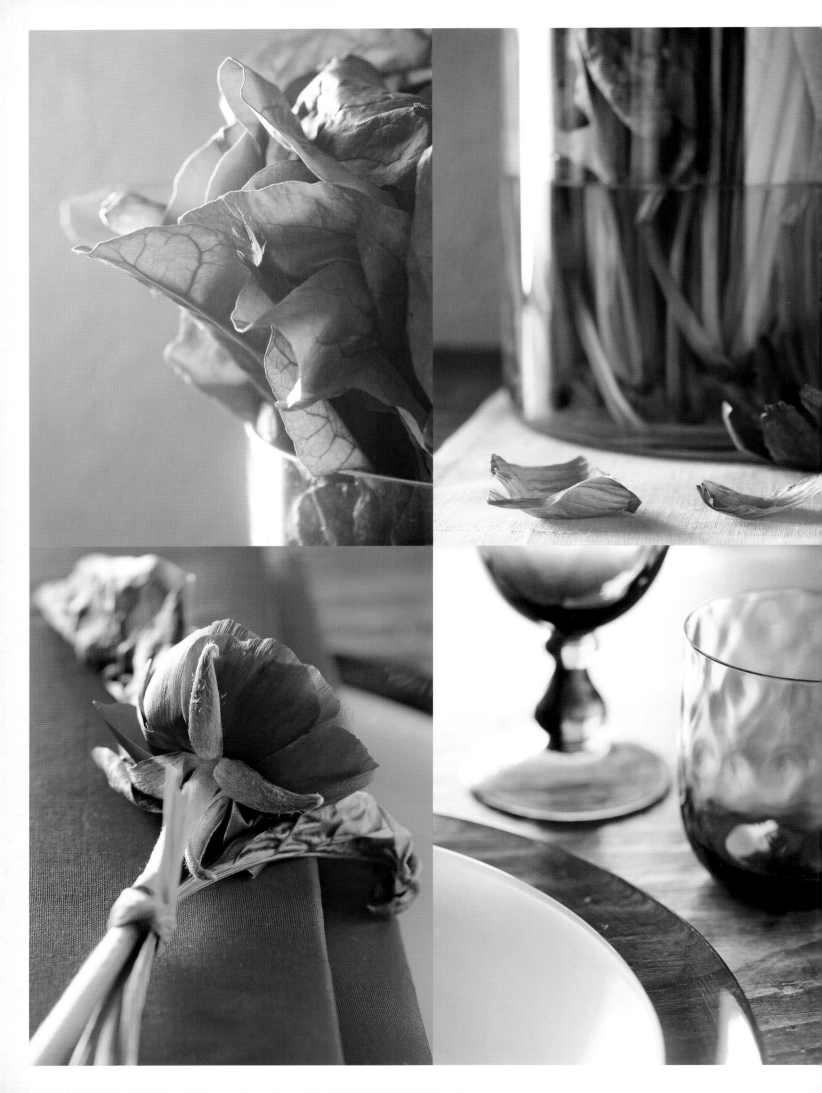

Marinated Vegetables Baked on a Cedar Plank

Although this cooking method is well known in North America, it is virtually unknown in Europe, so it's almost like cheating when I serve this here. The wood gives food the unique perfume of its resin, not at all like barbequing. Having said that, it is a great way to cook many things and the planks are very easy to mail order wherever you live.
Any mixture of seasonal vegetables can be used, so this dish is almost never the same twice. Feel free to use the quantities and types of veggies and herbs as a guideline only. Feel free to experiment and you will be sure to come up with a new family favourite.

Oil the surface of the plank, place in a cool oven and heat for about 15 minutes at 350°F.
In a large bowl, mix the extra-virgin olive oil, vinegar, garlic, salt, pepper and the finely chopped herbs.
Add the chopped vegetables and mix well. Pour the vegetables onto the hot plank and bake for about 30 minutes.

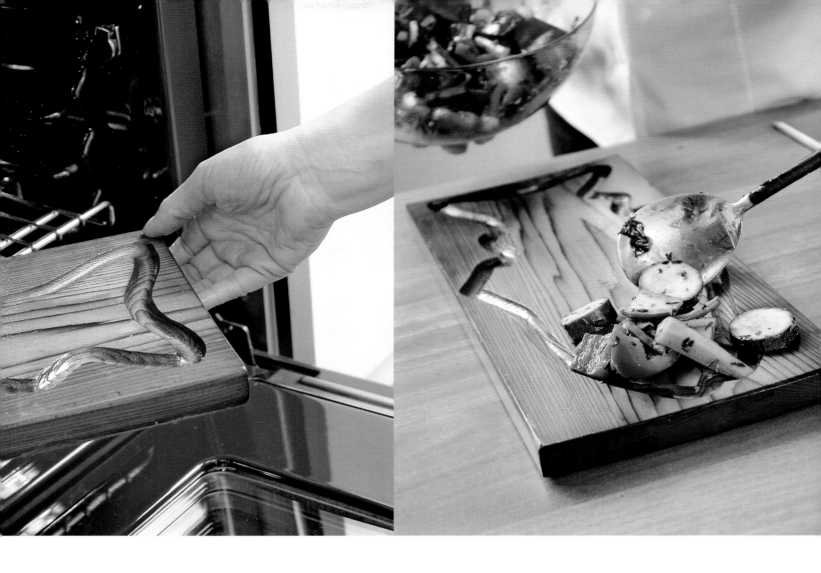

Serves 4-6

Preparation time: 15'
Cooking time: 30'

1 large plank (red cedar)
1 green zucchini, chopped
1 yellow zucchini, thickly sliced
1 red onion chopped into eighths
1 red pepper, diced
150 g green beans, cut in half diagonally
2 carrots cut lengthwise

Marinade
3-4 tablespoons extra-virgin olive oil
3-4 unpeeled garlic cloves
1 1/2 tablespoons of balsamic vinegar
2 tablespoons of freshly chopped herbs
(use your favourites! I used estragon,
rosemary and thyme).
Salt and pepper

"
The plank is a board
made from red cedar.
It was traditionally used by Native
Americans, on the West Coast
to prepare various types of food
"

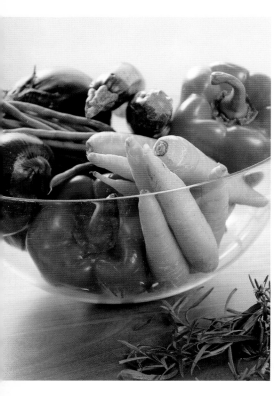

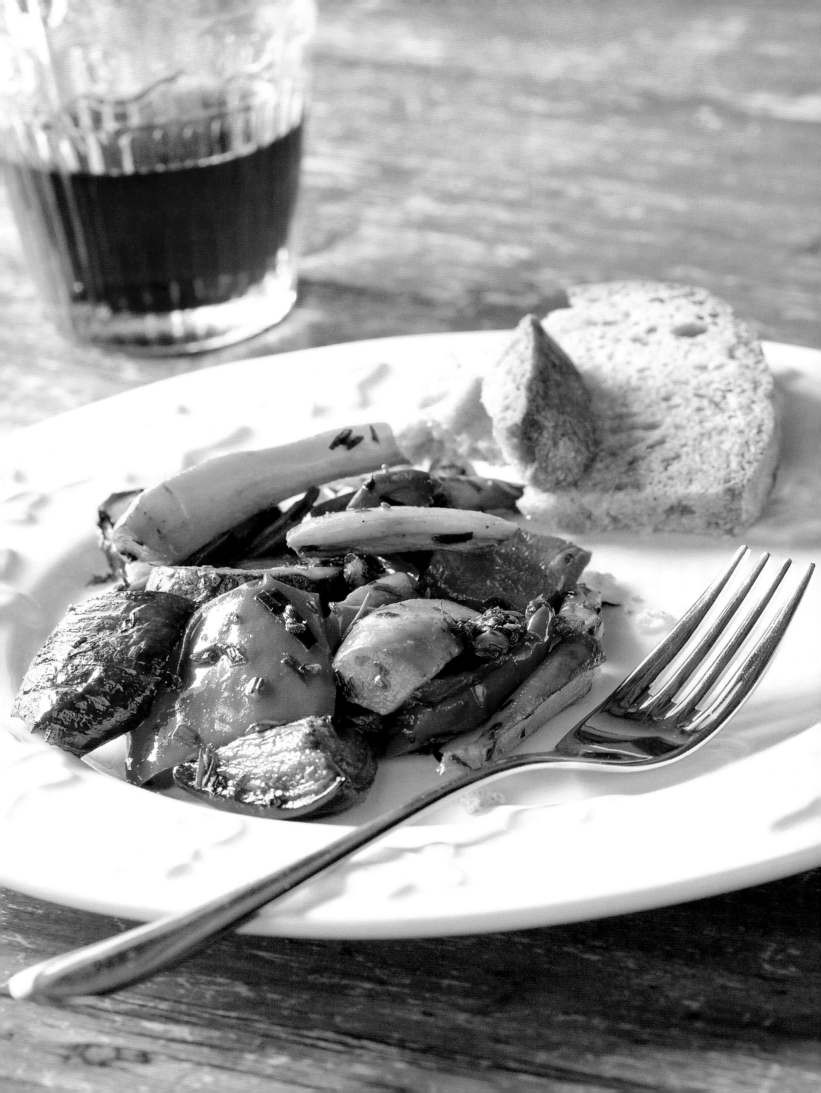

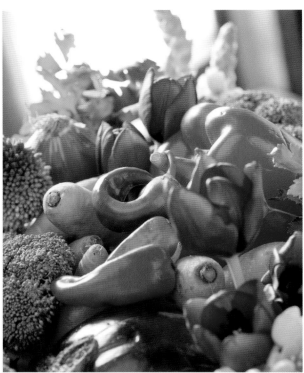

A Grocer's Flat of Flowers and Veggies

I love the wooden flats that green grocers give you. It makes your vegetables look ever so much more "professional." They generally get re-cycled for other uses and occasionally end up in the fireplace. This one, with its handles still intact, is used for a large decoration rather like an old-fashioned cornucopia with a wide variety of flowers and vegetables of all shapes and colours. It is too large for a centrepiece but would do nicely for a buffet or on a sideboard.

The list of ingredients is a suggestion. You may use any combination of vegetables and flowers that suit you or your colour scheme.

Put the moistened foam in the plastic tray and place it in the wooden flat on a diagonal. Start with the largest vegetables first: broccoli, aubergines and peppers. Insert them into the foam using floral picks maintaining the diagonal direction of the foam. Emphasize this even more so by putting the ornithogalums at the two extremes, at different heights to avoid symmetry.

Create two or three groups of tulips near the centre of the composition, accompanying them with the alliums.

Finish the decoration with the remaining vegetables and small bunches of parsley.

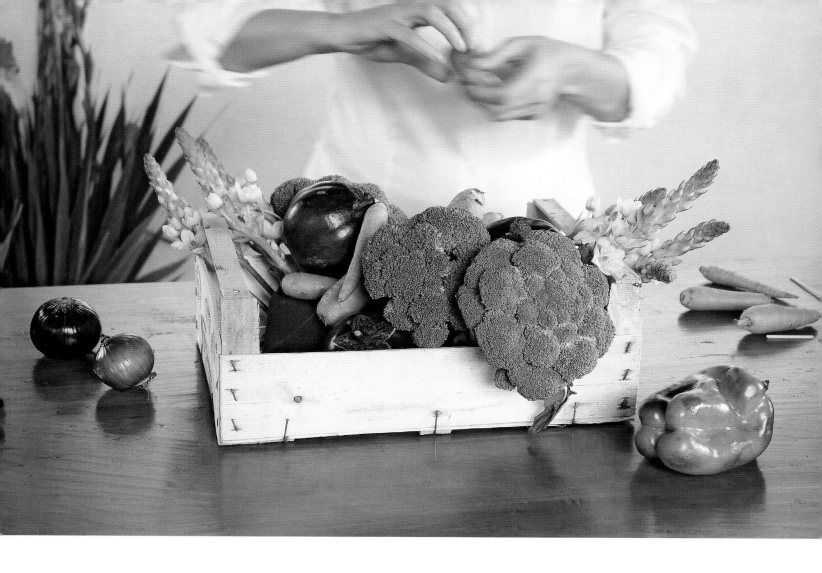

Preparation time: 1 hour

5 red onions
2 large red peppers
5 small sweet, green chilli peppers
3 large stalks of broccoli
1 bunch of carrots
2 aubergines
12 purple tulips
9 yellow ornithogalums
5 alliums
1 bunch of parsley
Floral picks
1 block of moistened floral foam
1 plastic florists' tray

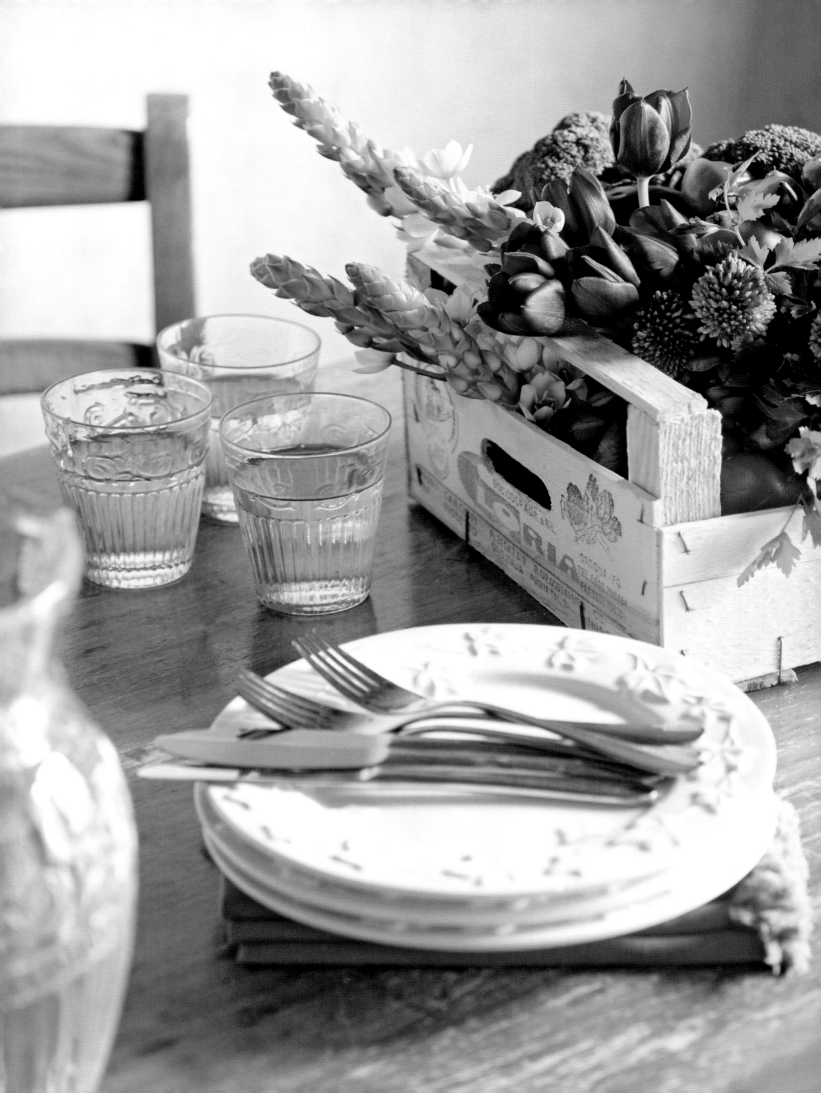

Salad of Porcini, Radicchio and Fontina

Serves 4

Preparation time: 20'
Cooking time: 5'

250 g very fresh, firm porcini mushrooms
2 heads of Treviso radicchio
1 heart of escarole
100 g aged Fontina cheese
40 g chopped walnuts
80 g shallots
Marjoram
Raspberry vinegar
6 tablespoons extra-virgin olive oil
Salt

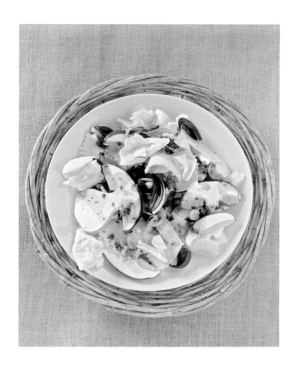

One of the great things about rain in the late summer and autumn, is that shortly after you will be certain to find porcini mushrooms. There are many people who go out and hunt for them on their own. Those who wish to sell them need to have them inspected and approved by a person who has a licence to do so. My local "fruttivendolo" in the country has one, so we are sure to have a great selection.
To be eaten raw, they need to be really firm and fresh, so make sure to choose them carefully, or specify that you intend to eat them in a salad.

Wash the radicchio and lettuce and then chop them coarsely, leaving the radicchio roots whole.
Clean the mushrooms with a damp cloth and then remove any remaining soil with a sharp knife. Slice them finely.
Peel and slice the shallots very finely. Sauté them briefly with 2 spoons of extra-virgin olive oil, adding lots of marjoram leaves (preferably fresh) and sprinkle with two tablespoons of raspberry vinegar. Let it evaporate briefly over very high heat. Set aside.
Mix the lettuce and the radicchio with the chopped walnuts and the shallots. Place on the plates, sprinkle with the mushrooms and finely-shaved Fontina cheese, add salt. Season with the remaining extra-virgin olive oil (4 tablespoons) and serve.

We have a big walnut tree at the front
of the house which provides us
with small but very tasty nuts.
They add a lovely texture to the salad

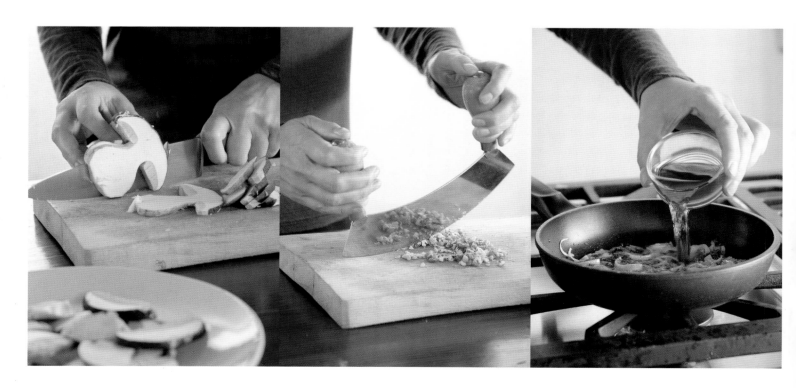

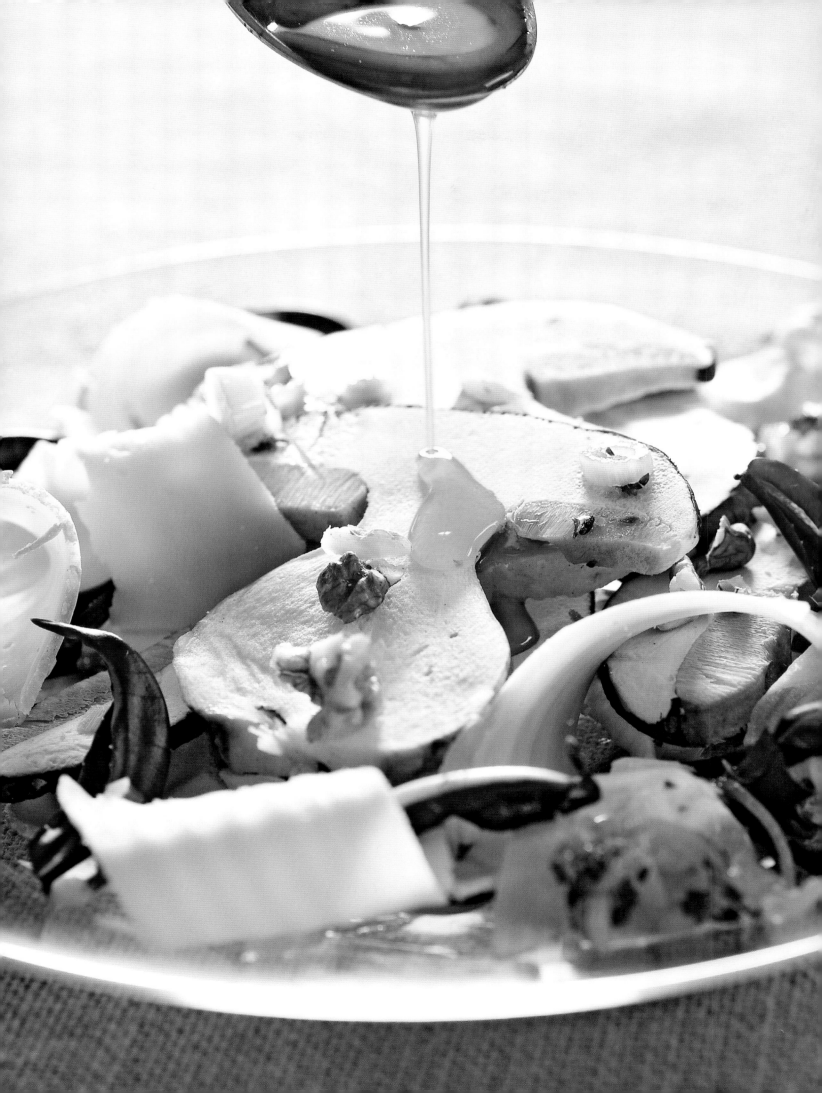

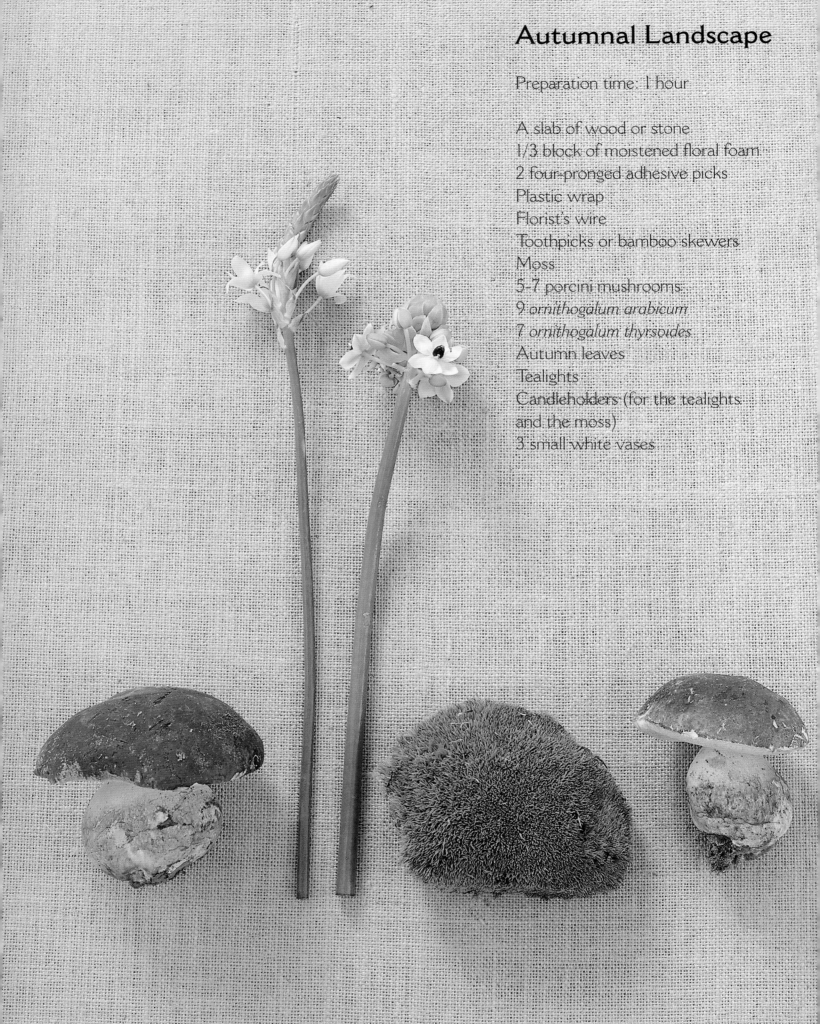

Autumnal Landscape

Preparation time: 1 hour

A slab of wood or stone
1/3 block of moistened floral foam
2 four-pronged adhesive picks
Plastic wrap
Florist's wire
Toothpicks or bamboo skewers
Moss
5-7 porcini mushrooms
9 *ornithogalum arabicum*
7 *ornithogalum thyrsoides*
Autumn leaves
Tealights
Candleholders (for the tealights
and the moss)
3 small white vases

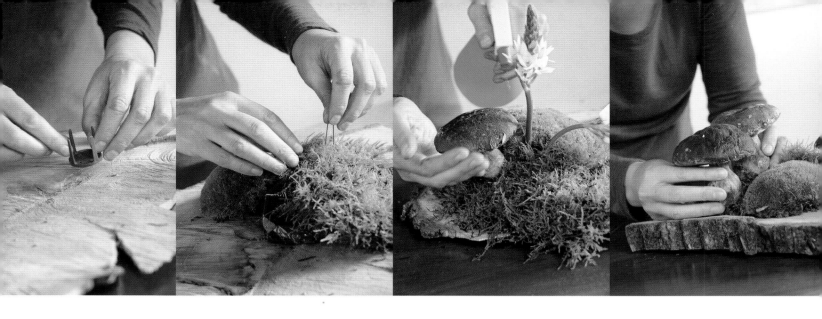

There is not always place on the table for a large centrepiece. In that case, I often create something to put in the same room, on a sideboard, on a bookshelf, or a side table as well as a smaller centrepiece. The two decorations will have some, but not necessarily all, elements in common.

In autumn there are so many wonderful materials you can find in the woods and this decoration for the sideboard contains most of them; mushrooms, moss, fallen leaves and wood and is very natural looking. The table is lovely in its simplicity and could easily stand on its own.

Landscape of moss, dry leaves, ornithogalum *and porcini mushrooms*
Place the two picks on the wooden base so that they create two different spaces to decorate. Cut the moistened foam into two pieces, with one being more or less twice as large as the other. Give them each an irregular shape with a slant to them so they have a more natural look once they are covered with moss. Cover them in plastic wrap so they don't drip on your furniture, and place them firmly on the picks.

Cut the florist's wire into 10 cm lengths and bend them in half. These will be used as a sort of hairpin to hold the moss in place.

Cover the two blocks of moistened foam with a thin layer of moss, fixing it in place with the folded wire. Group the mushrooms in a natural looking arrangement using the toothpicks or skewers cut in half. Vary the size, shape and direction to make them look as if they grew there.

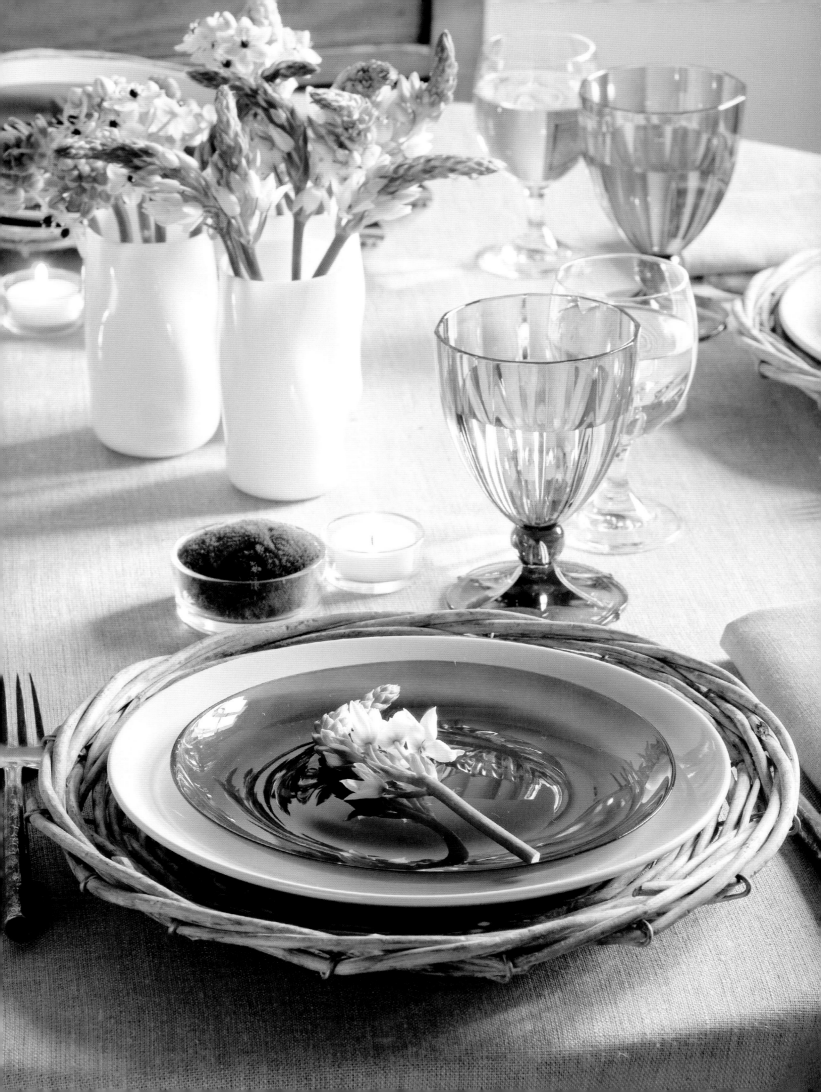

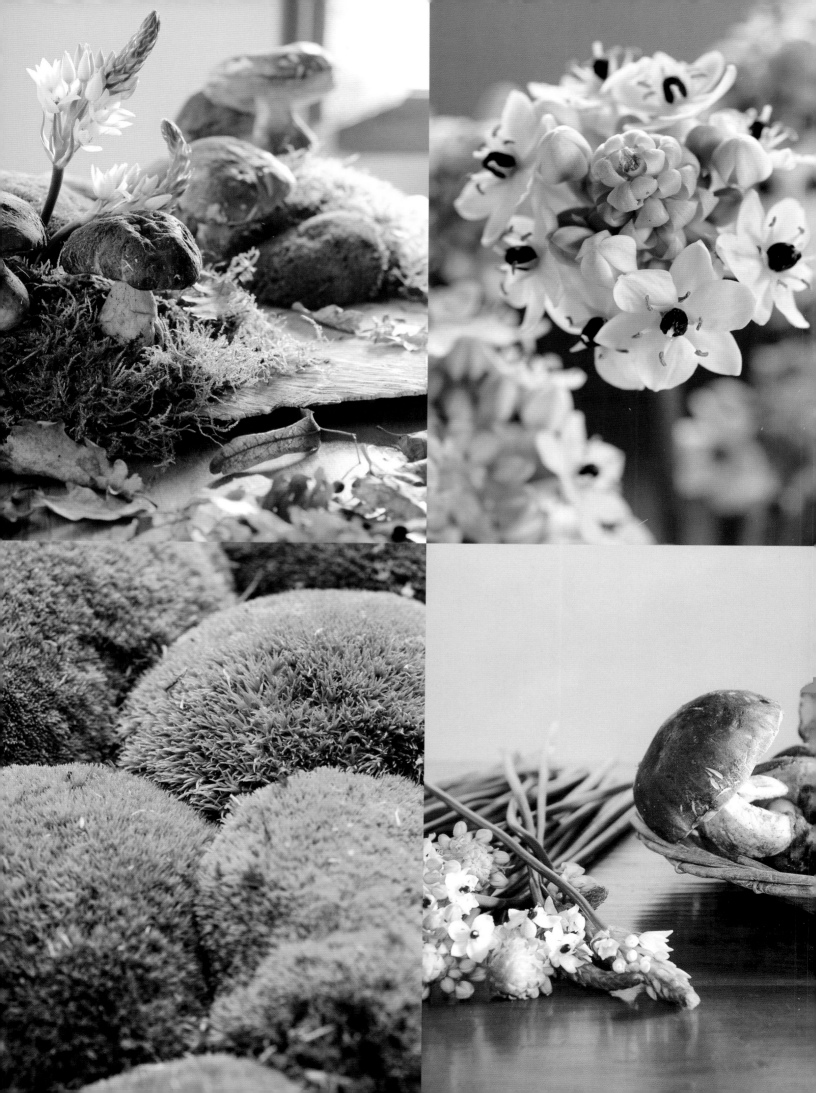

Add the *ornithogalum* a few at a time, then sprinkle with the dry leaves. If you wish to add candles, make sure that they are not near the leaves and when lit, don't leave them unattended.

Table Setting
Divide the two different types of *ornithogalum* amongst the three vases and place them in the centre of the table. You may either keep each flower separate, or mix them as you prefer.
Put a small clump of moss into a candle holder, place it along with a candle at each place setting and a single perfect bloom on each plate.

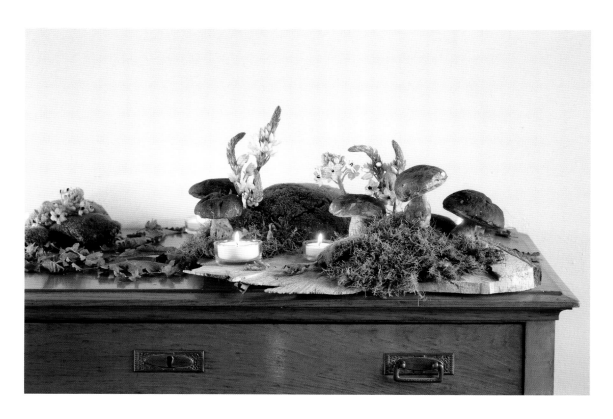

Winter

The leaves have fallen, the harvest is in. The olive oil is stored in the cisterns, ready to enliven our table with its heady scent. The short days and frequent bad weather drives us indoors, each of us intent on our daily tasks. Expeditions to the wider world are confined to buying the papers and a stroll through the woods before curling up again in the cosy warmth of the house. Mealtimes are convivial affairs, when we share our pastimes.

The vegetables from the vegetable garden are the usual winter favourites: broccoli, cauliflower and the famous Tuscan black cabbage, with its characteristic flavour ready to be savoured only after the first frosts. These are solid, massive vegetables and require equally forceful recipes. Meals become heartier affairs; grains and pulses to warm you up and a dizzy array of au gratin dishes with lashings of cheese.

I even weaken and produce some deep-fried food…

I love getting up early and making a cake, ready and warm from the oven, for when the others come down. With two teenagers, two thirty year-olds and a Neapolitan husband in the household, meeting everybody's dietary requirements and tastes can be a difficult task, but I am sure that I will make someone happy, apart from myself. What I love most is the scent of fresh baking wafting through the house and the warmth of the oven heating the kitchen. If the weather is really horrible I light the fire too. An intimate delight is to make up for having been a poor *girl guide* by diligently kindling a blaze, blowing on the warm embers from the evening before.

As an antidote to the dearth of flowers in the garden I have bulbs all over the house: hyacinths, crocuses, grape hyacinths, and daffodils, whose perfume pervades the rooms on a sweet-scented tide. Hyacinths with their paper hoods, their rounded forms and their white roots that gradually fill their vases. Once exposed, they burst into a bloom so abundant that they can no longer stand straight, and bend in graceful curves. Daffodils, *tête à tête*, elegantly poised with their delicate flowers emanate a scent so heady it al-

most stuns. Little crocuses and grape hyacinths, with their lyrically dainty blooms, pop up in the most un-likely places, nestling in containers of all shapes and sizes.

In the woods I gather ivy, wild hellebore and interestingly-shaped branches. In autumn I eagerly seize all the woods have to offer, whereas in winter I am more selective, privileging things I have grown myself; *viburnum tinus* with its dark blue berries and slightly scented pinky-cream flowers, cotoneaster and hawthorn, with their red berries and branches of arbetus, with their shiny green leaves and bright red fruits.

At home broad sprays of green alternate with landscapes of moss and flowers, with orderly arrays of hy-acinths in their serried ranks of vases commanded by the odd regal *amaryllis* towering over them... they all watch as we perfect the art of idleness.

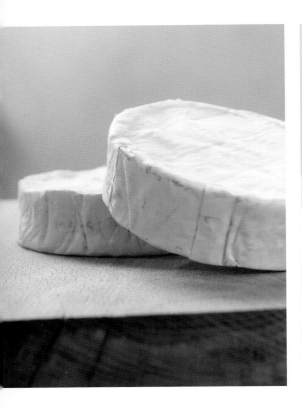 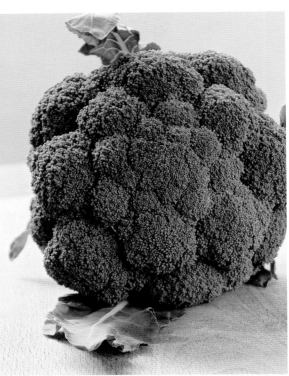

Cream of Broccoli and Camembert

This is an exquisite soup and really quick to make. I do it so often and with pleasure, especially because the recipe is from my sister Susan. With very fresh bread and some good red wine, it is a great way to kick off an informal dinner with friends.

Sauté the shallot in butter in a non-stick pan until transparent. Peel and dice the broccoli stems. Sauté the broccoli for about 5 minutes. Put aside some florets for the garnish. Add the broth and wine; cover and cook over a low heat until the broccoli becomes very soft (about 10-15 minutes)
Separately, mix the cornstarch and milk before adding this mixture to the broccoli. Bring to a boil and then reduce the heat, allowing it to cook for another 2-3 minutes.
Add the diced Camembert cubes and then, over low heat, allow it to melt.
Blend everything in a food processor. Add salt and pepper to taste. Garnish with the broccoli florets and a sprinkling of paprika.

Serves 4-6

Preparation time: 10'
Cooking time: 20'

2 tablespoons butter
1 chopped shallot
225 g broccoli
275 ml broth, ideally chicken
275 ml white wine
2 teaspoons cornstarch
175 ml milk
225 g diced Camembert
with the peel removed
Salt and pepper
Sweet paprika

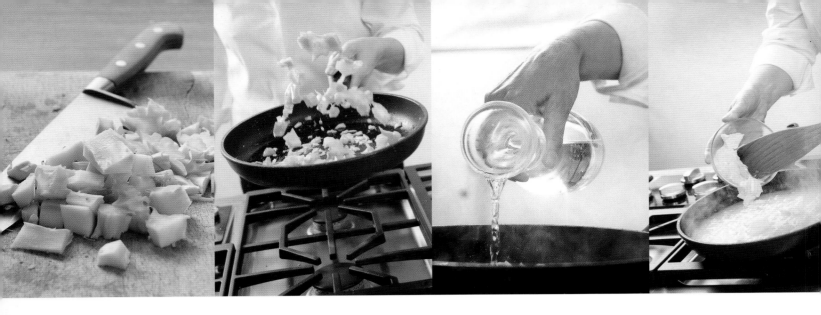

Broccoli is a beautiful vegetable
that is extremely versatile and tasty.
The Camembert gives this soup
its special flavour, so use
the best you can find

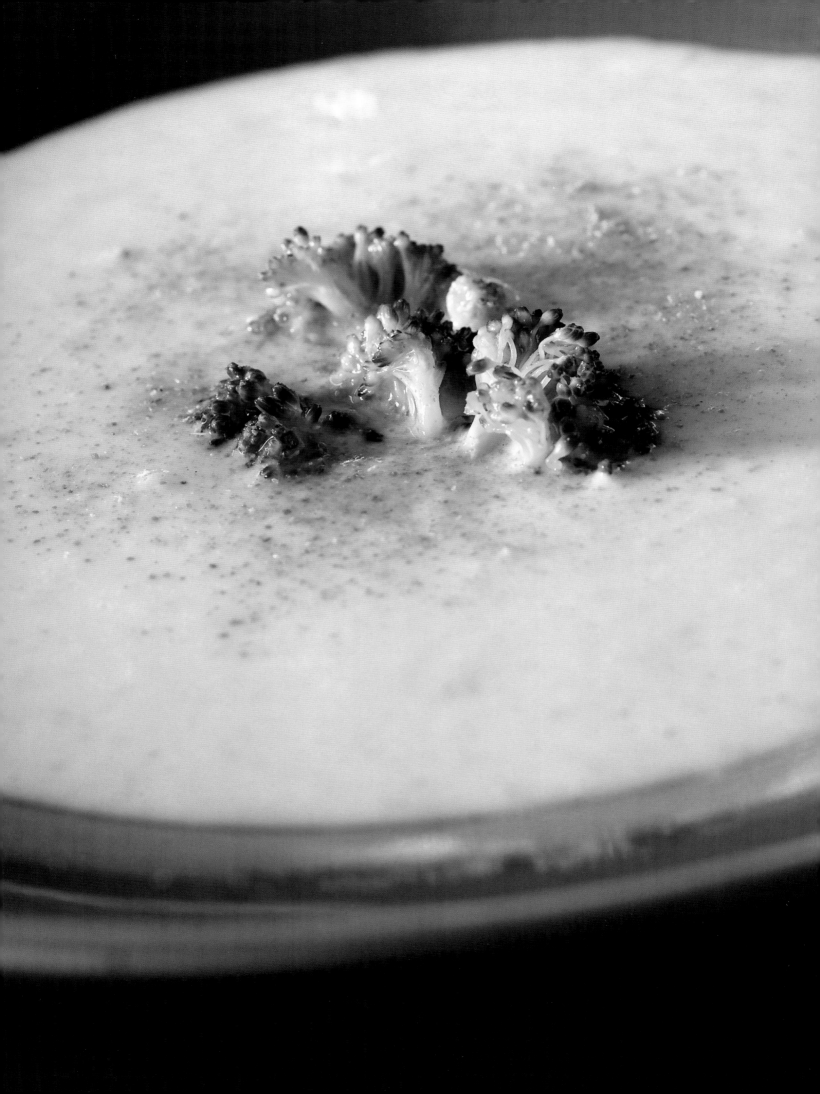

Baskets of Broccoli and Glads

Preparing time: 30'

1 large stalk of broccoli with a firm, round head
2 or 3 gladiola stalks, the colour of your choice
1/2 block of moistened floral foam
2 baskets

This charming, colourful decoration shows the broccoli off to advantage and gives glads a new twist. They are a wonderfully long, spiky flower and have suffered the ups and downs of fashion more than most flowers have. Gladiolas have a fantastic colour range and last a long time. Here is a way to turn one stalk into many single, fluffy blooms.

If you look at a glad carefully, the individual flowers grow on the same side. If you turn the gladiola on its side, you will see how, by cutting it on a diagonal just above each blossom, you can divide the stalk into many pieces. It is a good idea to prepare several blooms at a time so as not to have to stop and cut each time you want to use another flower.

Put the piece of moistened floral foam in one of the baskets. Insert the cut gladiolas in the foam to form a rounded cushion. Very simply place the broccoli into the other basket. If the shape is not as perfectly round as you would like, you could cut a few florets off another or the same stem to adjust the shape.

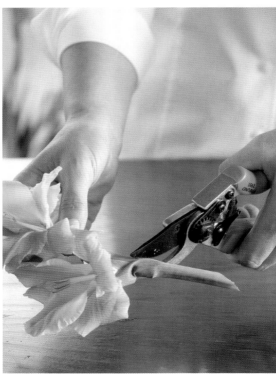

Gladiolas come in fantastic shades
that will light up your table, forming
a light and airy cushion of colour

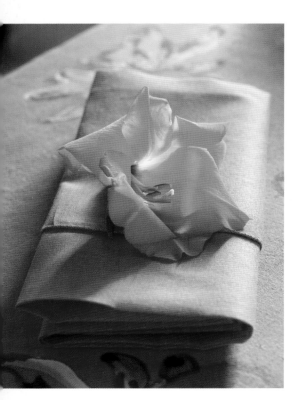
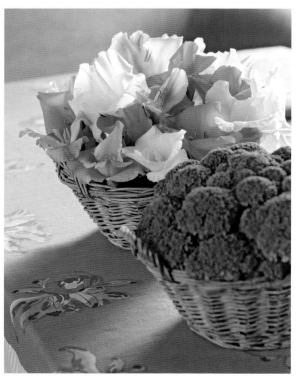

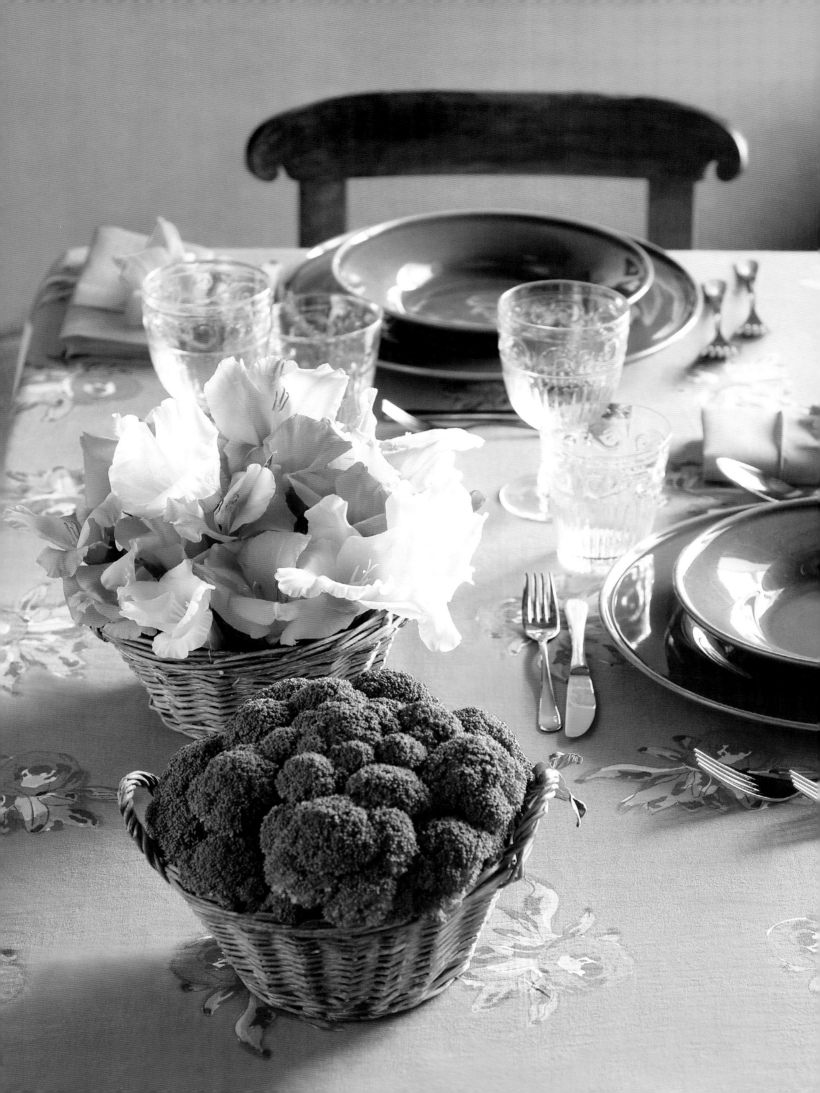

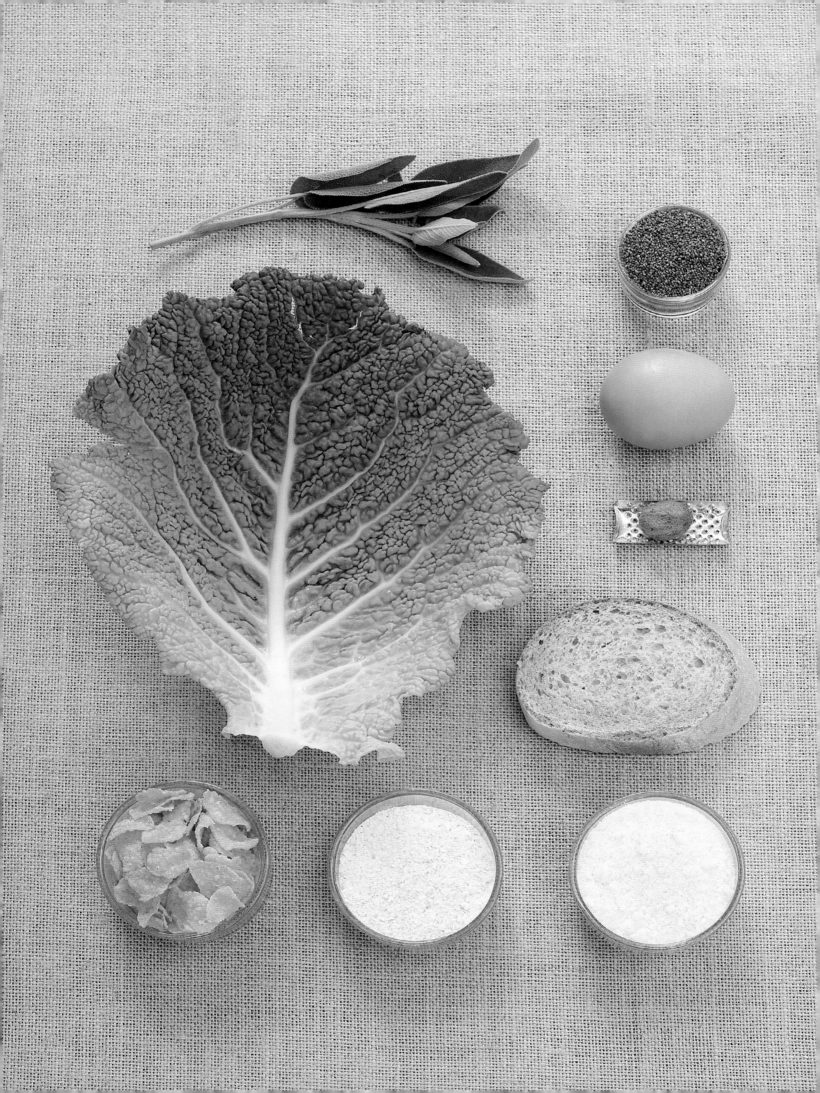

Canederli of Savoy Cabbage with Butter, Sage and Poppy Seeds

Serves 4

Preparation time: about 30'
Cooking time: about 50'

250 g stale wholemeal bread
60 g corn flakes
400 g Savoy cabbage
1 onion
2 eggs
80 g grated Parmigiano
80 g wholemeal flour
70 g clarified butter
2 tablespoons extra-virgin olive oil
1 tablespoon poppy seeds
Nutmeg
A few sage leaves
Salt and pepper

Canederli are a type of bread dumpling that are served in broth, as a side dish, or on their own.
In this recipe the Canederli are served simply in a butter, sage and poppy seed dressing. They may also be served in a vegetable or chicken broth.

Peel and chop the onion. Sauté in 2 tablespoons olive oil, adding a touch of water until the onion becomes transparent. Wash and chop the cabbage leaves, add to the onion and continue to cook slowly for about 20 minutes until the cooking juices have completely evaporated.
Add salt, pepper and some grated nutmeg.
Remove the crust from the bread, chop it up, wet it and mix with the corn flakes, whisked eggs, half the cheese and the cooked cabbage. Mix well, add salt and pepper to taste and then allow to stand for at least 30 minutes. With damp hands, form the canederli into plum-sized balls, then roll them lightly in flour. Melt the clarified butter in a small pan with a few sage leaves and a pinch of salt. Once the butter has taken on the aroma of the sage, remove the leaves, add the poppy seeds and remove from heat. Boil the canederli gently in plenty of salted water for about 10 minutes and remove them with a slotted spoon. Season with the sage-scented melted clarified butter, the poppy seeds and the remaining cheese. Serve straight away.

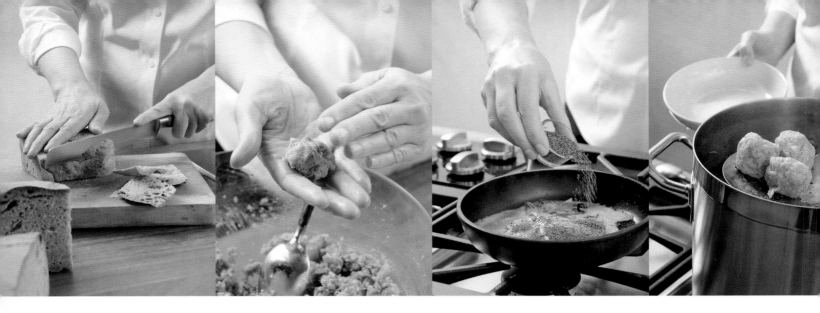

Canederli are easy to make and can be
flavoured with different vegetables
or classic speck. You could get
the children to help you roll the balls

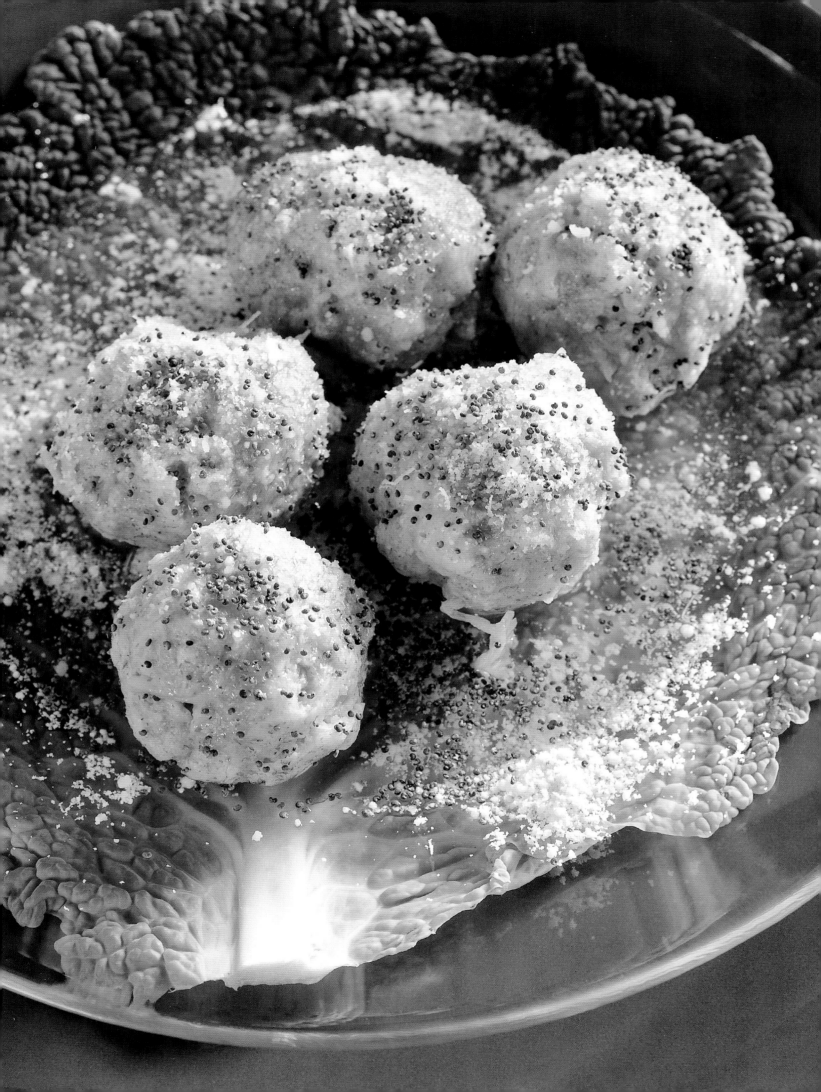

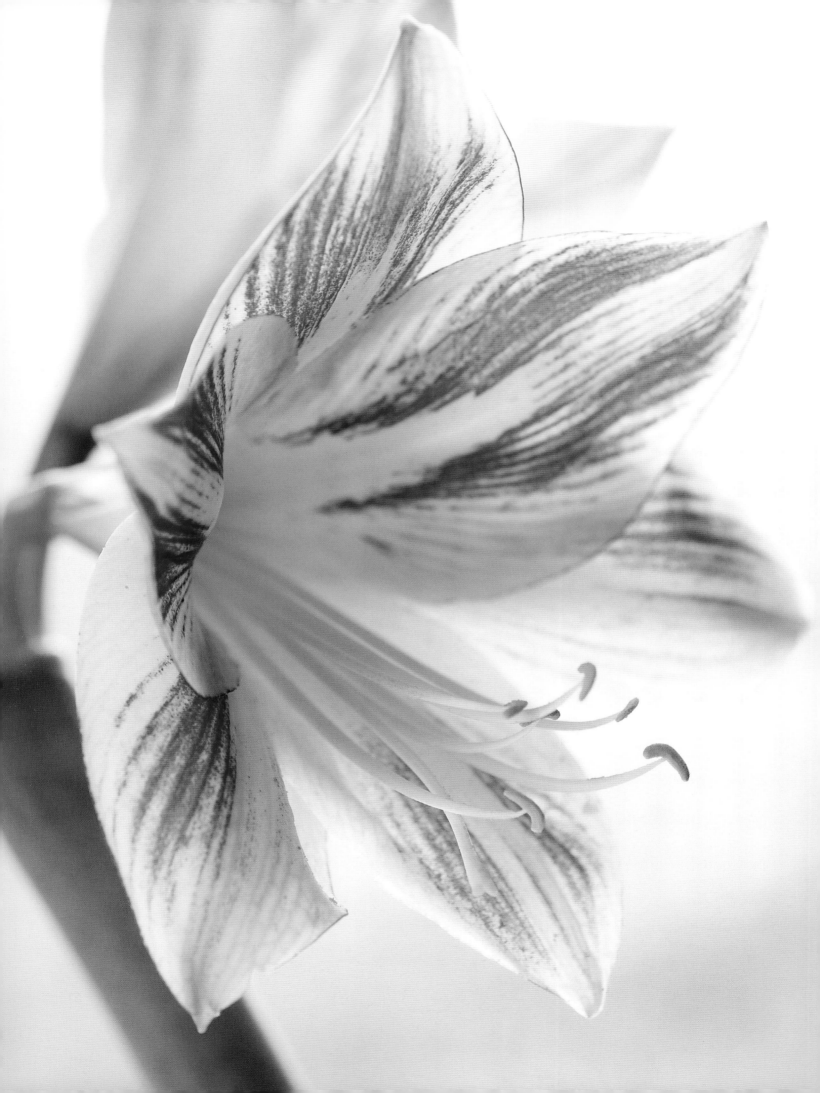

By the Fireside

Preparing time: 1 hour

5-7 whole Savoy Cabbage
12-15 amaryllis "Apple Blossom"
Grass twine
Votive candle holders
Votive candles
Large dinner plate
Smaller glass plate
5 large ceramic containers, bronze,
dark green or dark red

Fortunately most winter vegetables are inexpensive and very interesting. I adore the amazingly crinkly leaves of the Savoy cabbage and can't resist using them as a decoration as well as for sustenance. The amaryllis with their strong stalks and thick petals are a perfect counterpoint to the cabbage.

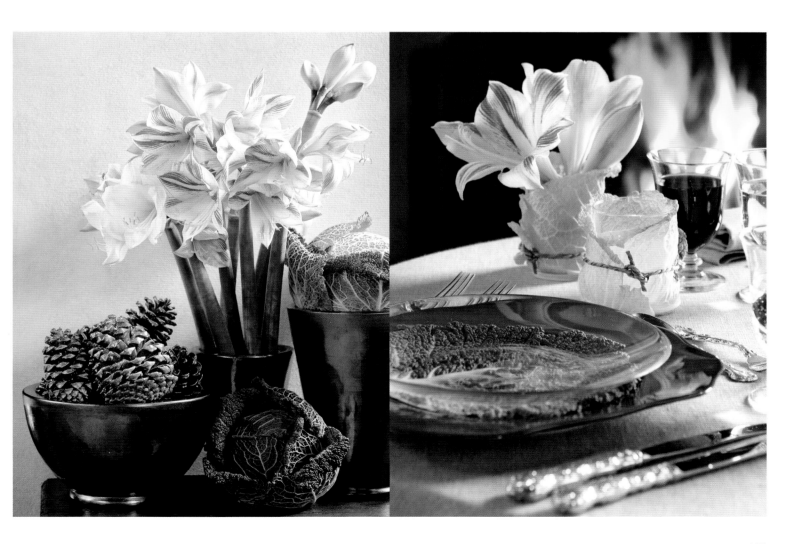

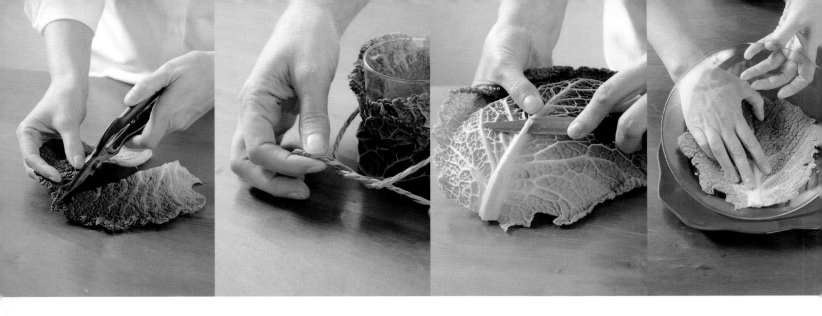

For a romantic dinner beside the fireplace I have taken a few bronze-coloured ceramic *cachepots*, filled them with cabbage and amaryllis and made two different groups on either side of the fireplace. The cabbages may be placed either in the containers or placed at their base.

The size of what you do will obviously have a lot to do with the amount of space available. Don't be afraid to do something large, even over-sized; it can be very effective. You are looking for a large sweeping effect. The table, on the other hand, is quite simple, its interest is made of details; a cabbage leaf votive candle and vase for a beautiful, single bloom and a fantastically graphic dinner plate.

Candleholder and Vase

To make the candleholder and vase, take a cabbage leaf, divide it in half lengthwise, wrap it around the candleholder, hold the leaf in place with a rubber band. Cut a length of grass twine and tie the leaf in place. When done, remove the rubber band. This may be used as either a candle holder or a bud vase.

Dinner Plate

Take a cabbage leaf and turn it over. With a small paring knife, trim the thick rib of the leaf until it is approximately the same thickness as the rest of the leaf. Place the leaf right side up on the larger dinner plate and pressing down to keep it flat, put the glass plate on top.

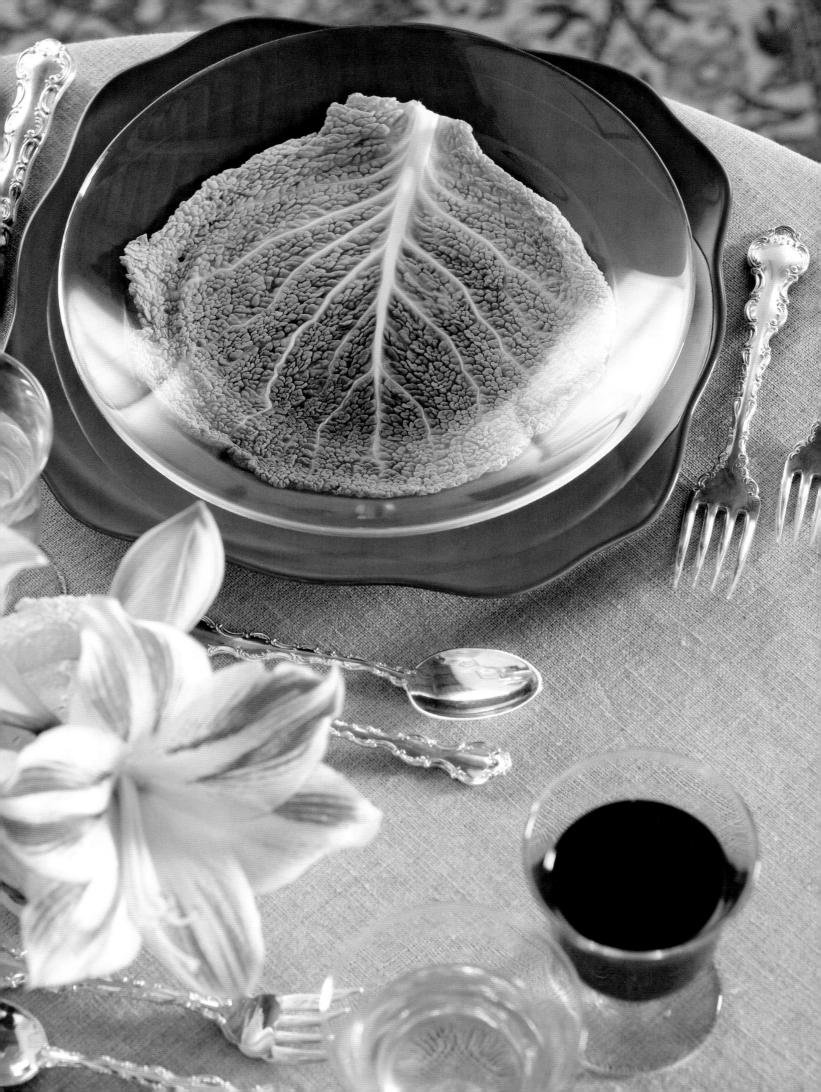

Poori of Cauliflower and Coriander

Our family is a great fan of Indian food and we eat it whenever we can. Add to that the eternal fascination with all fried dishes and you have the makings of a perfect meal.

These little *poori* are extremely easy and fun to make and fry up quickly. Sieve together the two types of flour and then place them on a pastry board (or in a food processor). Add 2 tablespoons of extra-virgin olive oil and 100 ml of lukewarm water. Add a touch of salt and then knead the dough thoroughly until it becomes soft and smooth to the touch. Shape into a ball and then wrap in plastic film. Allow to stand for approximately 30 minutes.

Boil the cauliflower and the potato in salted water until *al dente*. Drain and then fry, in a pan, with the ghee for a few minutes. Add the chopped garlic, salt and the coriander powder. Add chopped chilli to taste, the lime juice and a spoon of turmeric. Turn off the heat and add the freshly chopped coriander.

Divide the dough into pieces and roll these into balls roughly the size of small eggs. Dip the balls in ghee on one side only. Roll into discs using a rolling pin. Fry in plenty of boiling oil without turning and then place on paper towel to absorb the oil. Fill the *poori* with the cauliflower and serve immediately.

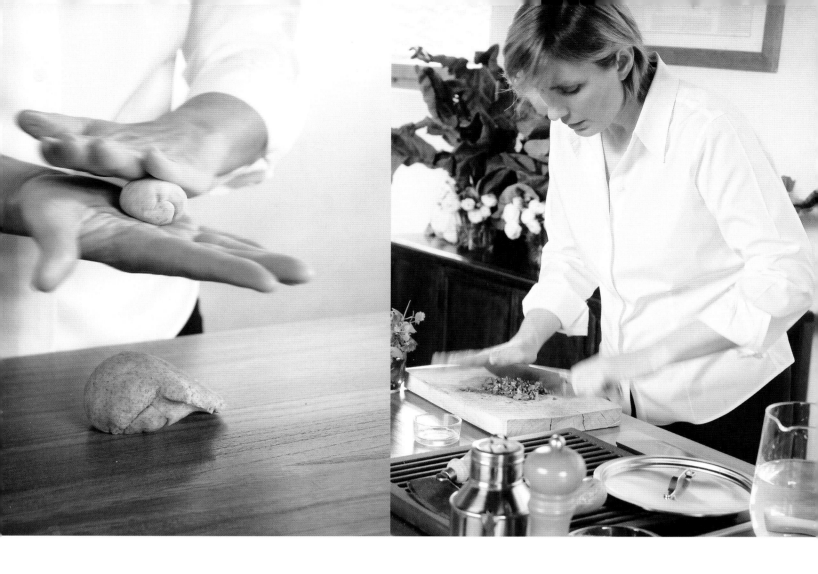

Serves 4

Preparation time: 25'
Cooking time: 15'

Poori
100 g white flour
100 g wholemeal flour
2 tablespoons extra-virgin
olive oil
100 ml (40 g) lukewarm water

Coriander flavoured cauliflower
1 clove garlic
400 g white or green cauliflower florets
2 green chilli peppers, sweet
or hot (optional)
1 lime
1 teaspoon turmeric
1/2 teaspoon powdered coriander
1-1/2 tablespoons freshly
chopped coriander
1 small diced potato
3 tablespoons ghee (clarified butter)
Extra-virgin olive oil
Frying oil
Water
Salt

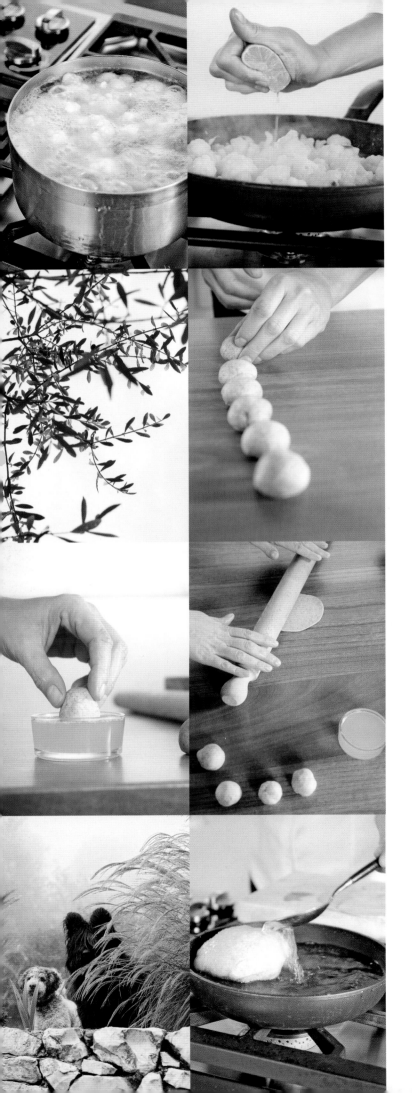

You will have to keep greedy hands from stealing them as you take them out of the pan or you will have nothing left to fill!

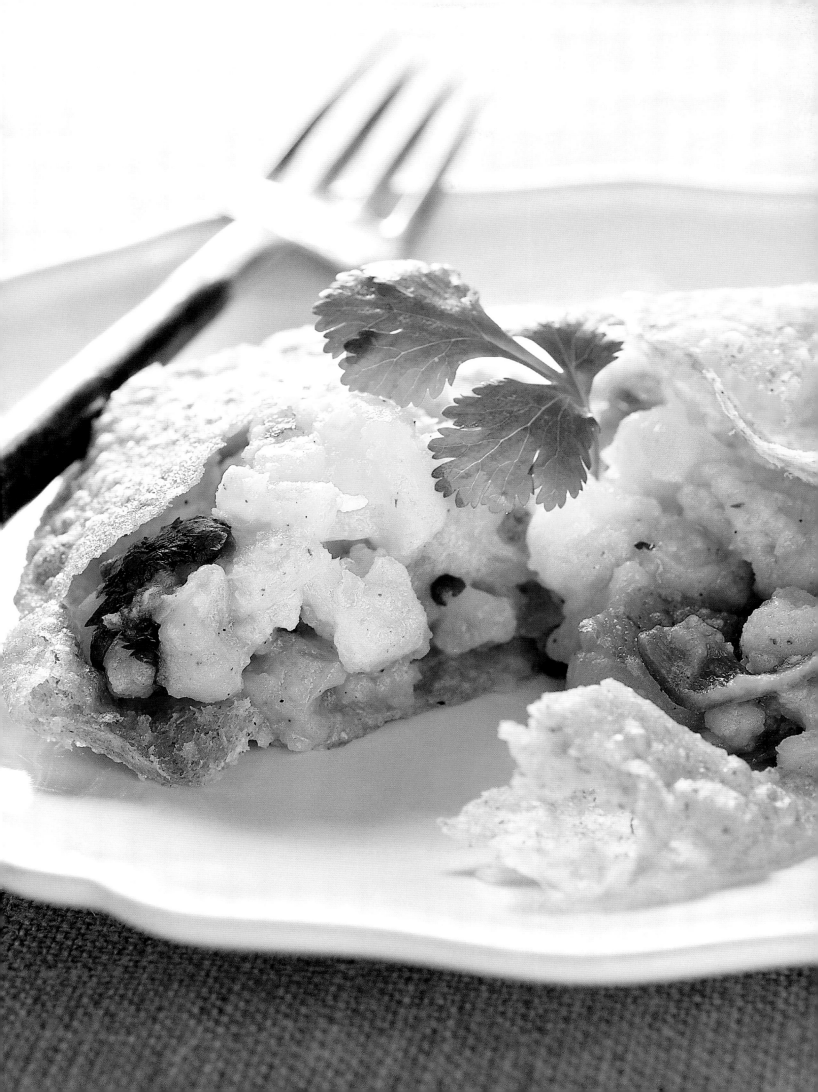

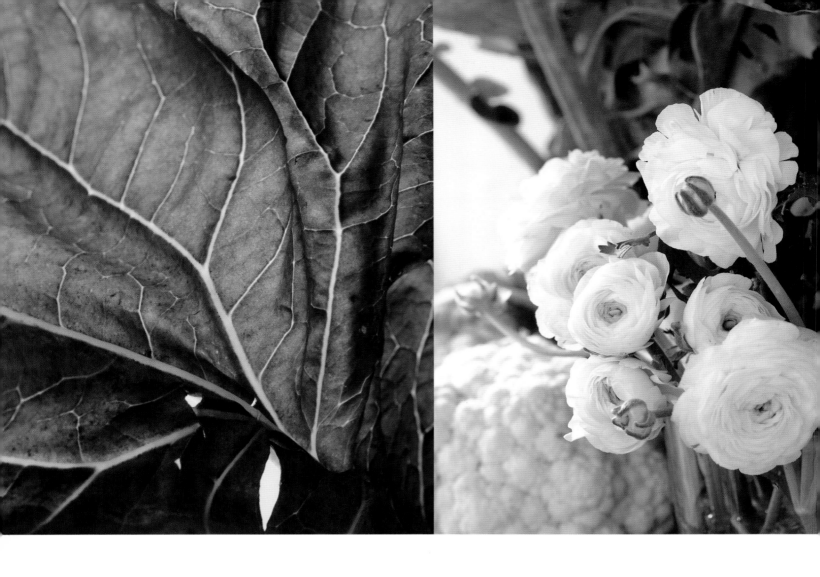

"
Ruffled ranunculuses are
a delicate counterpoise
to the dense structure
of the cauliflower
"

A Garden of Cauliflowers and Ranunculuses

For conditioning plants: 3-12 hours
Preparation time: 30'

2 or 3 cauliflower plants, heads, leaves, roots and all
2 or 3 extra cauliflowers heads
50 white ranunculuses
2 or 3 baskets or waterproof vases
2 or 3 glass vases

Have you ever noticed how beautiful winter vegetables are, with their strong leaves and architectural shapes? Looking at them in the vegetable garden I couldn't resist and actually pulled up a couple of plants to make this decoration. Although it sounds extravagant, when the cauliflower has been harvested, the plant has done its job.
The leaves are wonderful and also make a great "serving dish." For the plants and leaves to last longer, they should be conditioned for several hours in a large basin (or bathtub) of cold water deep enough to cover the entire plant. Remember to shake the water off and let them "drain" upside-down before using.
That is the main effort you will have to make; the rest is very simple.

Put the whole cauliflower plants in waterproof baskets or vases filled with water.
Cut the ranunculuses, fill several vases and nestle them underneath the plants with the extra cauliflower heads at the base of the composition. Surprising and beautiful and yes, your bathtub does get rather full of mud.

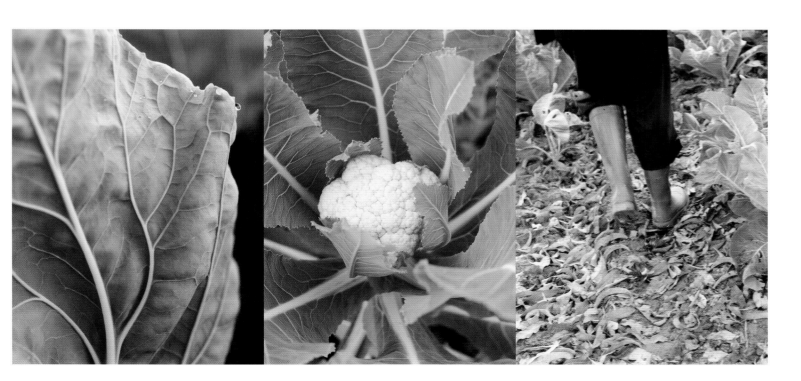

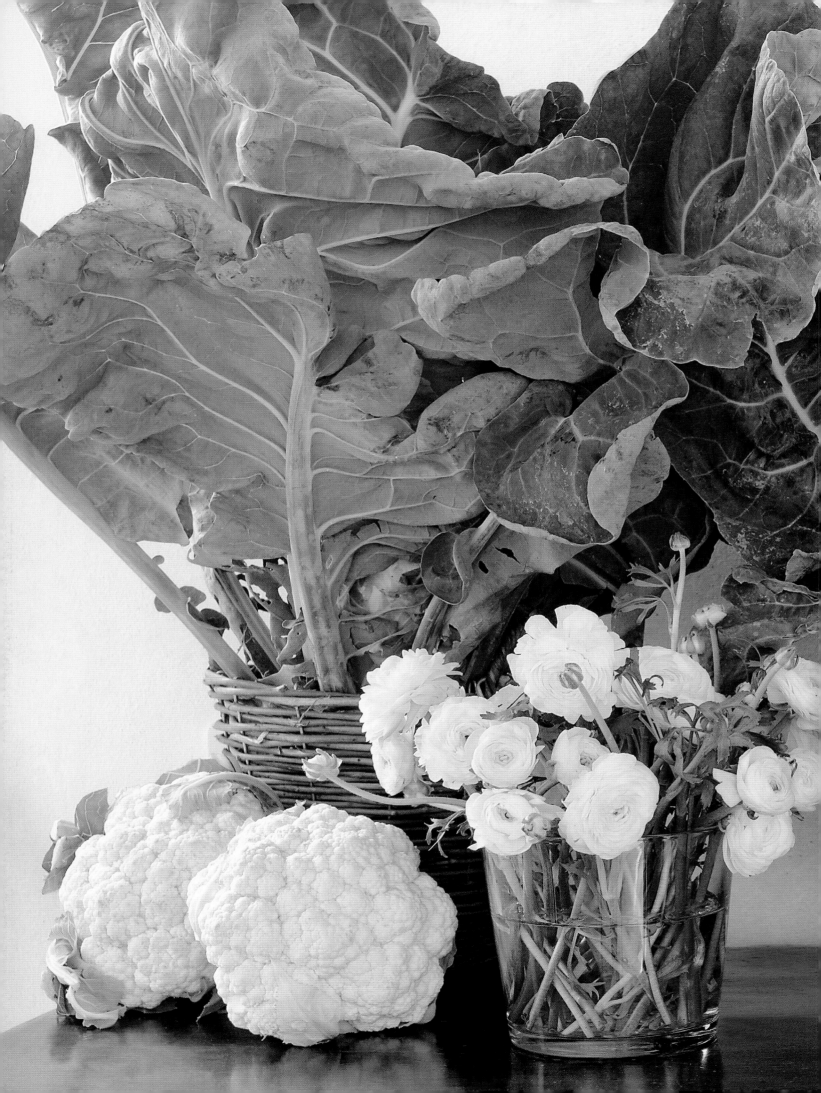

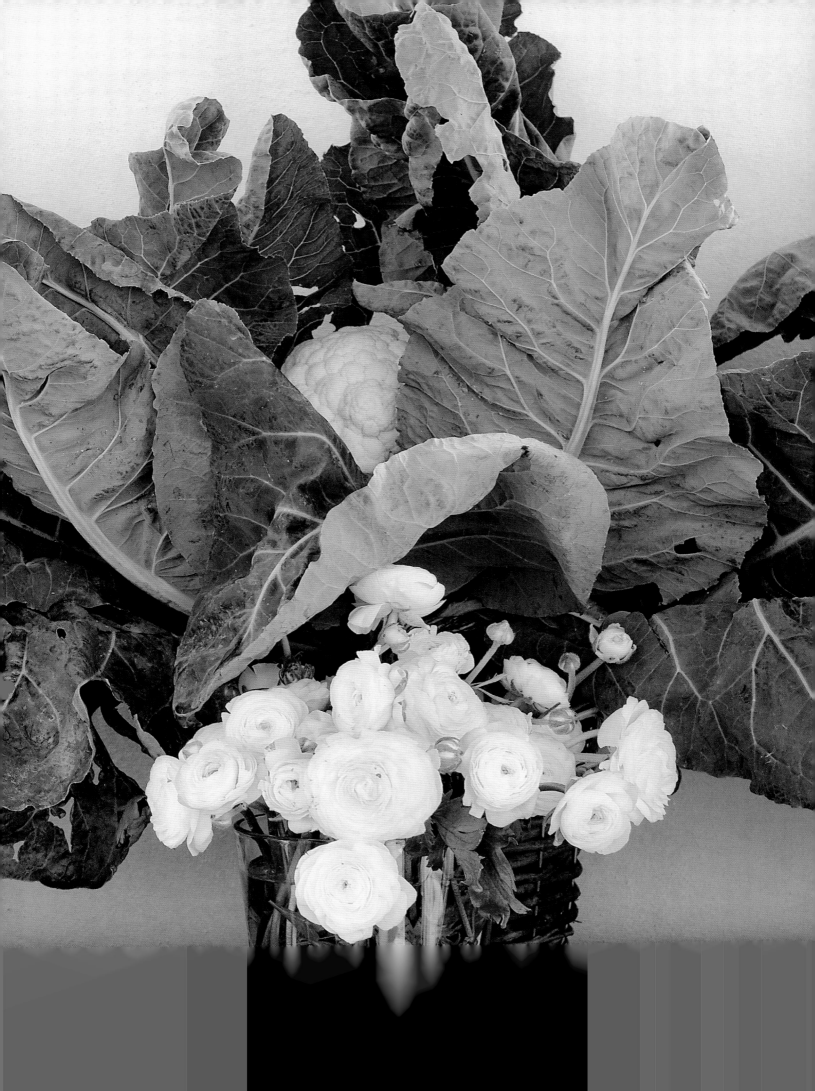

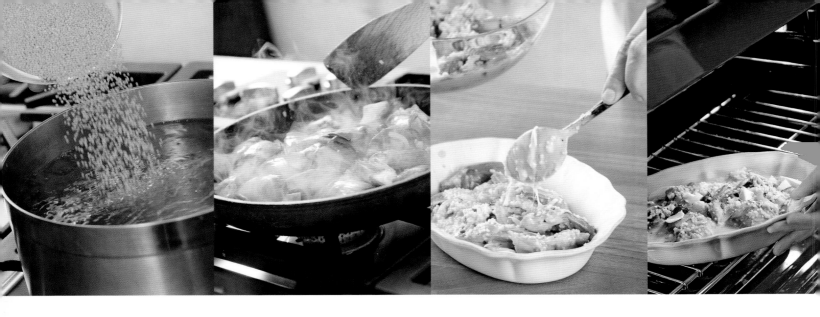

Gratin of Artichokes, Black Olives, Millet and Capers

Clean the artichokes by removing the hardest external leaves and any choke around the heart.
Cut each artichoke into 6 wedges.
Thinly slice the onion and finely chop the garlic. Sauté in a pan with 4 tablespoons of extra-virgin olive oil and then add the artichokes, cooking for several minutes over high heat. Add the olives and capers before pouring in half a glass of wine.
Boil off the liquid, add salt and pepper and turn off the heat before sprinkling with the finely chopped parsley.
Blend the white sauce, eggs and cheese together. Stir the artichokes into the sauce, add the millet and place everything in a well buttered oven-proof dish. Dot with butter and put in a pre-heated oven at 410°F for approximately 20 minutes.

White sauce
Melt the butter in a non-stick pan and, when it turns lightly golden, sprinkle in the flour. Stir well and heat for a couple of minutes before adding the hot milk. Mix everything thoroughly and cook for 10 minutes. Add salt and pepper to taste.

Serves 4

Preparation time: 15'
Cooking time: 35' plus 20' to cook
the millet and make the white sauce

6 artichokes (preferably from Liguria)
1 clove garlic
1 large white onion
120 g boiled millet
300 ml white sauce
5 eggs
100 g stoned black olives ("Taggiasche")

50 g capers
1 glass dry white wine
100 g grated Swiss Emmentaler cheese
Extra-virgin olive oil
50 g butter
2 tablespoons chopped parsley
Salt and pepper

White sauce
30 g butter
30 g flour
300 ml hot milk
Salt and pepper

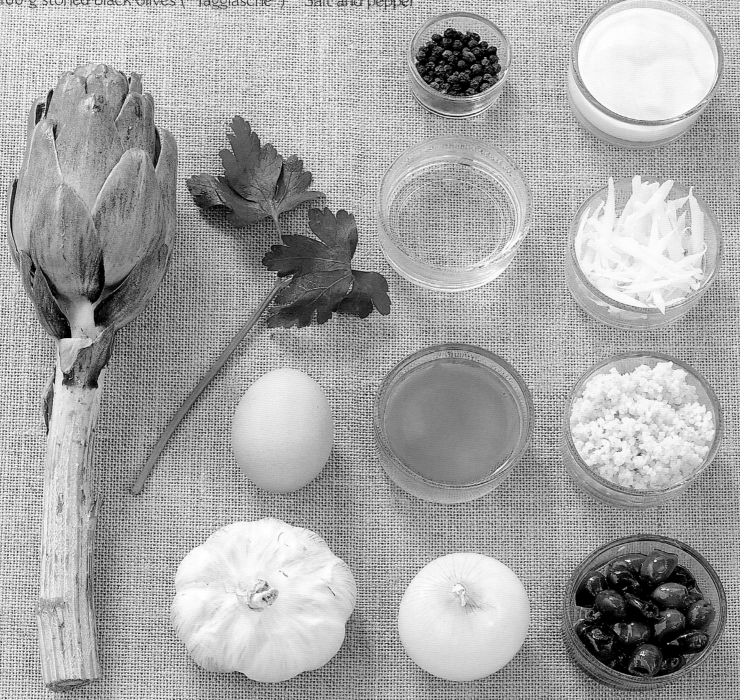

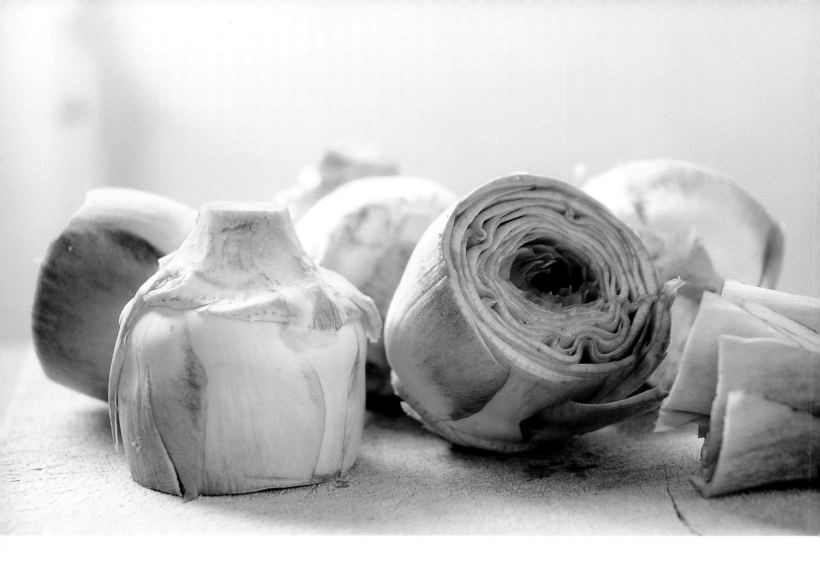

The two artichoke eaters in our family would live off them if they could. This gratin makes a lovely, satisfying main course and uses another of our favourite ingredients: olives.

It seems fitting to serve this dish during the olive harvest at the farm, when the conversation revolves exclusively around olives, their harvesting, weighing and pressing and the long-awaited first grassy throat-burning taste of freshly-pressed olive oil as it comes out of the mill.

We do make a small quantity of green eating olives (not the same variety as those used for oil) that do not last as long as the commercial ones but are good while they last. For this recipe, I recommend the little black olives from Liguria called "Taggiasche."

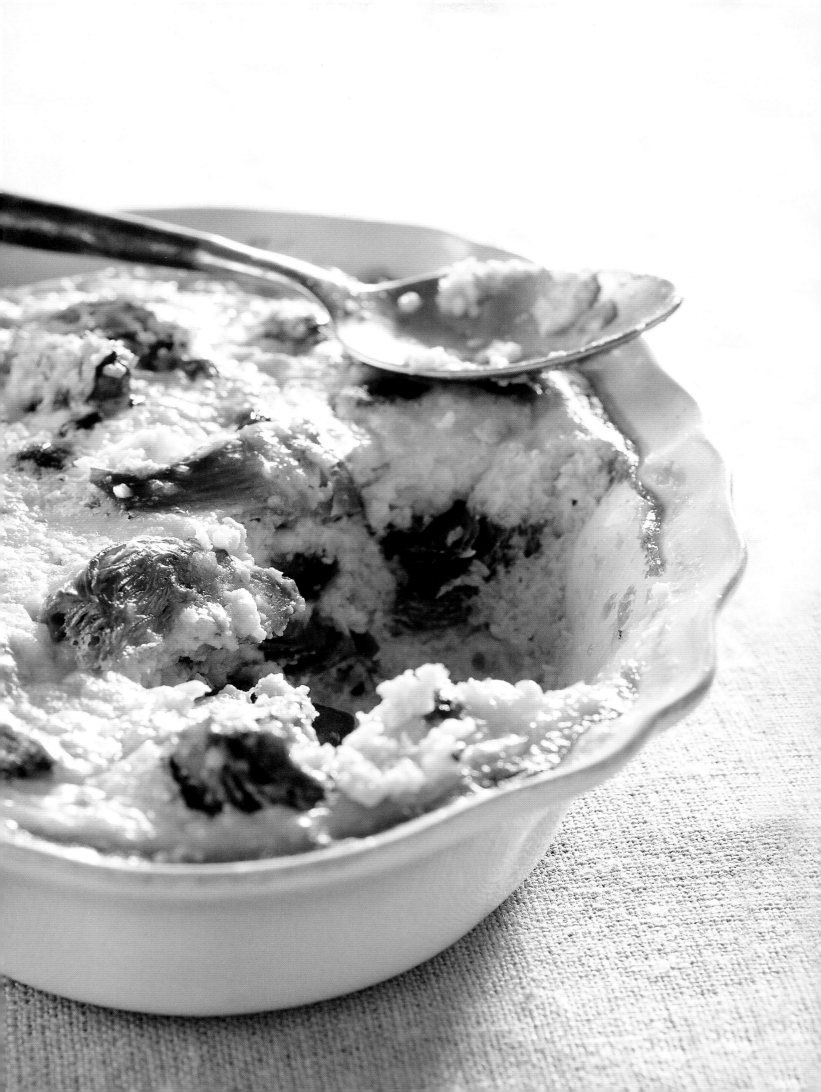

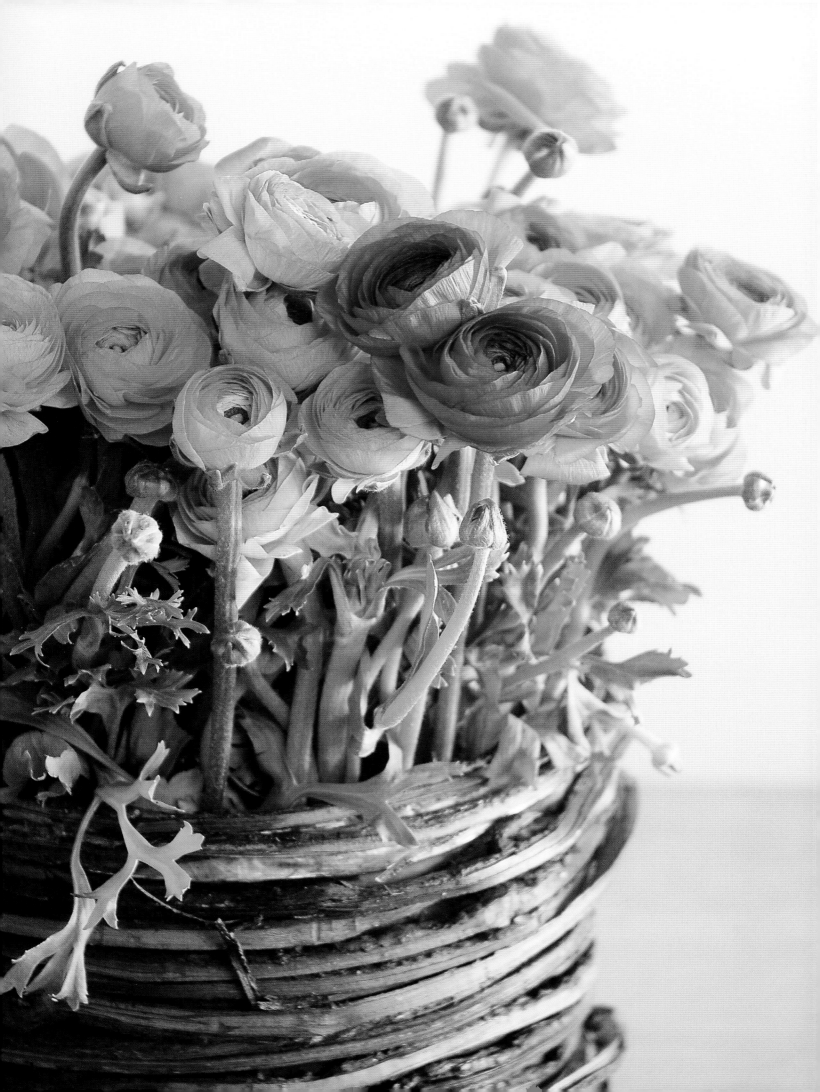

Harvest of Olives with Artichokes and Pink Ranunculuses

Preparation time: 30'

15-20 pink ranunculuses
5-7 artichokes
1.5 kg green or black olives
1/2 block of moistened floral foam
5-7 floral picks
Large, wide-mouthed glass bowl or vase

I took unfair advantage of the fact that in November we are submerged with fresh olives. Amid protests, I took some to make this decoration. To alleviate the fears of olive-oil lovers, they were returned to their rightful place: the mill.
The technique used for this decoration is extremely easy and may be used for many different combinations of vegetables, fruit and flowers.
First of all, put a few handfuls of olives in the bottom of your container and place the block of moistened foam firmly on top. Add more olives in order to fill the sides of the vase around the block of foam, leaving the top uncovered so that it is easy to insert the flowers and artichokes.
To add the artichokes, use a pick for each one, inserting them into the stalk of the artichoke. Create a sinuous grouping of artichokes from one side of the container to the other, keeping them quite close together.
Fill the remaining space with the ranunculuses keeping the shape of the composition rounded.
Coax a few more olives under the flowers and artichokes to cover any foam that is still visible.

If you don't feel up to making
a structured composition, you could
achieve a similar effect by using the same
elements freely in the container without
the moistened foam. Make sure
that the artichoke stem is left long
as well as the stems of the flowers.
The olives will help keep things in place

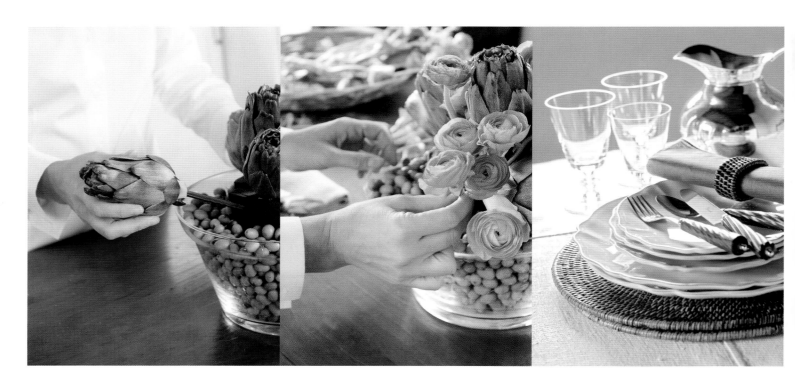

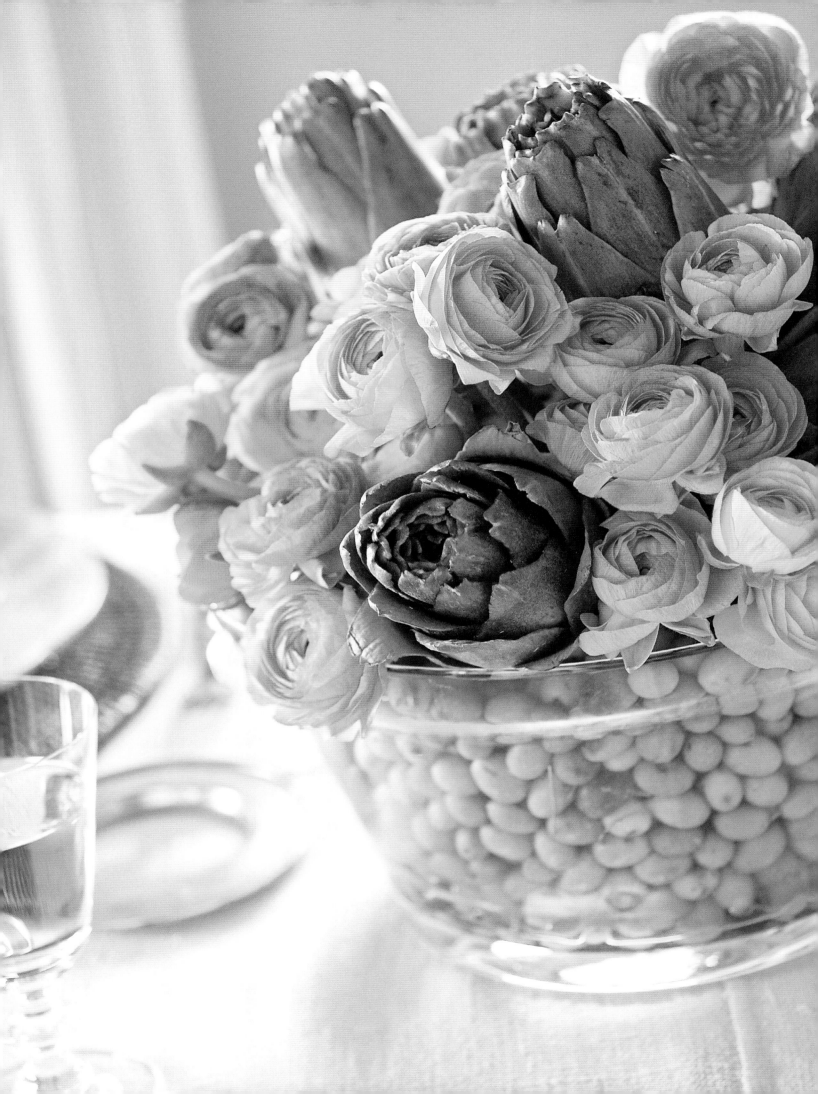

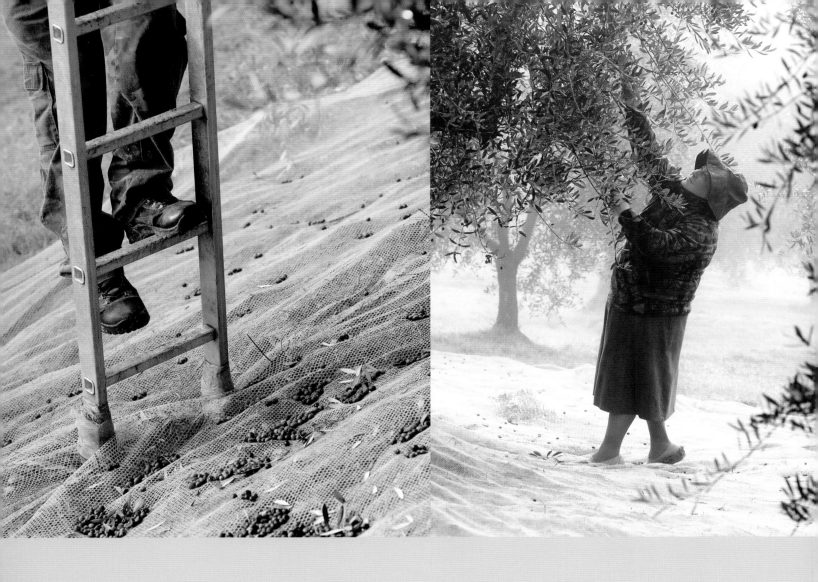

66

The pickers spend long days in the fields
and pack amazing picnic lunches
to sustain them. We are often lucky
enough to have some of their
homemade offerings, and each group
of pickers has its own specialities

99

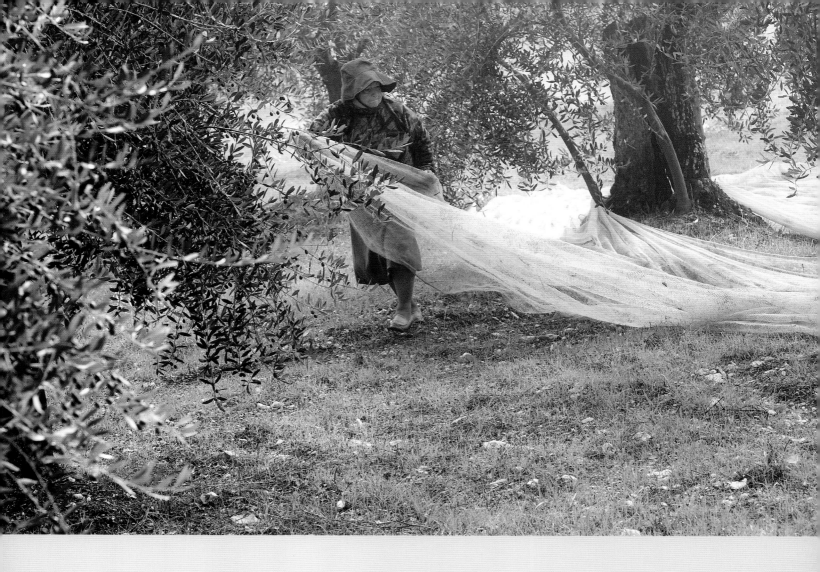

Olive harvesting in Tuscany is a labour of love, with long hours in the fields spent picking them by hand. Pickers come to see the grove owners during the summer months and make arrangements for the autumn; how many people will come, for how many days and which groves will be assigned to them.

When harvest time comes at the beginning of November, the groups of pickers start their work. The olives are picked from the trees using what looks like a little rake; they fall onto nets which have been placed under the tree. When all the olives have been picked, they are gathered into large crates to keep them well aerated. They are then taken to the mill and pressed the same day for the best quality oil. We are lucky enough to be able to do so having our own mill on the property.

Late in the afternoon the tractor makes its rounds to load the crates of olives to bring to the mill to be weighed and pressed. The end-of-day discussions about the crop, its quality and its bounty accompany the weighing and the registering of the day's work. Then the all-night job of pressing starts.

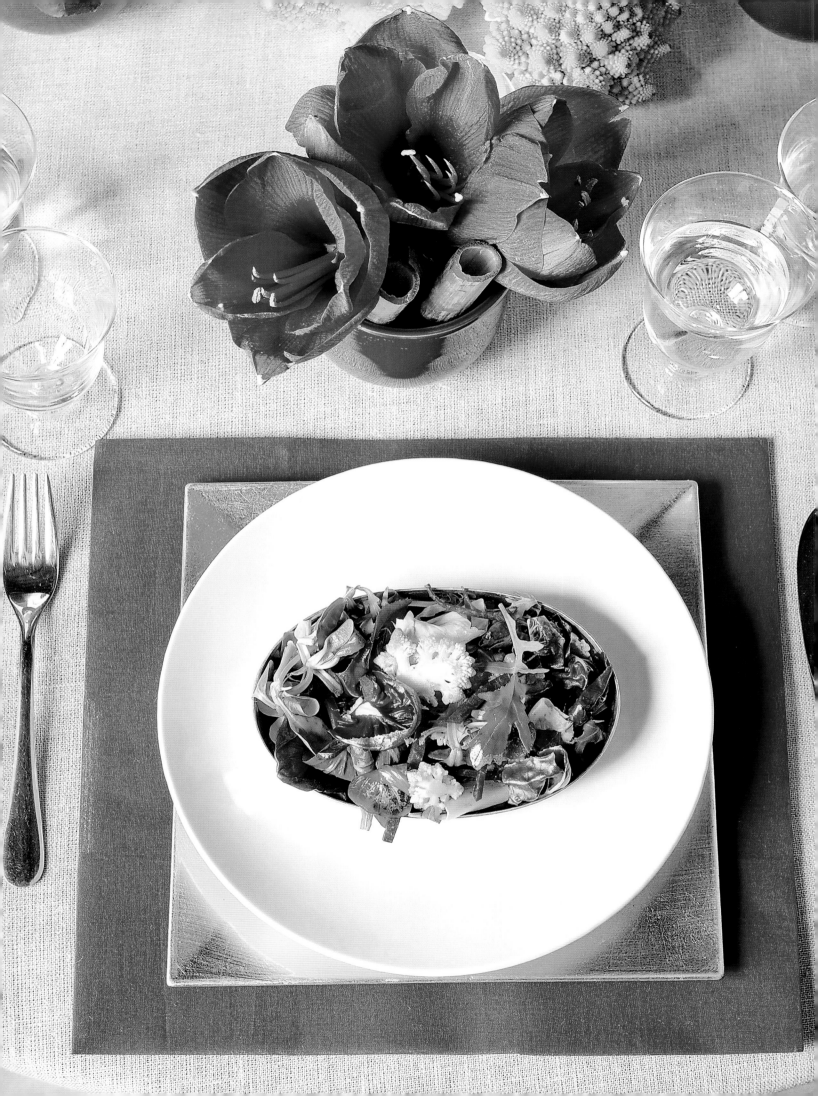

Variegated Salad of Winter Vegetables with Orange and Sunflower Seeds

Serves 4

Preparation time: 20'

1 heart of escarole
100 g rocket
100 g Lamb's lettuce
1 head Verona radicchio
100 g raw beetroot
100 g raw cauliflower florets,
Romanesque if possible
60 g peeled sunflower seeds
A small bunches of chives
1 small organic orange
Extra-virgin olive oil
Salt and pepper

This is a great winter salad, full of colour, flavour and texture. The Romanesque cauliflower is a bright acid green, the beets are ruby-red and little bright flecks of orange peel make this a feast for the eyes.

Clean and wash all the different types of lettuce. Thinly slice the radicchio and break up the escarole with your hands. Clean, peel and julienne the beetroot. Slice the cauliflower florets and put all the ingredients in a salad bowl. Toast the sunflower seeds in a small non-stick pan, then finely chop a quarter of the orange zest and add both to the salad along with the chopped chives. Blend the juice from half an orange with 4 spoons of extra-virgin olive oil, salt and pepper. Pour onto the salad, toss and serve.

The brilliant magenta red
of the beetroot, the acid green
of the Romanesque cauliflower
and the marbled purple of the radicchio
make this salad an ideal appetizer
for a special holiday luncheon

Centrepiece with Étagère of Greenery

Preparation time: 1 hour

Table Setting
4 red amaryllis
2 Romanesque cauliflowers
1 large radicchio Trevisano
Handful of baby radicchio
4 dark red ceramic *cachepots*
Candle holders
Tea lights

Étagère
Selection of Radicchio, large, baby and Castelfranco
2 large Romanesque cauliflowers
A selection of branches: rosemary, bay leaves, box, *viburnum tinus*
Floating candles
Tealights
2 glass dishes

Sometimes a centrepiece, no matter how lovely, just isn't enough. A decoration somewhere else in the room can do a lot to create a unique atmosphere and will also add extra strength to the table setting. It doesn't have to be a complicated affair, just a few branches, vegetables and candles; the important thing is to be generous.

Table Setting
The vases or ceramic containers shouldn't be very tall, just slightly taller than the cauliflower. In this way, the various elements will blend together to make a whole.
Cut the amaryllis very short, put them in the *cachepot*. Use the stem as well by cutting them to form two "pipes" and add them to the amaryllis. The lovely bright green of the stems will set off the colour of the blooms.
In one of the other two vases put the baby radicchio and in the other, the larger one. Place a cachepot in front of each place setting and the cauliflower in the centre. Candles and tealights where you like.

Étagère
If you don't have an *étagère* to fill, you could dress up a sideboard or coffee table. First of all, place your bowls for the water and floating candles, the other tealights, add branches around them and then the cauliflower and radicchio. A few amaryllis would look nice if space permits.

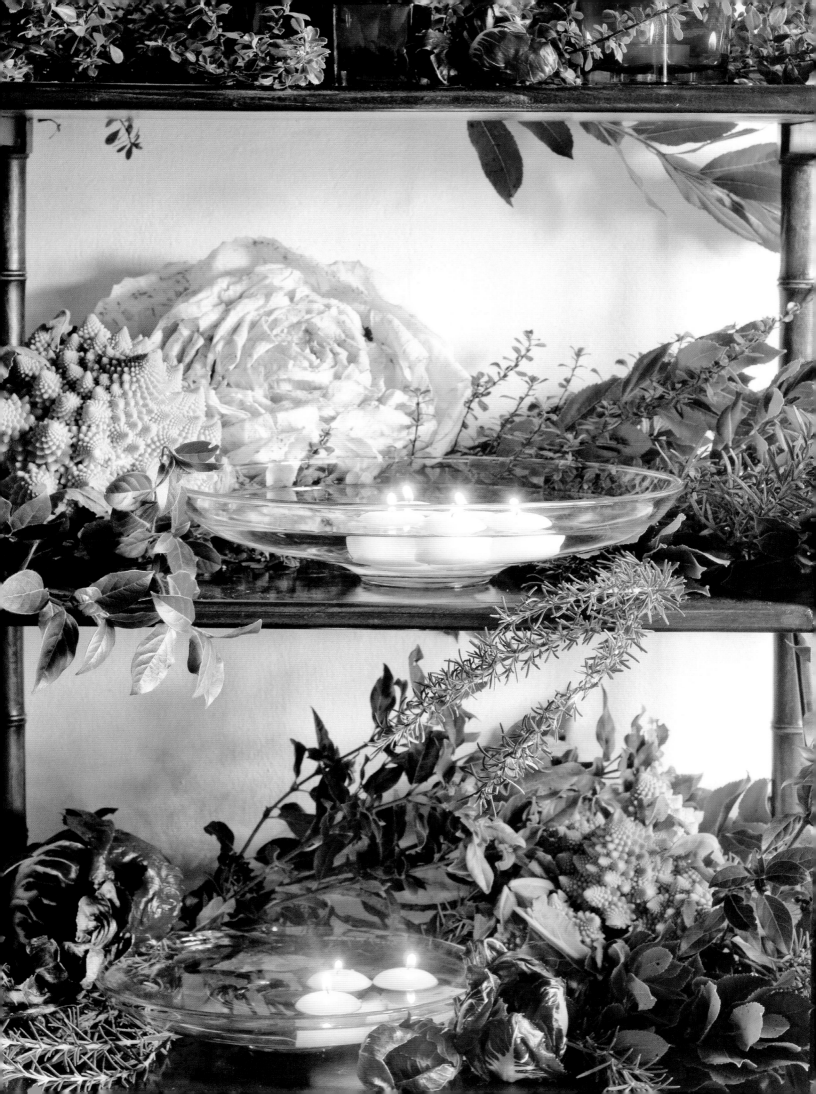

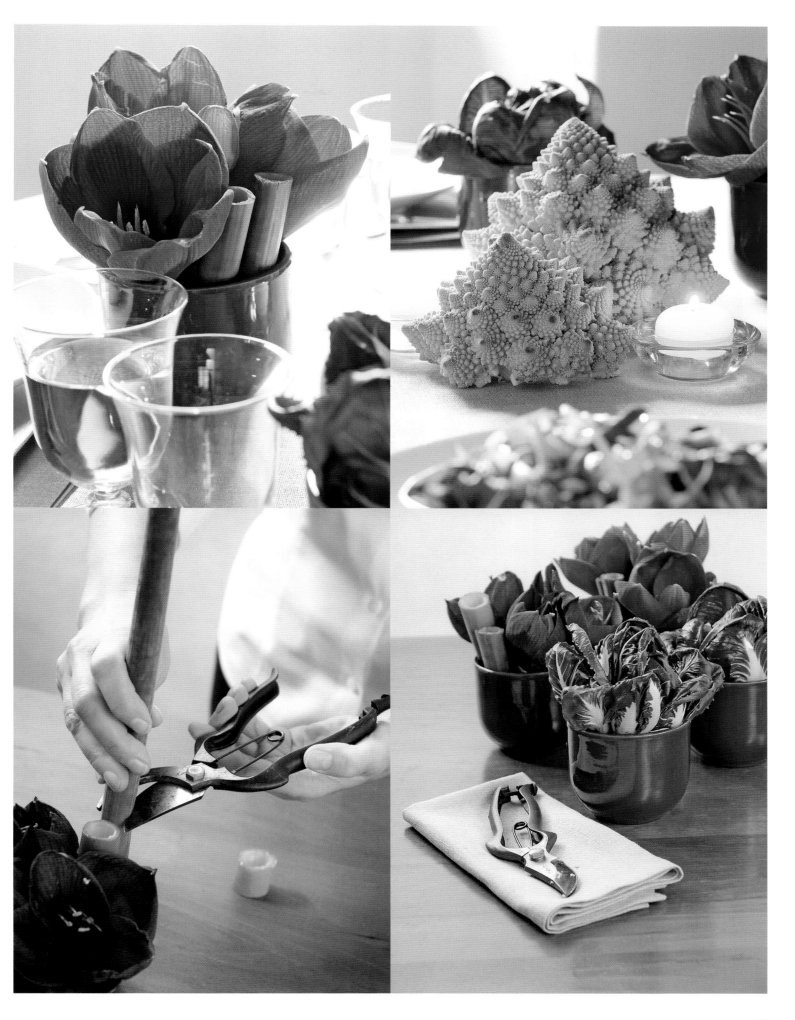

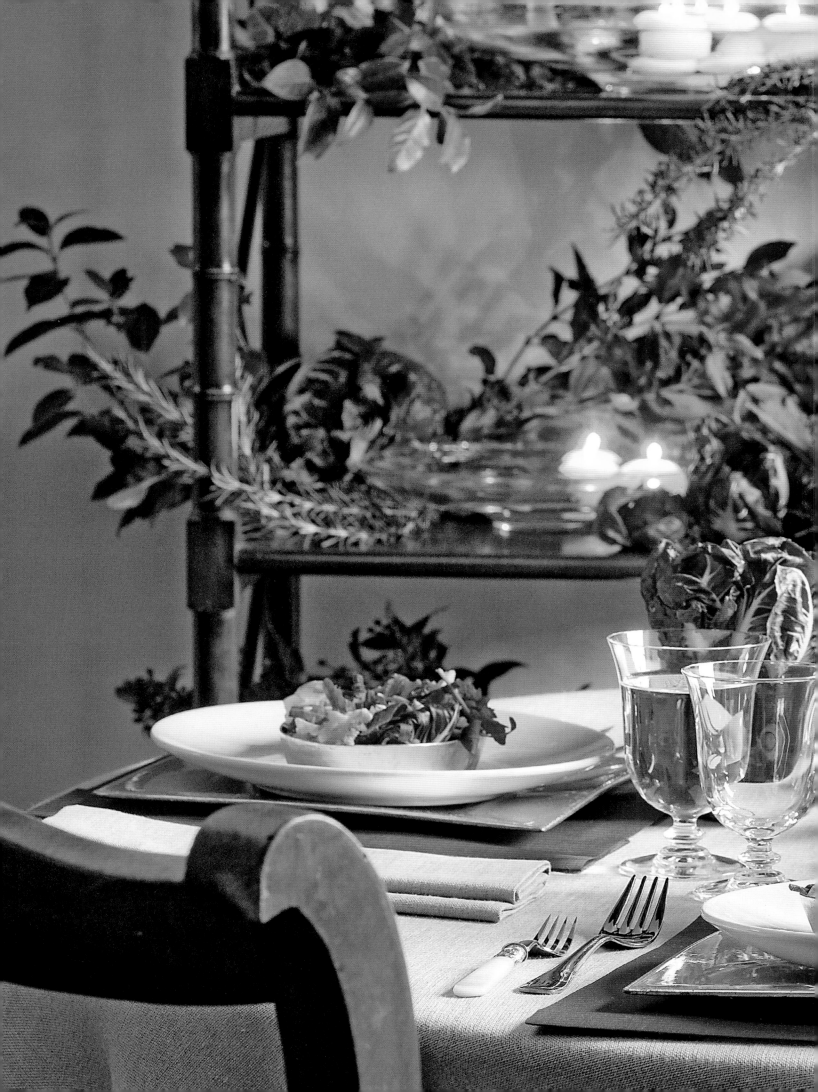

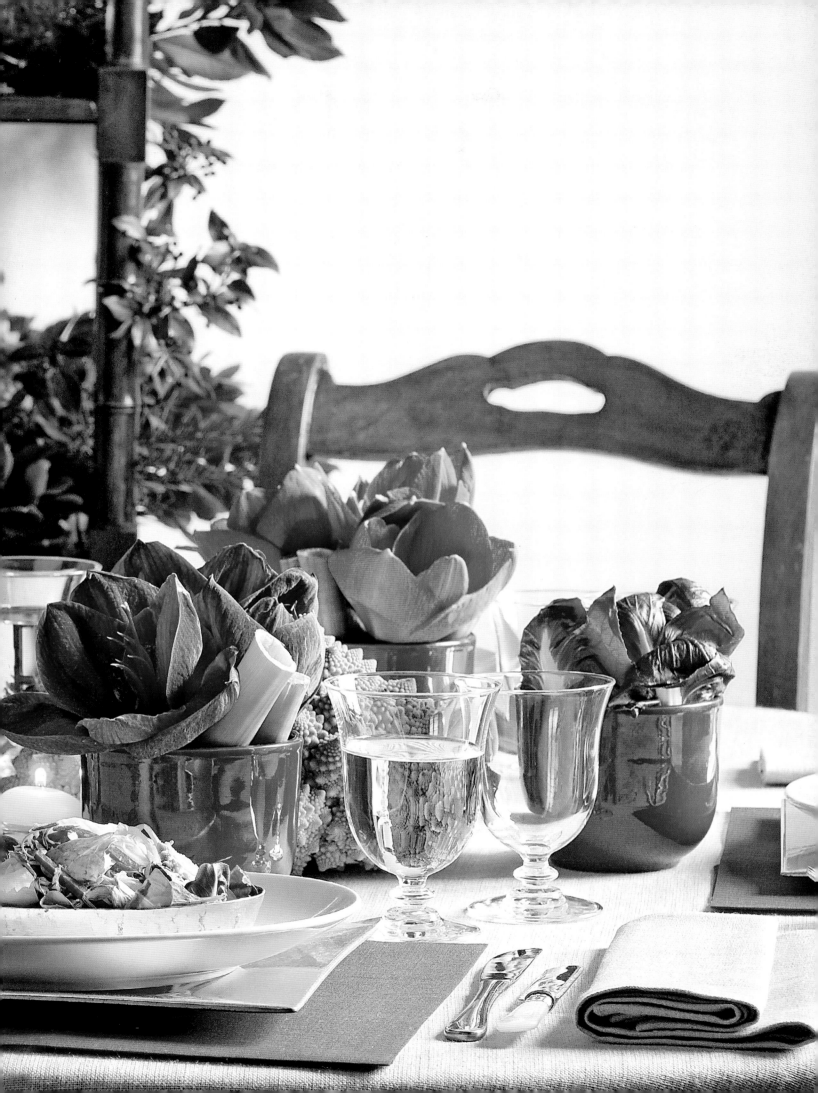

Acknowledgements

As with all endeavours, this book was made with the contribution of many different people without whom none of this would have been possible.
Any faults of this book are mine alone, while the merits are theirs.
I would like to thank Federico for his wonderful and sensitive photography, his unfailing help, support and laughter throughout the work of the book as well as for its beautiful cover. Sara, my assistant, thank you for your long hours, hard work and faith in the project and my work. To Paola, my home economist, for her generous help and creative recipes. Thanks to Remus and Mioara for their indispensable behind-the-scenes hard work at Il Casellino.
To my publishers at Electa; my hearfelt thanks to Enrica, Luciano, Massimo, Anna, Dario, Virginia, Eva, Monica, Tiziana for their faith in this book as well as their advice, hard work and friendship. To the publishing company Il Faggio, who helped every step of the way with patience and humour; Tanja for forging the text into what it is, Veronica for the fantastic layout, and to Franco, who oversaw it all and reassured me at all the right moments as only a truly experienced professional could.
I would like to thank the International Flower Bulb Centre for the wonderful flowers you have seen in this book as well as Lucas and Elena for their enthusiasm and support of the project. Enzo, Inka and Sylvio at Lombardaflor for their advice, wonderful service and generosity; Lisa Corti for her generosity and beautiful tablecloths; Rossana Orlandi, Rosanna and Flamant for tableware and Frigo 2000 / Sub-Zero Wolf for their fantastic appliances that made cooking such a pleasure.
I would like to thank all those who have contributed to my personal and professional growth and who have sustained me troughout my career.
Last of all, to my family. Each one of you participated in your own unique way and each of you knows to which measure you were part of or supported my endeavours.
Thank you.

Biographies

Donna Brown, is Canadian by birth but Italian by adoption. She has applied her skills in several artistic spheres over the years and ventured into the music, fashion and design worlds. She has worked with La Scala on several occasions and in particular for the inauguration of the opera season 2004, the year it returned to its original home designed by Piermarini. Today, she plans events, designs gardens and teaches floral decoration.
She also contributes to specialist publications and various television programmes.

Federico Magi, visual director of TheYellowDog, has a wide ranging experience in the fields of photography and graphic design. He now teaches at Milan's New Academy of Fine Arts and has published works, under various publishing houses, both in Italy and abroad.

Credits

Lisa Corti
Tablecloth: 27, 28, 29, 31, 46, 66, 67, 74, 75, 164, 165, 188, 189
Napkins: 29, 31, 35, 36, 37, 46, 65, 67, 74, 75, 118, 119, 134, 164, 165, 188
Chargers: 192, 200, 201
Glasses: 151

Flamant
Napkin Rings: 188
Plates: 177, 188, 189
Serving Plates: 182, 185
Chargers: 188
Glasses: 118, 119, 188, 189
Cutlery: 188
Jug: 188
Carafe: 118
Ladle: 118, 119

Lombardaflor
Chargers: 145, 151
Vase : 28, 29, 30, 31, 83, 84, 85, 171, 192, 199, 200, 201
Basket: 53, 106, 152, 164, 165, 180, 181, 186

Rosanna
Chargers: 27, 29, 31, 169, 171, 172, 173

Rossana Orlandi
Tablecloth : 36, 37, 126, 127
Table Runner: 118, 119
Plates: 27, 29, 31, 192, 195, 200, 201

Sub-Zero Wolf
Cooker: 24, 25, 78, 95, 114, 121, 122, 146, 160, 168, 176, 182, 194
Oven: 42, 130, 137, 182
Grill: 69, 175

Adresses

Azienda Agricola Il Casellino
info@casellino.com
www.casellino.com

Lisa Corti
Lisa Corti Home Textile
Emporium
Via Lecco, 2
20124 Milano, Italy
Tel. +39 02 20241483
www.lisacorti.com

Flamant
Flamant Italia
C.so Magenta, 10
20123 Milano
Tel. +39 02 7273041
Fax +39 02 7273042
International
www.flamant.com

Frigo 2000 s.r.l.
Viale Fulvio Testi, 125
20092 Cinisello Balsamo (MI)
tel +39-0266047147
info@frigo2000.it
www.subzerowolf.it

International Flower
Bulb Centre
Weeresteinstraat 10
2181 Ga Hillegom
Holland
tel. +31252628960
info@bulbsonline.org
www.bulbsonline.org
www.tuttobulbi.it,
www.floweryourlife.com

Lombarda Flor
Lombarda Flor Srl
Via E. De Nicola, 20
20090 Cesano Boscone (MI)
Tel. +39 02 4504523
Fax +39 02 4504345
www.lombardaflor.com

Rosanna
Rosanna by ART snc (Europa)
Via C. Crescente, 41/a
27058 Voghera (PV)
Tel. +39 0383 212086
Fax +39 0383 214478
www.storeart.it

Rosanna, Inc. (Usa e Canada)
440 South Holgate Street
Seattle, WA 98134 USA
Tel. 2026.264.7882
Toll-free 866. ROSANNA
Fax 2026.264.7637
www.rosannainc.com

Rossana Orlandi
Via M. Bandello, 14-16-18
20123 Milano, Italy
Tel. +39 02 4674471
Fax +39 02 48008387
www.rossanaorlandi.com

Sub-Zero Wolf
www.subzero.com
Toll Free Canada USA
Sub-Zero: 800.222.7820
Wolf 800: 332.9613

Editorial coordinator
Virginia Ponciroli

Editing
Tanja Beilin, Marina Marcello Del Majno
for Il Faggio, Milan

Graphic project
and Graphic coordinator
Anna Piccarreta

Layout
Veronica Bellotti, for Il Faggio, Milan

Cover
Federico Magi

Technical coordinator
Lara Panigas

Quality control
Giancarlo Berti

This volume was printed for Mondadori Electa spa
at Mondadori Printing spa, Verona, in 2009